50 BRITISH ARTISTS
YOU SHOULD KNOW

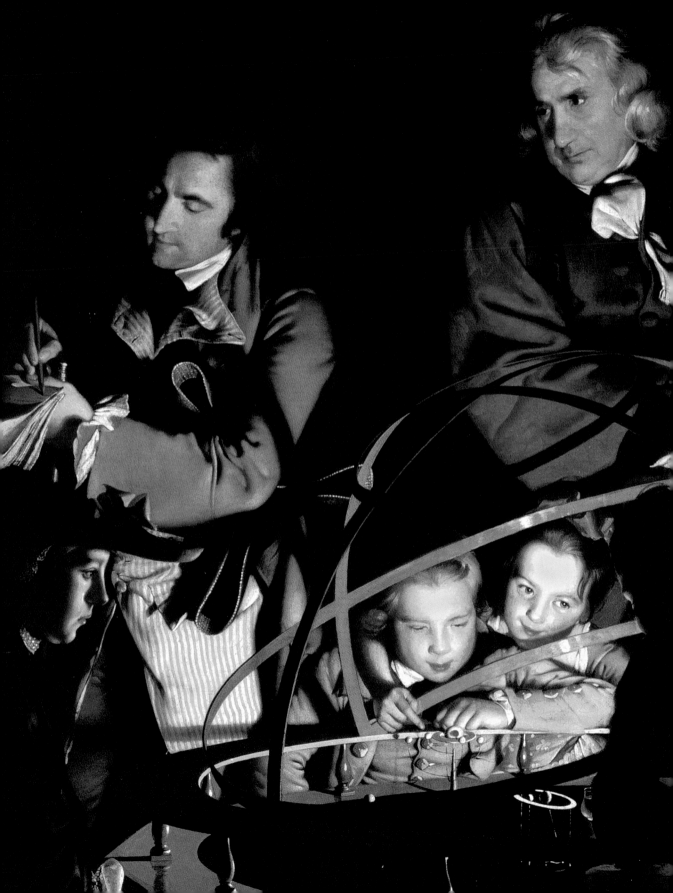

50 BRITISH ARTISTS
YOU SHOULD KNOW

Lucinda Hawksley

Prestel
Munich · London · New York

To my godson, Samuel Hurst

Front cover from top to bottom:
Antony Gormley, *Angel of the North*, see page 130
Banksy, *Stamps*, see page 152
J M W Turner, *Rain, Steam and Speed*, see page 52
John Everett Millais, *Ophelia*, see pages 66–67

Frontispiece: Detail of Joseph Wright of Derby, *The Orrery*, see page 40

Prestel, a member of Verlagsgruppe Random House GmbH

Prestel Verlag
Neumarkter Strasse 28
81673 Munich
Tel. +49 (0)89 4136-0
Fax +49 (0)89 4136-2335

Prestel Publishing Ltd.
4 Bloomsbury Place
London WC1A 2QA
Tel. +44 (0)20 7323-5004
Fax +44 (0)20 7636-8004

Prestel Publishing
900 Broadway, Suite 603
New York, NY 10003
Tel. +1 (212) 995-2720
Fax +1 (212) 995-2733

www.prestel.de

www.prestel.com

Library of Congress Control Number: 2010941110

British Library Cataloguing-in-Publication Data: a catalogue record for this book is available from the British Library; Deutsche Nationalbibliothek holds a record of this publication in the Deutsche Nationalbibliografie; detailed bibliographical data can be found under: http://dnb.d-nb.de

Prestel books are available worldwide. Please contact your nearest bookseller or one of the above addresses for information concerning your local distributor.

Editorial direction: Philippa Hurd
Artists' biographies, timelines and picture research by Jonathan Aye
Art direction: Cilly Klotz
Cover and design: LIQUID, Agentur für Gestaltung, Augsburg
Design and layout: zwischenschritt, Rainald Schwarz, Munich
Origination: Repro Ludwig, Zell am See
Printing and binding: C & C Printing

Verlagsgruppe Random House FSC-DEU-0100
The FSC®-certified paper *Chinese Golden Sun matt art* is produced by
mill Yanzhou Tianzhang Paper Industry Co. Ltd., shandong, PRC.

Printed in China

ISBN 978-3-7913-4538-3

CONTENTS

INTRODUCTION

Choosing just fifty artists to represent the history of British art is a Herculean task; the artists who made it into the final list are not the only masters in their field, but they are all groundbreaking, fascinating figures whose lives and work have changed the course of art history. Each artist in this book is also representative of many other superb artists with whom they have worked alongside or in competition.

A turbulent and exciting history that spans thousands of years has given British artists a rich seam to plunder for inspiration. The Celts, Angles, Saxons, Vikings, ancient Romans and Druids are just a few of the varied groups of people who have influenced the development of British art. From Nicholas Hilliard's laudatory portraits of Queen Elizabeth I to Banksy's wittily irreverent portrait of Queen Elizabeth II, 50 *British Artists You Should Know* is not just the history of British art, it is the history of Britain itself.

The landscape of the British Isles reflects the British people's artistic nature: white horses and fertile giants carved into chalky hills, Celtic crosses, the magnificence of stone and wood circles, such as those at Stonehenge and Avebury, the skilled artists and crafts-men who created towers, castles and baronial homes — all reflect the generations of artists and artisans who have made this collection of islands their home.

Despite this long tradition of artistry, however, for many centuries British fine art was an amalgamation of influences from elsewhere in Europe. For hundreds of years, the greatest names in British art were those of Dutch, German, French and Italian painters who learned their craft in their own countries and then made their homes — and fortunes — in Britain. Artists such as German-born Hans Holbein the Younger and Flemish-speaking Anthony van Dyck dominated the British art world for decades. Foreign artists were appointed painters to the royal court and received all the most lucrative commissions. During the first Elizabethan age, however, British artists suddenly began to come into their own and a new and exciting period of British painting was born. It was a long and arduous journey, but with the founding of the Royal Academy under King George III, Britain finally had an artistic academy to rival those of Paris, Antwerp and Rome.

Throughout the centuries, ships have brought people of all cultures to the British Isles, enriching the already diverse indigenous cultures of Scotland, Ireland, Wales and England. British art reflects all these influences, especially during the most recent centuries when this small collection of islands has welcomed people from all over the world. In the 20th and 21st centuries, the British art scene has flourished and developed in more exciting ways than could possibly have been envisaged when Joshua Reynolds proudly accepted the role of First President of the Royal Academy in 1768.

Ever since around 1600 when Nicholas Hilliard wrote, in *A Treatise Concerning the Art of Limning*, 'of all things, the perfection is to imitate the face of mankind', British portrait painters have sought to recreate the faces of the British people. Hilliard flattered his queen and her courtiers in the same way that Joshua Reynolds would seek to create an idealised race of heroic, stoic men and beautiful, maternal women. At the same time as Reynolds was performing his painterly style of plastic surgery, his satiric contemporary, William Hogarth, sought to show the world his sitters as they truly looked. In the 19th century, John Everett Millais sought to recapture the realism he felt was lacking in contemporary British portraiture while his friendly rival Frederic, Lord Leighton produced paintings of beautifully formed men and women who seemed to hail from a modern Mount Olympus. In the 20th century, Barbara Hepworth created an entirely new style of sculptural portrait, an 'abstract vision of beauty'. Several decades later Chris Ofili would begin his journey to make portraits that could speak — and cry out — for themselves and for humanity, while Antony Gormley encompassed both the 20th and 21st centuries with his human figures as 'vessels that both contain and occupy space'.

The diversity of the British landscape has proved equally as inspirational as the British people themselves. While J. M. W. Turner was recreating the seascapes that surrounded the British Isles, his rival John Constable was idealising the rural Suffolk of his childhood. As Britain grew more industrialised and greater numbers of people moved to urban areas, artists including L. S. Lowry, Walter Sickert and Charles Rennie Mackintosh turned city streets and buildings into works of art.

Rebellion has long been a part of the British psyche, with each generation discovering a reason to break away from the art that went before. The Romantics felt the need to break away from the Classicists, the Pre-Raphaelites rebelled against the Royal Academy, the Bloomsbury Group firmly shut out the Victorian period of their childhoods and Francis Bacon and Gilbert & George rebelled against Britain's archaic homosexuality laws. By the late 20th century, it was becoming increasingly difficult to find a new and unique reason for artistic rebellion, but the Young British Artists (YBAs) purported to create an entirely new style of art for a new millennium, and Banksy chose to rebel against using anything as conventional as a canvas and oils.

The fifty artists you will encounter in this book encapsulate the diversity, beauty, joy and wit of British life, culture, people and landscapes. For a small collection of islands, Britain has played an astonishingly large role in the history of the world and *50 British Artists You Should Know* reflects that story. The artists chosen to illustrate these pages take the reader on a journey from the time when England, Wales, Ireland and Scotland were separate kingdoms, through the age of unification, into the age of the vast world-encompassing British Empire and into a modern world, in which all four countries are exploring their own unique identities once again. With every generation, a new style of British art will continue to evolve and the British art world will continue to be peopled by activists, visionaries and rebels.

1492 Christopher Columbus discovers America

1486 Sandro Botticelli paints *The Birth of Venus*

1512 Michelangelo completes work on the ceiling of the Sistine Chapel

1532 Sir Thomas More resigns as Lord Chancellor of England

1460 1465 1470 1475 1480 1485 1490 1495 1500 1505 1510 1515 1520 1525 1530 1535 1540 1545

Nicholas Hilliard, *Portrait of Queen Elizabeth I*, oil on panel, 58.4 x 44.5 cm, Private Collection

1557 Robert Recorde invents the Equals sign

1564 Death of Michelangelo

1584 Beginning of Golden Age in Dutch Painting

1602 First recorded performance of William Shakespeare's *Twelfth Night*

1616 Death of William Shakespeare

1626 Death of Sir Francis Bacon

1550 · 1555 · 1560 · 1565 · 1570 · 1575 · 1580 · 1585 · 1590 · 1595 · 1600 · 1605 · 1610 · 1615 · 1620 · 1625 · 1630 · 1635

NICHOLAS HILLIARD

Trained in the arts of goldsmithing and jewellery Nicholas Hilliard's exquisite portraits combine the production of likenesses and fine brushwork with a sensitivity to the pearls, jewels and fine fabrics worn by his eminent sitters.

Nicholas Hilliard was born into an artistic family; his father was a successful goldsmith in the city of Exeter in Devon. Together with their local Protestant community, the Hilliards fought against the reintroduction of the Catholic faith into England — these beliefs would later lead to a necessity to flee England in fear of their lives.

In 1547, the year in which Nicholas Hilliard was born, Henry VIII's sickly son, Edward VI, ascended to the throne. After six years, the teenaged King Edward died and his Catholic sister was proclaimed Queen Mary I. The Hilliard family fled to Switzerland. Young Nicholas, a promising artist from childhood, learned to speak French and studied the work of French and Swiss artists, both skills served him well in later life.

The Hilliard family returned to England in 1558, following the death of Mary and the accession of her Protestant sister, Queen Elizabeth I. Through his father's contacts, Nicholas was found an apprenticeship in London with a goldsmith and limner (a painter). His earliest experiments in miniature portraiture date back to c. 1560, when he painted his self-portrait, aged just 13 years old. He would later write of his profession, 'Perfection is to imitate the face of mankind'.

By the early 1570s, Hilliard had finished his apprenticeship and his work was being talked about throughout fashionable London. His fame brought him to the attention of Queen Elizabeth I and he became her favourite and most trusted miniature painter. Hilliard later commented that the queen did not like to be painted in shadows, so she would sit to him outdoors, in full sunlight. Following Elizabeth I's death, in 1603, Hilliard worked for her successor, King James I (also known as King James VI of Scotland).

Hilliard ran a successful studio in Gutter Lane, not far from St Paul's Cathedral. As a favourite of the queen, he was highly fashionable and his sitters included the most famous and wealthy people in London. A large number of studio assistants worked with Hilliard, but the most famous of his pupils was Isaac Oliver, a French artist whose family the Hilliards had met while living in Switzerland.

In c. 1600, Hilliard wrote *A Treatise Concerning the Arte of Limning* detailing some of his practises, including very precise details on how to paint specific elements, such as pearls. In his introduction, the artist commented, 'I wish it were so that none should meddle with limning than gentlemen alone, for that it is a kind of gentle painting'. Hilliard mixed his own pigments, both oil- and water-based, and painted either on wood or very fine vellum (animal skin). Hilliard's preferred type of vellum was that taken from an aborted calf foetus, which he liked for being so smooth and hairless; the vellum would be glued to a stiff material, such as wood or card. The brushes used by miniaturists were made from animal hair, often squirrel hair, and would sometimes be composed of a single hair. Hilliard became renowned for the delicacy of his lines and the elaborate work he could produce — such as recreating the patterns of lace or fine filigree — in such a small space. One of his most admired techniques was the creation of 'jewels', such as the rubies seen in this miniature portrait of Queen Elizabeth I; he made them by using coloured resin and burnished silver or gold. He was, however, deliberately secretive in his *Treatise*, careful not to give away to rivals one of his most important secrets. Hilliard also produced large oil paintings, but it is for his miniatures that he remains most renowned.

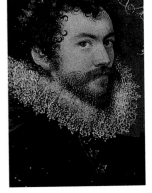

c. 1547 Born in Exeter, Devon, England, son of Richard Hilliard, a Protestant goldsmith and High Sheriff of the city and county in 1560

1553 Accession of catholic Queen Mary I; sent into exile by his father to escape the Marian Persecutions

1558 Accession of Queen Elizabeth I; Hilliard apprenticed to the Queen's jeweller Robert Brandon

1569 Made Freeman of the Worshipful Company of Goldsmiths

1570 Appointed Court Limner (miniaturist) and Goldsmith by Queen Elizabeth I

1571 Produces 'a booke of portraitures' for the Earl of Leicester

1572 Paints first dated portrait of Queen Elizabeth I

1576–79 Marries Alice Brandon; paints a miniature of Francis Bacon in Paris

1584 Designs obverse for a Great Seal of Ireland

1586 Engraves the Great Seal of England

c. 1588 Paints *Youth Among Roses*

1603 Accession of James I; Hilliard remains Court Limner and Goldsmith

1617 Receives a special patent of appointment from King James I, granting him sole license for royal portraits in engraved form for twelve years

1619 Dies 7 January in London

FURTHER READING
Karen Hearn, *Nicholas Hilliard (English Portrait Miniaturists)*, London, 2005

Nicholas Hilliard, *Self-portrait*, 1577

1563 Pieter Brueghel paints
The Tower of Babel

1581 English Parliament outlaws
Roman Catholicism

1624 Frans Hals
paints
*The Laughi
Cavalier*

1559 Coronation of Queen Elizabeth I

1607 Caravaggio paints *David
with the Head of Goliath*

1545 1550 1555 1560 1565 1570 1575 1580 1585 1590 1595 1600 1605 1610 1615 1620 1625 1630

Mary Beale, *Portrait
of Aphra Behn,*
c. 1670, oil on panel,
25.2 x 20.1 cm,
St. Hilda's College,
Oxford University

1666 Great Fire of London

1690 John Locke's *An Essay Concerning Human Understanding* is published

1650 Diego Velázquez paints *Portrait of Pope Innocent X*

1676 Foundation of the Royal Greenwich Observatory

1702 End of Dutch Golden Age in Painting

1635 1640 1645 1650 1655 1660 1665 1670 1675 1680 1685 1690 1695 1700 1705 1710 1715 1720

MARY BEALE

Mary Beale's success as a painter with a thriving portraiture business made her the breadwinner in her family and assured her place in the canon of women artists.

In 17th-century England, very few women were able to reach the top of their chosen profession, but Mary Beale became one of London's most famous portrait painters. Her world was one in which women were considered far inferior to men. Even while praising her, one of her contemporaries wrote what seems to be an astonished critique of her abilities, in which he declared himself amazed that Beale was 'little inferior to any of her [male] contemporaries, either for Colouring, Strength, Force or Life'.

Mary Beale was born Mary Cradock, the daughter of a Puritan clergyman. Her father was also a keen amateur painter and taught and encouraged his daughter to paint. Later, he paid for her to have an art tutor. It is not certain who her tutor was, but there are two likely candidates: one is the portrait painter Robert Walker, the other was Sir Peter Lely. Both men were friends with Mary's father and both painted his portrait, so it is likely Mary studied both men's work and perhaps learned from both of them.

It was fortunate that Mary married a man who not only understood his wife's talent, but encouraged her and was happy to take a step back from the limelight. Charles Beale, whom Mary married in 1651 or 1652, worked as a merchant and as a clerk at the Patents Office. His career went through a number of crises and Mary's talent helped keep the family's finances out of trouble.

The Beales moved in an exaltedly intellectual circle, numbering scientists, fellow artists, writers, poets and eminent clergymen amongst their closest friends. Mary also had literary aspirations and, although it was never published, wrote a text that could have proved as important, in terms of female equality, as Mary Wollstonecraft's *A Vindication of the Rights of Women*. Unlike Wollstonecraft, Beale was a dedicated Christian, yet in *Discourse on Friendship*, which Beale dedicated to her friend Elizabeth Tillotson, she reasoned that God created Eve as the equal of Adam, as 'a wife and friend, but not a slave'. The Beales were living through a turbulent time. Mary was a teenager when the English Civil War broke out and King Charles I was beheaded. She lived through Oliver Cromwell's brief reign as Lord Protector and the reinstatement of the monarchy. In addition to the bloodshed of civil war, she survived the virulent outbreak of the bubonic plague, or 'Black Death', in 1665, as well as the Great Fire of London in 1666. The Beales expediently left their native London for the Hampshire countryside during the plague.

In 1670, Mary and Charles made the decision to return to London and set up a portrait studio in which they would work as equal partners. Charles Beale managed the finances as well as providing much-needed help in the thriving and often frenetic artist's studio. The couple had two surviving sons, Bartholomew and Charles (their first son, also called Bartholomew, died shortly after being born). The artist painted her sons' portraits on a number of occasions: the paintings are softly coloured, richly evocative portrayals of the fleeting years of child-hood. She also taught her children to paint and, as they grew older, they worked as her studio assis-tants. The younger Charles Beale went on to become a professional artist.

Mary Beale was buried on 8 October 1699, at the parish church of St James's, Piccadilly. The church, which was designed by Sir Christopher Wren and decorated by Grinling Gibbons, was badly damaged during the bombs of World War II; sadly no remains of Mary Beale's grave survived the attacks.

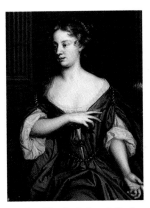

1633 Born Mary Cradock on 26 March in Barrow, Suffolk, England.

1652 Marries Charles Beale, a cloth merchant and amateur painter from London

c. 1654 Settles with Charles Beale in London and embarks upon a career as a professional portrait painter

1658 Mentioned in William Sander-son's book *Graphice*

1665 Moves with her family to a farmhouse in Allbrook, Hampshire due to financial difficulties and to escape the Great Plague of London

1670 Returns to London and establishes a studio in Pall Mall, with her husband working as her bookkeeper and studio assistant

1677 Receives a commission for thirty portraits of the Lowther and Thynne families

1699 Dies in London

FURTHER READING
Tabitha Barber, *Mary Beale (1632/3–1699): Portrait of a Seventeenth-century Painter, her Family and her Studio*, London, 1999

Mary Beale, *Self-portrait*, c. 1675–80, oil on sacking, 89 x 73 cm, Moyse's Hall Museum, Bury St Edmunds

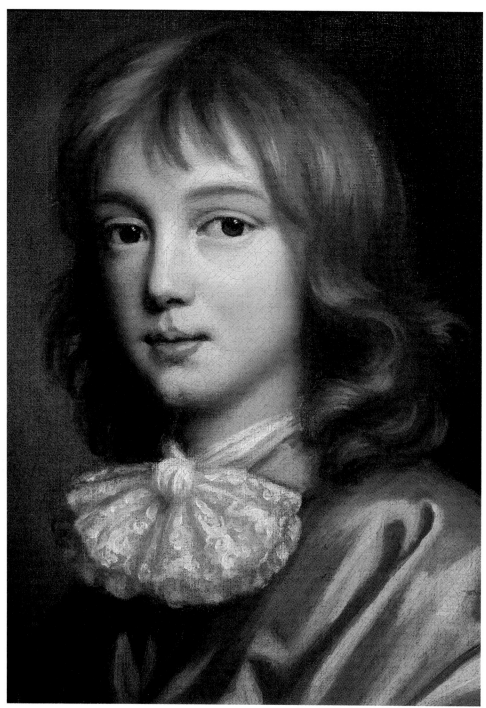

left
Mary Beale, *Portrait of the Artist's Son*,
c. 1680, oil on canvas, Private Collection

right
Mary Beale, *Portrait of the Artist's
Husband, Charles Beale in a Black Hat*,
oil on canvas, 44 x 35.5 cm,
Private Collection

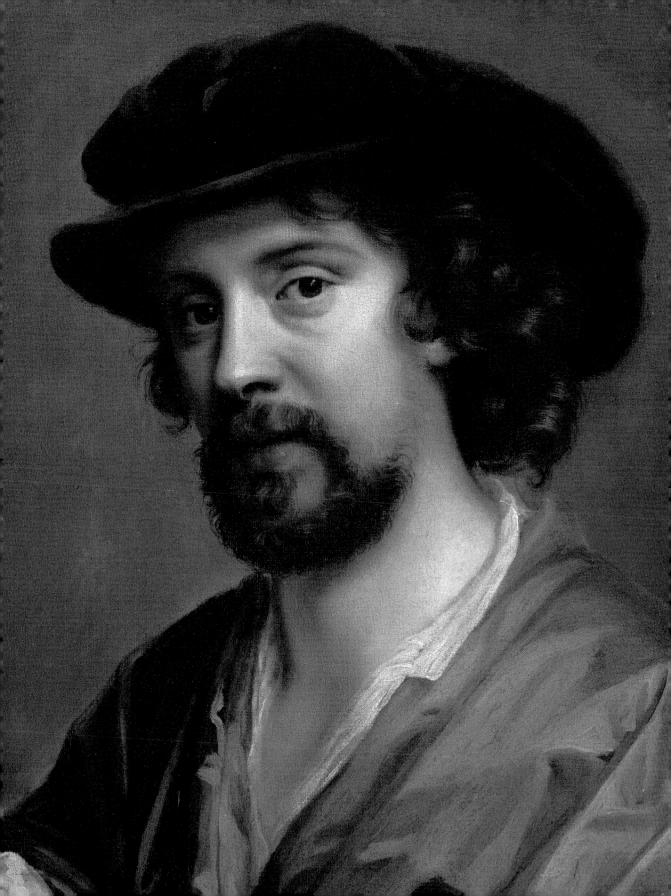

1642 Rembrandt paints *The Night Watch*

1626 Peter Paul Rubens paints
The Assumption of the Virgin Mary

1656 Diego Velázquez paints
Las Meninas

1610 1615 1620 1625 1630 1635 1640 1645 1650 1655 1660 1665 1670 1675 1680 1685 1690 1695

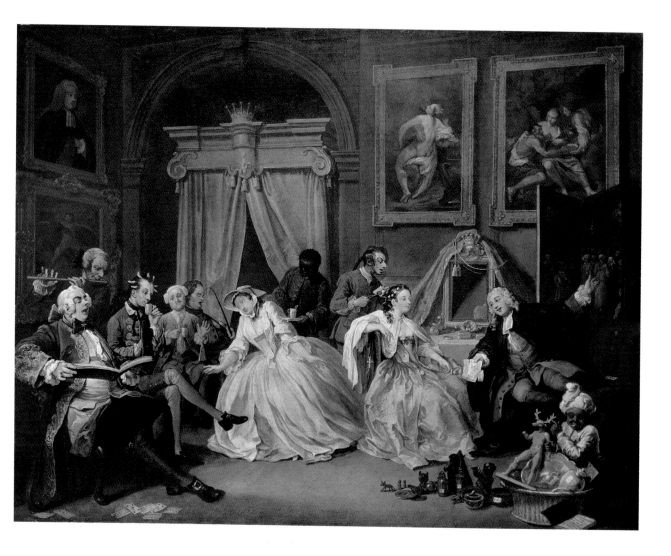

William Hogarth, *Marriage A-la-mode:*
4 *The Toilette*, 1743–45, oil on canvas,
70.5 x 90.8 cm, National Gallery, London

PIRANESI

1732 The first Royal Opera House opens
in Covent Garden, London

1755 Samuel Johnson's A Dictionary of
the English Language is published

1776 The United States
of America
declares inde-
pendence from
Great Britain

1703 Isaac Newton becomes chairman of
the Royal Society

1724 Blenheim Palace construction
is completed

1748 David Hume's An Enquiry
concerning Human Under-
standing is published

1762 Construction of the
Trevi Fountain in Rome
is completed

1700	1705	1710	1715	1720	1725	1730	1735	1740	1745	1750	1755	1760	1765	1770	1775	1780	1785

WILLIAM HOGARTH

Skilled engraver, painter and satirist William Hogarth commented on the morals of the modern world and raised the international status of British art with his complex depictions of British types and stereotypes.

William Hogarth created a uniquely British school of painting and an unusually honest style of portraiture. While artists such as Joshua Reynolds and Thomas Gainsborough were vying for aristocratic patrons and employing flattery to court wealthy sitters, Hogarth created portraits of people he admired and satirical engravings that made him wealthy.

As a young man, Hogarth made enough money to feel financially secure; it was a world away from his childhood. His father, Richard Hogarth, was an innovative schoolmaster eager to make his name and fortune by a brilliant scheme. His idea was to set up a fashionable coffee house in which the scholarly patrons would communicate only in Latin; it was not a success and he lost all his money. William Hogarth was ten years old when his father was arrested for debt and incarcerated in the Fleet Prison.

At the age of 16, Hogarth began an apprenticeship with silversmith Ellis Gamble, from whom he learned etching and engraving. He also attended free classes at the art academy set up by James Thornhill; Hogarth married Thornhill's daughter in 1729. By the end of the 1720s, Hogarth was making a profit by selling engravings of his own pictures. He had hit upon the simple fact that most people could not afford to buy original paintings, but Britain was full of people who could afford to buy prints. One of his early successes was *The South Sea Scheme* (c. 1721) an allegorical attack on a disastrous financial speculation the government had endorsed. His 'Progress' series, part morality tale, part comic soap opera, made him famous. *A Harlot's Progress* (1732) and *A Rake's Progress* (1732–33) were made up of six paintings that, when viewed together, told a story. While his artist contemporaries struggled to make money, Hogarth's prints became bestsellers.

In 1743, Hogarth began his most famous series: *Marriage-A-la-Mode* (1743–45), the story of a marriage of convenience between a dissolute and impoverished aristocrat and the daughter of a very wealthy, but also indubitably middle-class, merchant. It is a comedy, but a twisted comedy which ends in tragedy. The comic effect comes solely from the viewer's ability to laugh at aristocrats — the story itself tells of adultery, murder and suicide.

Hogarth had a well-developed social conscience and much of his work was created to highlight the social ills of the contemporary world. He used his satires to parody politicians, aristocrats, idlers and drunkards. With pictures such as *Gin Lane* and *Beer Street* (both 1751), Hogarth brought the issues of the day directly to the public. He was also able to poke fun at the country he hated: France, the traditional enemy of the 18th-century Englishman. Gin, which had arrived in Britain from France, had become the favourite drink of the poor — with dire social consequences. Beer was the traditional drink of the British working class. With these two pictures, Hogarth was comparing the evils of France with what he perceived as the benignity of English life. When his friend, the novelist and social reformer Henry Fielding, began campaigning for an act to be passed to limit the selling of gin, Hogarth produced *Gin Lane* and *Beer Street* to aid the campaign.

When his father in law retired, Hogarth successfully took over the running of James Thornhill's art school, the St Martin's Lane Academy. He also garnered praise for the publication of his book *The Analysis of Beauty* (1753) in which he contradicted the classical belief that beauty was to be found in order, symmetry and straight lines. Hogarth argued that beauty was found in serpentine curves, which he called 'the line of beauty'. When Hogarth died, the great actor David Garrick wrote the epitaph for his tomb.

1697 Born 10 November in London
c. 1714 Apprenticed to the silversmith engraver Ellis Gamble
1720 Begins working as an independent engraver
c. 1726 Studies painting under the artist James Thornhill
1729 Marries Jane Thornhill, James's daughter
1731 Produces the series of six paintings, A Harlot's Progress
1732 Publication of A Harlot's Progress
1732–33 Produces the series of eight paintings, A Rake's Progress
1735 Publication of A Rake's Progress; is influential in the passing of a copyright law banning pirated copies of print editions
1743 Produces series of six paintings, Marriage-A-la-Mode
1747 Produces series of twelve prints, Industry and Idleness
1748 Arrested while sketching the gate of the port and drawbridge in Calais, France; is made to prove he is an artist for his release; paints The Gate of Calais
1753 Publishes The Analysis of Beauty
1755 Original paintings for A Harlot's Progress destroyed in a fire at Fonthill Abbey
1757 Appointed Serjeant Painter to the King
1764 Dies 26 October in London

FURTHER READING
Jenny Uglow, Hogarth: A Life and a World, London, 1997
Mark Hallett and Christine Riding, Hogarth, London, 2006

William Hogarth, *Self-portrait*, 1748–49, etching, 34.3 x 26.2 cm, British Museum, London

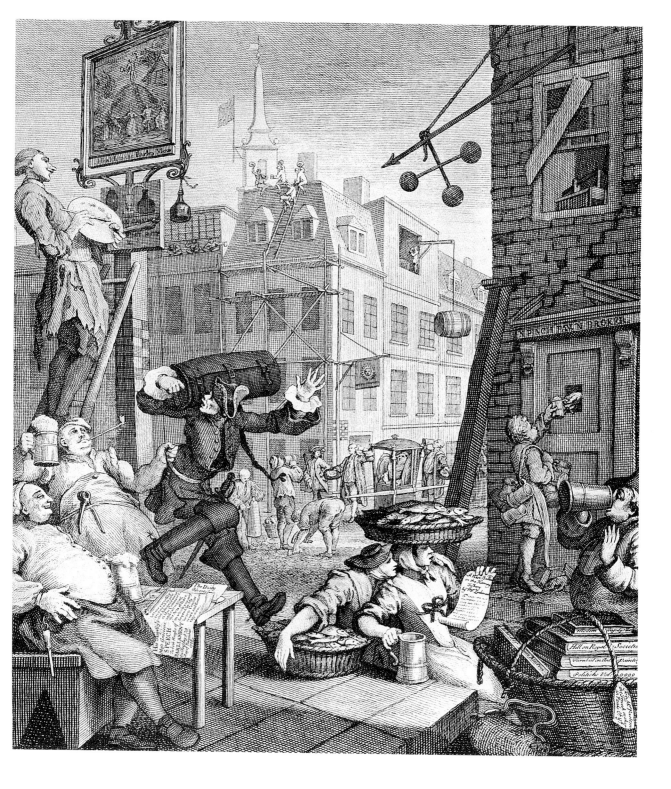

William Hogarth, *Beer Street*, 1751,
etching, 35.9 x 30.3 cm, British Museum,
London

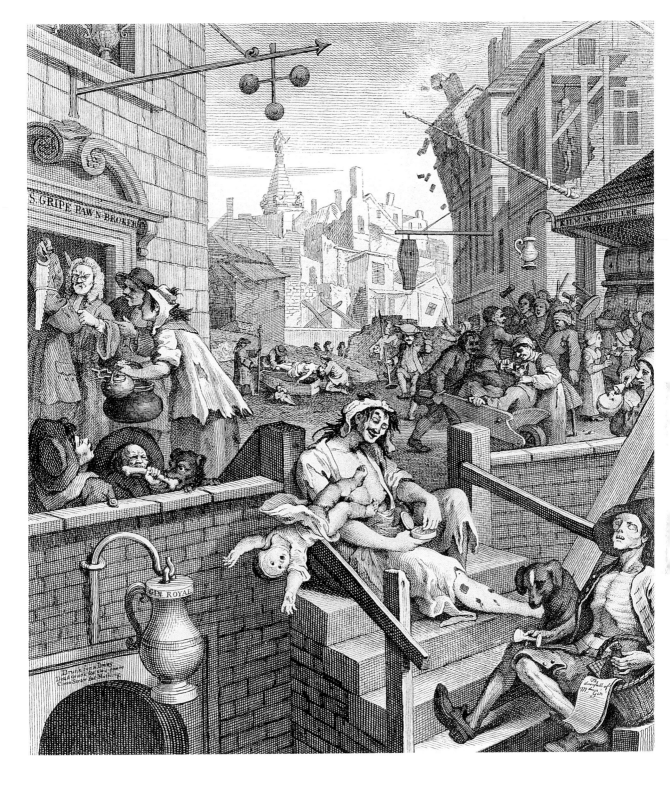

William Hogarth, *Gin Lane*, 1751, etching,
41.9 x 30.5 cm, British Museum, London

RICHARD WILSON

GIOVANNI BATTISTA TIEPOLO

FRANÇOIS BOUCHER

1674 Death of John Milton

1683 The Ashmolean Museum
opens in Oxford

1711 Death of David Hume

1705 Edmond Halley determines
periodicity of what will be
known as Halley's Comet

1722–23 Russo-Persian War

1660 1665 1670 1675 1680 1685 1690 1695 1700 1705 1710 1715 1720 1725 1730 1735 1740 1745

Richard Wilson, *Lake Albano*, oil on
canvas, 30.5 x 42.9 cm, Private Collection

1775 Start of the American Revolution

1801 United Kingdom of Great Britain
and Ireland is formed

1762 Founding of the Sorbonne
Library in Paris

1789 French Revolution

1821 John Constable paints
The Hay Wain

| 1750 | 1755 | 1760 | 1765 | 1770 | 1775 | 1780 | 1785 | 1790 | 1795 | 1800 | 1805 | 1810 | 1815 | 1820 | 1825 | 1830 | 1835 |

RICHARD WILSON

Richard Wilson's landscapes had a profound influence on later British artists. The delicacy and inventiveness of his work brought both an intellectual and emotional dimension to subjects that were previously treated in a more scientific manner.

At the age of 14, Richard Wilson left his native Wales and moved to England, where he was to train as a portrait painter. For six years he worked as an apprentice in the studio of Thomas Wright, in London. Wright was an accomplished portrait painter, but ironically his greatest claim to fame today is for having been Richard Wilson's teacher.

Wilson was born in the Welsh village of Penegoes, in today's Powys. There was little call for professional artists in such a remote part of Wales, nor were there many wealthy patrons waiting to make an artist's fortune, so after his apprenticeship ended, Wilson stayed in London for another 15 years. He did not enjoy the life of a portrait painter and longed to stop painting demanding, spoilt clients and to realise his dream of becoming a painter of landscapes.

In 1750, Wilson left London and journeyed to Rome, the destination of choice for almost every Grand Tourist. Artists who travelled to Grand Tour destinations did so knowing they could earn good money producing works of art for wealthy patrons to take back to their country homes in Britain. Wilson spent seven years travelling around Italy and living and working in Rome and Venice. He studied the art of the great masters and honed his skills as a landscape painter, producing accomplished works in the grand, classical style which proved highly popular. He also made the acquaintance of a number of wealthy aristocrats, who would become important patrons when he returned to Britain. Works such as *Lake Albano* (of which Wilson produced several versions) were the Grand Tourist's ideal souvenir. In 1757, he returned to London and set up his own studio, taking on apprentices as well as teaching students. He had moved from portraiture into landscape painting at exactly the right time: in the 1750s and 1760s, landscapes were highly fashionable. Wilson was influenced by Nicolas Poussin and Claude Lorrain and he would go on to influence generations of landscape artists, including

J. M. W. Turner and John Constable. He is also credited with having made painting landscapes of Wales a very fashionable pastime.

When Wilson returned to Britain, in addition to painting evocative landscapes of England and Wales, such as *Hounslow Heath, The Quarry and Valley of the Mawddach with Cader Idris beyond*, he continued to produce images of Italy. His students, the most famous of whom included Thomas Jones and Joseph Farington (who wrote of 'the largeness and dignity of Wilson's mind'), followed his example. Wilson was also not averse to painting landscapes of places he had never seen, such as *The Falls of Niagara* (c. 1768–74), painted when all things North American were very popular with the public.

By the late 1760s, Wilson was a well-known figure in London's artistic world. Although he would never reach the financial status of artists such as Sir Joshua Reynolds or Benjamin West, Wilson's studio was thriving and he earned an enviable income. In 1768, he was one of the founder members of the Royal Academy, with which he retained ties until the end of his life.

Unfortunately for Wilson, artistic fashion is fickle, and by the 1770s landscapes had largely fallen out of favour. His studio began to suffer and he began to fail financially; the Royal Academy came to his aid, appointing him Librarian (for which he earned £50 a year). In 1781, with his health fading, Wilson returned to the country of his birth. He lived in Mold, in Wales, for just a year before he died, an artist who had been so famous a mere decade earlier, but whose reputation was already starting to be forgotten by a new generation.

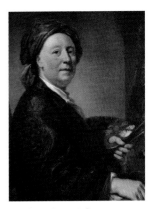

1714 Born 1 August in Penegoes, Montgomeryshire, Wales
1729 Moves to London; studies portrait painting under Thomas Wright
1750–57 Lives in Italy; begins painting landscapes under the advice of Francesco Zuccarelli
c. 1760 Returns to England; exhibits *The Destruction of the Children of Niobe* at the Society of Artists in London; begins receiving commissions from wealthy families seeking classical portrayals of their estates
1768 One of the founding members of the Royal Academy of Arts in London
1776 Appointed Librarian to the Royal Academy
1781 Moves to Colomendy, Denbighshire
1782 Dies 15 May in Colomendy

FURTHER READING
Andrew Wilton and Anne Lyles, *British Watercolours, 1750–1880*, London, 2011

Anton Raphael Mengs, *Richard Wilson*, 1752, oil on canvas, 84.6 x 75.2, National Museum Wales, Cardiff

1675 Construction begins on the Royal
Greenwich Observatory in London

1707 England and Scotland are joined
as the Kingdom of Great Britain
under the Acts of Union

1723 Antonio Vivaldi composes
The Four Seasons

1738 The Treaty
of Vienna is
ratified

1749 Samuel Johnso
*The Vanity of
Human Wishes*
is published

1670　1675　1680　1685　1690　1695　1700　1705　1710　1715　1720　1725　1730　1735　1740　1745　1750　1755

Joshua Reynolds, *Cupid Unfastens
the Belt of Venus*, 1788, oil on canvas,
128 x 101 cm, The State Hermitage
Museum, St Petersburg

1787 The Society for the Abolition of
the Slave Trade is established

1814 Francisco Goya paints *The Executions
of the Third of May 1808*

1768 Royal Academy of Arts established
in London

1802 John Constable paints
Dedham Vale

1836 Texas Revolution

1760 1765 1770 1775 1780 1785 1790 1795 1800 1805 1810 1815 1820 1825 1830 1835 1840 1845

JOSHUA REYNOLDS

The perfect ambassador for the newly established profession of painter in Britain, Sir Joshua Reynolds was a master of every genre, and his prolific work is loved in many collections in Britain and abroad.

Even when he was the most revered artist in England, Joshua Reynolds still spoke with the accent of his childhood. He grew up in the town of Plympton in west Devon, the son of a teacher. From a very young age his artistic ability was obvious and eventually even his father agreed he should become an artist.

At the age of 17, Reynolds travelled to London as an apprentice to Thomas Hudson (who also came from Devon). He left Hudson's studio before his apprenticeship was over and set himself up as a portrait painter, practising in Plymouth and London. His style was that of the Classical school, the most fashionable artistic movement of the time and, after travelling through Italy, Reynolds created a British style of Grand Manner portraiture. His ability to make himself agreeable to clients brought him a steady following and wealthy patrons. In his late twenties, Reynolds travelled around Europe for three years. In Italy, he studied art from ancient Greece and Rome and the Renaissance; he was particularly influenced by Michelangelo and Raphael.

In 1768, King George III signed the charter for a Royal Academy of Art in London. Finally Britain had an artistic school to rival that of the academies elsewhere in Europe; Reynolds was named its first President. He was hailed as the most prestigious painter of his time by almost everyone in London — except the king. Trying to ingratiate himself with the royal court, Reynolds developed a friendship with the Prince Regent (later King George IV). Samuel Johnson wrote a disapproving letter to James Boswell about the prince's bad influence on their friend: 'Reynolds has taken too much to strong liquor and seems to delight in his new character'.

After the death of Allan Ramsay, the king's official painter, Reynolds was terrified the king would name one of his rivals Ramsay's successor. King George III resisted all pressure, until Reynolds threatened to resign from the RA. The king was shrewd enough to realise it would make the British art world ludicrous in the eyes of the world, so he capitulated.

Reynolds painted many of the most famous names in Britain, including aristocrats, military leaders, actors, writers and thinkers. He is often accused of having been unable to paint women convincingly, yet although many of his paintings of aristocratic women seem stiff and stilted, when he painted women he knew he portrayed them in a more naturalistic, realistic style. Reynolds never married, although his name was linked to a number of women including the artist Angelika Kauffmann and the novelist Fanny Burney.

His more flamboyant portraits of men, such as that of the Polynesian celebrity Omai (1776), are also painted with a flair Reynolds seemed unable to use when painting men of a higher social class than himself. Reynolds taught his students to look for beauty and, if the subject so required, to correct any 'defects' of nature in landscape and portraiture. He would perform a painterly version of plastic surgery, correcting a sitter's 'defects' to make them look more attractive.

In addition to his paintings, one of Reynolds' greatest contributions was his *Discourses*, highly esteemed works of artistic theory — albeit very pompous. He wrote them during his years as President of the Royal Academy and delivered them at the annual awards ceremony. His discourses defined the Academy's ideology and remained the cornerstone of its teaching practices.

Reynolds also painted around 30 self-portraits, cataloguing his career from bohemian young man to a stately celebrated master artist. His self-portrait of c. 1778 shows him as an ageing man wearing spectacles. Within a few months, he had gone almost completely blind. He died the following year.

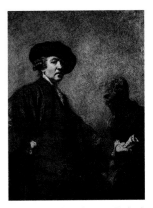

1723 Born 16 July in Plympton, England
1740 Apprenticed to the painter Thomas Hudson
1749–52 Develops appreciation of the Grand Manner while studying paintings and sculpture in Italy; suffers a cold while in Rome, leaving him partially deaf
1753 Returns to London to establish his practice; receives public recognition for his portrait of Commodore Augustus Keppel in the pose of the Apollo Belvedere
1764 Establishes the Literary Club in London with the essayist Samuel Johnson
1768 Founding of the Royal Academy of Arts in London by King George III, with Reynolds named first President of the Royal Academy
1769 Receives knighthood; begins series of lectures *Discourses on Art* at the Royal Academy
1773 Receives honorary Doctor of Civil Law degree from Oxford University; elected mayor of Plymouth
1784 Succeeds Allan Ramsay as Painter to the King
1790 Delivers final *Discourses on Art* lecture at the Royal Academy
1792 Dies on 23 February in London, and is buried at St Paul's Cathedral

FURTHER READING
Ellis K. Waterhouse, *Reynolds*, London, 1941
Joshua Reynolds, Robert R. Wark (ed.), *Discourses on Art*, Cambridge, Mass., 1997

Joshua Reynolds, *Self-portrait*, 1773, oil on canvas, 127 x 102 cm, Royal Academy of Arts, London

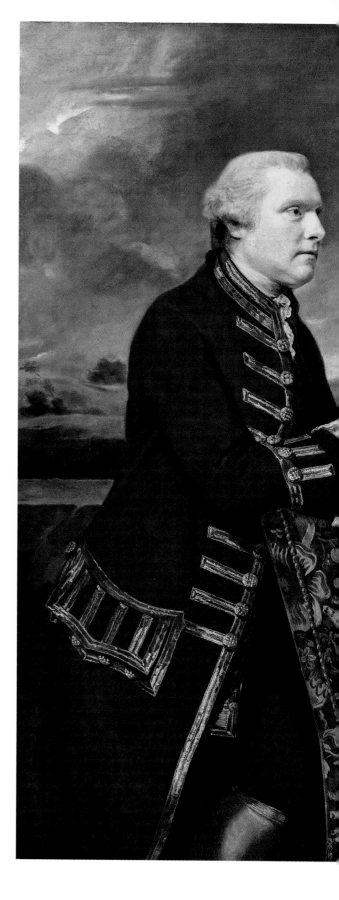

Joshua Reynolds, *George Clive and His Family with an Indian Servant*, 1765/66, oil on canvas, 140 x 171 cm, Gemälde-galerie, State Museum, Berlin

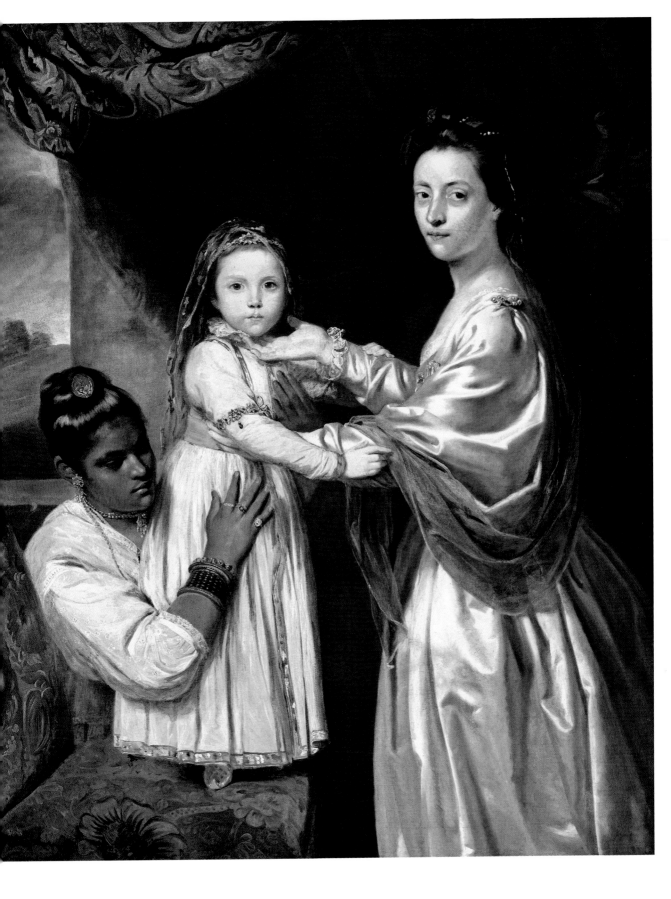

1687 Isaac Newton's *Philosophiae Naturalis Principia Mathematica* is published

1693 The dodo becomes extinct

1726 Voltaire begins exile in England

1739 The Foundling Hospital is created in London

1743 Henry Pelham becomes British Prime Minister

1675 1680 1685 1690 1695 1700 1705 1710 1715 1720 1725 1730 1735 1740 1745 1750 1755 1760

left
George Stubbs, *Two Shafto Mares and a Foal*, 1774, oil on panel, 80 x 100.3 cm, Private Collection

below
George Stubbs, *Bulls Fighting*, 1786, oil on panel, 61.5 x 82.5 cm, Yale Centre for British Art, Paul Mellon Collection, New Haven, CT

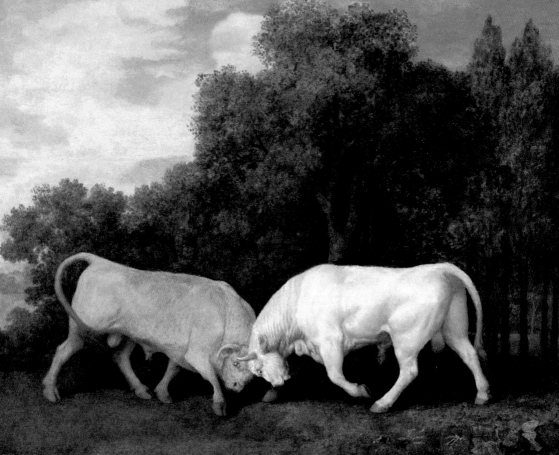

1839 French Academy of Sciences announces daguerreotype photography process

1789 George Washington becomes first President of the United States

1824 Ludwig van Beethoven's *Ninth Symphony* premieres in Vienna

1845 Edgar Allen Poe publishes *The Raven*

1778 Battle of Monmouth

1765 · 1770 · 1775 · 1780 · 1785 · 1790 · 1795 · 1800 · 1805 · 1810 · 1815 · 1820 · 1825 · 1830 · 1835 · 1840 · 1845 · 1850

GEORGE STUBBS

His Brood Mares and Foals *(1767) set a new record for a work by George Stubbs in December 2010, fetching just over £10 million at auction. The master of animal painting has found a new, appreciative audience in the 21st century.*

George Stubbs is best known today as a painter of animals, especially horses, yet he began his career as a portrait painter. He was born in Liverpool, where his father worked in the leather industry. As a child, Stubbs helped his father prepare horses' skins for the tannery; this gave him a greater understanding of anatomy than any of his peers and helped him to produce paintings of startling realism. How Stubbs first learned to paint is unknown: it has been suggested that he was taught by fellow Liverpudlian Hamlet Winstanley, a landscape artist for whom Stubbs worked as an apprentice, but it is also possible Stubbs was initially self-taught. In 1745 Stubbs moved to York, where he continued his study of anatomy at York hospital and worked as an illustrator, most notably illustrating a book on midwifery. He also spent a decade attempting to make his name as a portrait painter.

Although Stubbs did not marry, he spent most of his adult life living with Mary Spencer, with whom he had a son, George Townley Stubbs. In 1754 Stubbs travelled to Italy; after his return the couple moved to a remote farmhouse in Lincolnshire, where Mary helped him carry out comprehensive dissections of horses for one of his most ambitious works. The numerous scientific studies and sketches made in the course of the experiment resulted in a superb set of engravings, which he produced himself, to illustrate his book *The Anatomy of the Horse* (1766). The book took him six years to complete and was the first title on the subject in over 160 years. By the time the book had reached completion, Stubbs and Mary were living in London and the artist had begun to attract a circle of wealthy patrons.

While working on *The Anatomy of the Horse*, Stubbs produced one of his most famous paintings, *Whistlejacket* (1762), the magnificent portrait of a champion racehorse. It was commissioned by Whistlejacket's owner, the 2nd Marquess of Rockingham, and is over three metres tall. There is nothing to detract from majesty of the animal as Whistle-

jacket is set against an entirely neutral background. In the same decade, Stubbs painted his now-famous series *Mares and Foals*. The paintings are almost utopian in their beauty, with no discordant elements to disturb the gentle scenes of stately mares and suckling foals. Unfinished paintings show Stubbs' unusual technique of painting the mares and foals before the landscape around them.

Stubbs was often commissioned to produce portraits of dogs, of prize-winning bulls and of other 'celebrity' animals. He was also fascinated by exotic animals, including lions, leopards and zebras. He produced a series of works on the theme of a lion attacking a horse. The landscape used for the series is Creswell Crags in the Peak District, a wild and lonely place which allowed the artist's imagination full rein. The horse, which goes through various stages of sheer terror before death, was based on Stubbs' lifelong study of horses; the lion, which is less believable, was based on animals Stubbs saw at the Tower of London menagerie.

Although he is best remembered for animal paintings, Stubbs also painted landscapes and a highly fashionable form of painting known as 'conversation pieces' (group paintings of a family or a circle of friends). He also painted groups of workers, such as *Haymakers* (1785). He was, however, not allowed to be a full member of the Royal Academy, because his professional classification was as a 'sporting painter'. When Stubbs died he was part-way through what was to be a work of great scientific and anatomical significance: *A Comparative Anatomical Exposition of the Structure of the Human Body, with that of a Tiger and a Common Fowl.*

1724 Born 24 August in Liverpool, England
1739 Briefly apprenticed to the painter and engraver Hamlet Winstanley
1745–51 Studies human anatomy at York County Hospital
1751 Provides illustrates for a textbook on midwifery by Dr John Burton
1754 Travels to Rome
c. 1759 Moves to London
1761–76 Exhibits at the Society of Artists in London
c. 1762 Paints *Whistlejacket* for Charles Watson-Wentworth, 2nd Marquess of Rockingham
1766 Publishes *The Anatomy of the Horse*
1772 Elected President of the Society of Artists
1775 Begins exhibiting at the Royal Academy of Arts in London
1780 Elected an Associate Member of the Royal Academy
1781 Elected Royal Academician
1806 Dies 10 July in London

FURTHER READING
Martin Myrone, *George Stubbs*, London, 2002
Judy Egerton, *George Stubbs, Painter*, New Haven, 2007

George Stubbs, *Self-portrait*, 1781, enamel paint on ceramic, 67.6 x 51.1 cm, National Gallery, London

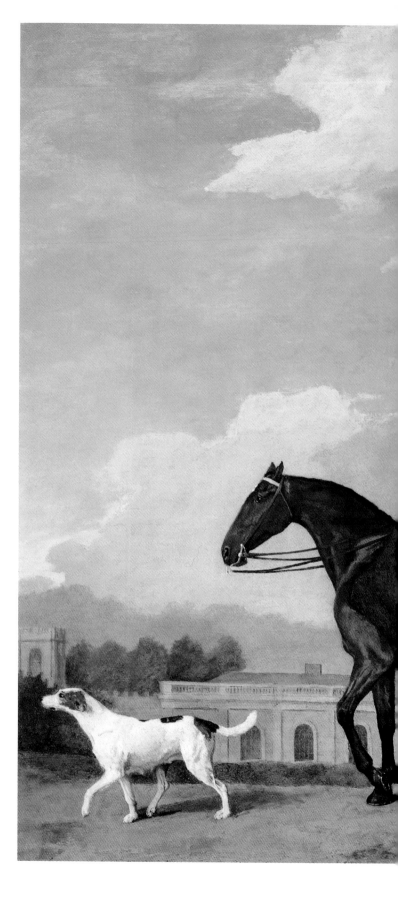

George Stubbs, *John and Sophia Musters
Riding at Colwick Hall*, 1777, oil on panel,
100.4 x 124 cm, Private Collection

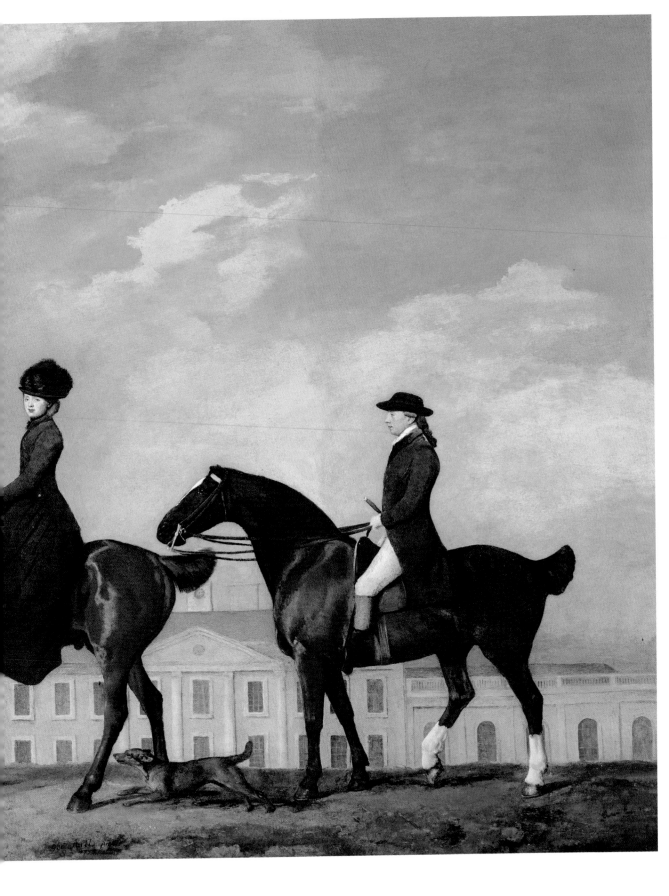

1698 Isaac Newton calculates
the speed of sound

1726–30 Canaletto paints
The Stonemason's Yard

1682 The city of Philadelphia is founded **1704** Death of John Locke

1740–48 War of the Austrian Succession

1675 1680 1685 1690 1695 1700 1705 1710 1715 1720 1725 1730 1735 1740 1745 1750 1755 1760

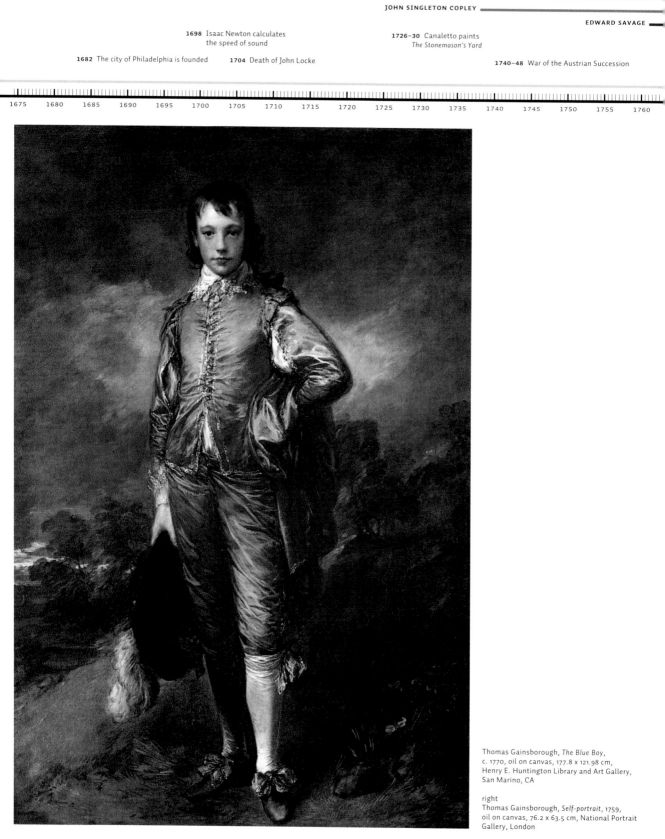

Thomas Gainsborough, *The Blue Boy*,
c. 1770, oil on canvas, 177.8 x 121.98 cm,
Henry E. Huntington Library and Art Gallery,
San Marino, CA

right
Thomas Gainsborough, *Self-portrait*, 1759,
oil on canvas, 76.2 x 63.5 cm, National Portrait
Gallery, London

1765 Jean-Honoré Fragonard
paints *The Swing*

1789 French Revolution

1810 Johann Wolfgang von Goethe
publishes his *Theory of Colours*

1830 Eugène Delacroix paints
Liberty Leading the People

1820 The Venus de Milo is discovered
on the island of Melos

1765 1770 1775 1780 1785 1790 1795 1800 1805 1810 1815 1820 1825 1830 1835 1840 1845 1850

THOMAS GAINSBOROUGH

Combining a Dutch sensibility for the landscape with a French flair for fashionable portraiture, Thomas Gainsborough's natural talent contributed to 'the honourable distinction of an English school', as Joshua Reynolds commented posthumously on his great rival.

Gainsborough was born in East Anglia, but moved to London in his teens as an apprentice to the French engraver Hubert Gravelot. At the age of 19, he married Margaret Burr, illegitimate daughter of the Duke of Beaufort. This strategic marriage ensured the artist received many aristocratic portrait commissions.

Robert Andrews and his Wife Frances (c. 1750) was painted at a pivotal moment in Gainsborough's career, shortly after he and Margaret left London in 1748 to return to East Anglia. The artist was just 23 years old, yet already he was being discussed widely enough for local landowner Robert Andrews to commission this 'conversation piece' of himself and his new bride, Frances. As the dog gazes up loyally at its master, the viewer can admire the couple's extensive property and the rich sheen of Mrs Andrew's blue silk gown. There is, however, a mystery about this painting: the unfinished space in Mrs Andrew's lap, which Gainsborough presumably meant to finish at a later date. Perhaps it was intended to hold a gamebird shot by her husband, or a book to emphasise her intelligence, or it may have been left for when the couple had a baby.

In 1752 Gainsborough opened a studio in Ipswich. His finances were precarious, especially once he had a family to support, but he managed to survive, often through borrowing money. Seven years later, he moved to the fashionable spa town of Bath. The identity of *The Blue Boy* (c. 1770), painted in Bath, is unknown, although it is believed to be Jonathan Buttell, son of a wealthy merchant, who owned the painting until the 1790s. Examination of the canvas has shown Gainsborough reused an earlier canvas. *The Blue Boy* is strongly reminiscent of the work of the Old Masters, particularly Anthony Van Dyck, which suggests Gainsborough was conforming to the buyer's instructions. *The Blue Boy* contrasts greatly with portraits of Gainsborough's own children, such as *The Painter's Daughters Chasing a Butterfly* (1755–56). Thanks to the wealthy tourists,

attracted to Bath by the regular presence of the Prince Regent, his portrait studio thrived,

After 15 years in Bath, Gainsborough returned to a London that was — artistically — dramatically different from the one he had known during his apprenticeship. Since the founding of the Royal Academy in 1768, the city had become an artistic centre capable of rivalling Paris and Rome. In London, Gainsborough's studio was in direct rivalry to that of Joshua Reynolds. Although Reynolds was largely considered the most fashionable portrait painter in London, Gainsborough had one distinct advantage over his rival: the patronage of King George III.

Although Gainsborough is renowned for his portraits, he far preferred painting landscapes and found portrait clients deeply frustrating. A letter to Edward Stratford, while Gainsborough was working on a portrait of Stratford's wife, demonstrates the artist's irritation: 'Mr Gainsborough presents his compts to Mr. Stratford. He does not understand whether Mr. Stratford means to have the Dog painted separate by Monsieur Dupont, or again put into Mrs. Stratford's Picture to spoil it'. In a letter written to his friend and physician, Dr Rice Charleton, in 1779, Gainsborough begins with 'I must beg pardon for not answering your letter sooner, I have had some plaguesome sitters'.

Despite being one of its founding members, in 1784 Gainsborough entered a furious row with the Royal Academy. Incensed over the poor hanging of his paintings, he withdrew his works and refused to submit any again. For the final four years of his life he held exhibitions in his own studio; during these years he was suffering from the onset of cancer, which killed him on 2 August 1788. He had produced over 300 paintings.

1727 Born 14 May in Sudbury, Suffolk, England
1740–48 Studies art in London under the engraver Hubert Gravelot; becomes associated with Hogarth and his school and works with Francis Hayman, repairing and restoring old paintings
1746 Marries Margaret Burr
1748 Exhibits *The Charterhouse* at the Foundling Hospital at Hogarth's request
1748–49 Returns to Sudbury; concentrates on painting portraits; paints *Robert Andrews and his Wife Frances*
1752 Moves with wife and two daughters to Ipswich; begins receiving portrait commissions
1759 Moves with family to Bath
1761 Begins exhibiting in London at the Society of Artists
1768 Becomes one of the Founder Members of the Royal Academy of Arts in London
1770 Paints *The Blue Boy*
1774 Moves with family to Schomberg House, Pall Mall, London
1780 Paints portraits of King George III and Queen Charlotte
FROM 1784 Refuses to exhibit at the Royal Academy, instead showing his work at Schomberg House
1788 Dies of cancer on 2 August in London

FURTHER READING
Malcolm Cormack, *The Paintings of Thomas Gainsborough*, Cambridge, 1992

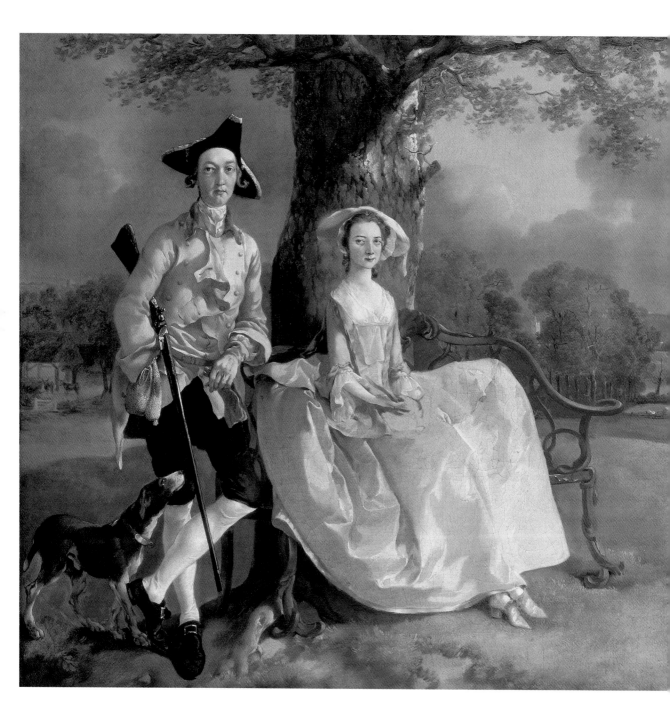

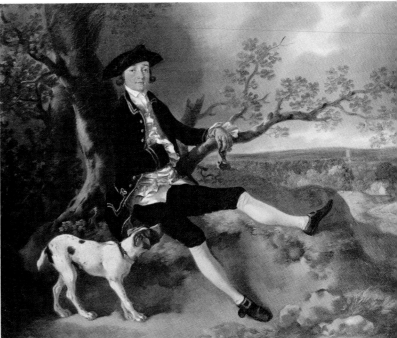

left
Thomas Gainsborough, *Robert Andrews and his Wife Frances*, c. 1950, oil on canvas, 69.8 x 119.4 cm, National Gallery, London

above
Thomas Gainsborough, *John Plampin*, c. 1753–54, oil on canvas, 50.2 x 60.3 cm, National Gallery, London

1702 Dutch Golden Age of Painting ends

1703 Construction begins on
Buckingham Palace

1723 Christopher Wren dies

1744 First auction at Sotheby's
in London

1752 Benjamin Franklin proves
that lightning is electricity

1680 1685 1690 1695 1700 1705 1710 1715 1720 1725 1730 1735 1740 1745 1750 1755 1760 1765

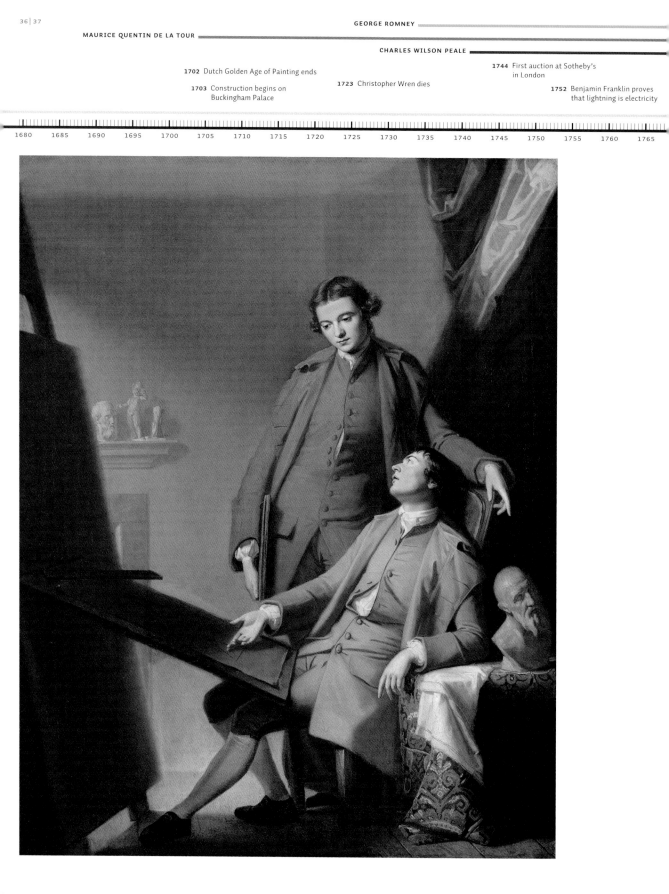

1805 Battle of Trafalgar

1812 First volume of *Grimm's Fairy Tales* is published

1833 Slavery is abolished in the British Empire

1842 China cedes Hong Kong to Great Britain

1850 William Wordsworth dies

1770　1775　1780　1785　1790　1795　1800　1805　1810　1815　1820　1825　1830　1835　1840　1845　1850　1855

GEORGE ROMNEY

For many years, George Romney was Britain's most famous society portrait painter, more famous than his close rivals, Sir Joshua Reynolds and Thomas Gainsborough. Yet while Reynolds and Gainsborough remain household names today, Romney's has been unfairly forgotten.

Although Romney was born in Cumbria — where he also died — he is most closely associated with London, the area in which he made his name. He was born in Dalton-in-Furness, the son of a cabinet maker and his wife. From the age of ten he worked alongside his father, making picture frames, furniture and musical instruments. He spent his spare time sketching, mainly drawing faces, and it was decided that this talent should not be wasted. At the age of 21 he travelled to Kendal and joined the studio of Christopher Steele, a portrait painter. One year after joining Steele's studio he married Mary 'Molly' Abbot and they had two children. Their son, John, would become a Cambridge don, but their daughter, Ann, died at the age of three.

After just two years with Steele, Romney bought his way out of his apprenticeship eager to set up on his own. Within a few years, he had raised enough money to move to London, leaving his young family behind. Making his name in a city bursting with talented artists was not easy, but eventually Romney came to the notice of the art collector and patron, the Duke of Richmond. In 1762, a year after arriving in London, he sold *The Death of General Wolfe in Quebec*: the painting was an immediate success. By the end of the decade he had become renowned for his family portraits, such as *The Gower Family* and *The Leigh Family*.

In 1770, Romney exhibited for the first time with the Incorporated Society of Artists. He developed a love of travelling, spending time in Paris and Italy, studying art and meeting artists from other cultures. By the late 1770s he was back in London and earning a very generous income.

In 1782, the Hon. Charles Greville visited Romney's studio to commission a portrait of his teenaged mistress, Emma Hart. She would go on to become Lady Emma Hamilton, famous for her love affair with Admiral, Lord Nelson, and for being Romney's muse. From their first meeting the artist was obsessed with her: over a decade after their first meeting he described her as 'the divine lady… superior to all womankind'.

Within four years, Romney had painted Emma more than a hundred times. She became the enchantress Circe, the personification of Nature, a Bacchante or Medea. She was portrayed as a domesticated spinster, as a simple country woman and as a fashionable society lady; sometimes she appears demure and innocent, at others she is sexually alluring. Emma was the perfect model and was sought out by a number of Romney's friends and rivals who paid her to sit to them as well. Following her marriage to Sir William Hamilton, Emma's friendship with Romney came to an end. It is for his obsession with painting Lady Emma Hamilton that Romney remains best known today.

During the 1790s, Romney fell out of favour with the authorities: a radical who believed fervently in equality of the classes, he began to be viewed with suspicion. At the height of the French Revolution Romney visited Paris, where he was appalled by the brutality of the new regime. He returned to London a disillusioned and saddened man and suffered regular bouts of depression. He had lived apart from his wife for many decades, but in 1799 he decided to return to her in Cumbria and he left his studio in London. He died in Kendal three years later.

1734 Born 26 December in Beckside, Dalton-in-Furness, Lancashire, England
1755 Apprenticed to the portrait painter Christopher Steele in Kendal
1756 Marries Mary Abbot
1757 Begins working as a portraitist, landscape and historical painter in Kendal
1762 Moves to London
1763 Enters *The Death of General Wolfe* into a competition at the Royal Society of Arts in London, where it wins second prize
1764 Travels to Paris and studies the works of the Old Masters
1769 Exhibits a large portrait of Sir George Warren and his family at the Free Society of Artists in London
1770 Begins exhibiting his work at the Chartered Society of Artists
1772 Travels to Rome to study the works of the Old Masters
1782 Introduced to Emma Hamilton, who will become his muse
1799 Returns to his wife in Kendal
1802 Dies 15 November in Kendal

FURTHER READING
David A. Cross, *A Striking Likeness: The Life of George Romney*, Aldershot, 2000
Alex Kidson, *Those Delightful Regions of Imagination: Essays on George Romney*, New Haven, 2002

left
George Romney, *Peter and James Romney*, 1766, oil on canvas, 110.5 x 87.5 cm, Yale Centre for British Art, Paul Mellon Collection, New Haven, CT

above
George Romney, *Self-portrait*, c. 1749, oil on canvas, 106 x 81 cm, Louvre, Paris

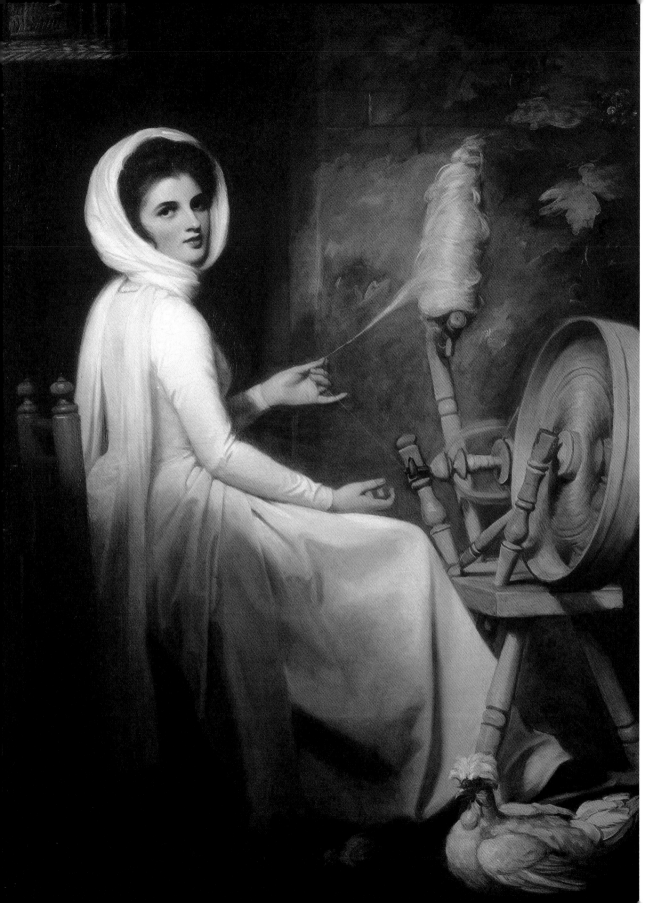

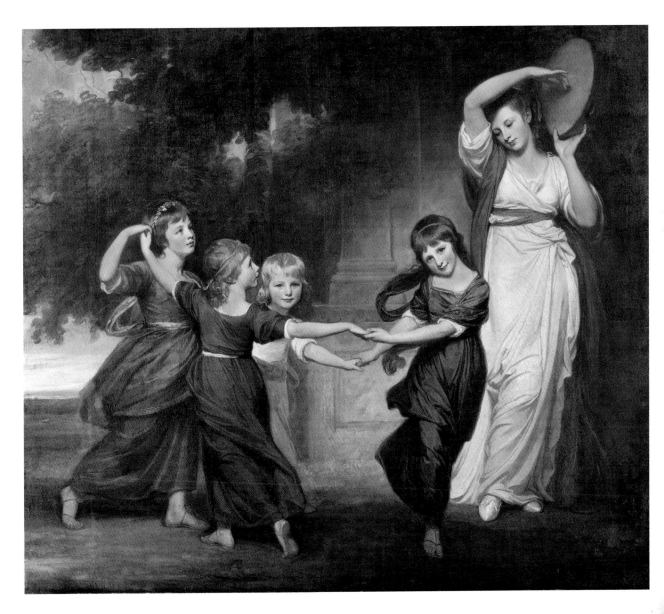

1701–14 War of the Spanish Succession

1746 Canaletto paints the first
Westminster Bridge

1689 John Locke publishes
Two Treatises of Government

1726 Jonathan Swift publishes
Gulliver's Travels

1750 The first Westminster Bridge
is opened

| 1680 | 1685 | 1690 | 1695 | 1700 | 1705 | 1710 | 1715 | 1720 | 1725 | 1730 | 1735 | 1740 | 1745 | 1750 | 1755 | 1760 | 1765 |

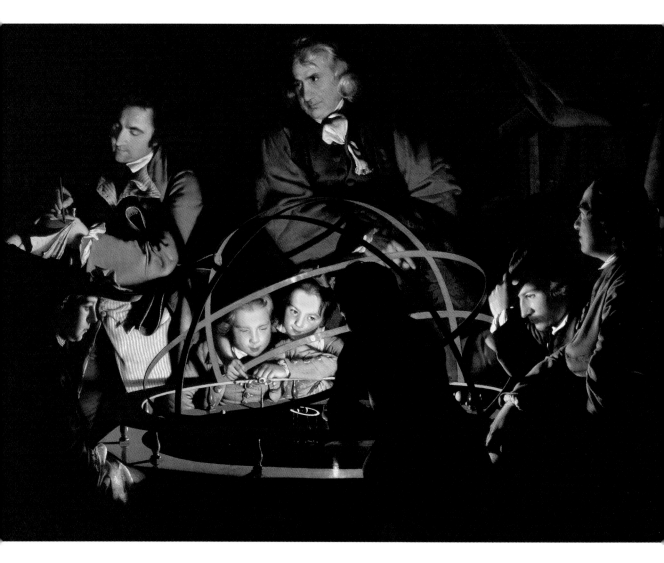

Joseph Wright of Derby, *The Orrery*,
c. 1766, oil on canvas, 147.3 x 203 cm,
Derby Museum and Art Gallery

1813 Jane Austen publishes *Pride and Prejudice*

1839 Beginning of the First Opium War

1850 Alfred Lord Tennyson named Poet Laureate

1798 Alois Senefelder invents lithography

1822 Eugène Delacroix paints *The Barque of Dante*

1770 1775 1780 1785 1790 1795 1800 1805 1810 1815 1820 1825 1830 1835 1840 1845 1850 1855

JOSEPH WRIGHT OF DERBY

Born in the heartland of England's industrial revolution, Joseph Wright's paintings convey the excitement of a world of innovation and flux.

Joseph Wright, the son of a lawyer, was born in the town of Derby. As there were several other artists who shared his surname, he became defined by the county of his birth. As a young man, Wright was sent to London to serve an apprenticeship with the portrait painter Thomas Hudson, with whom he remained for three years. In the 1750s, Wright returned to Derby and established his own studio.

Today, Wright is best known for his landscapes and genre paintings, but in his own time he was renowned as a portrait painter. Pictures such as *Mr and Mrs Thomas Coltman* (c. 1770–72) allowed Wright to use both his portrait and landscape skills, painting the sitters (in this case, two of his friends) in an attractive background setting. His 1769 portrait of the slave merchant Thomas Staniforth shows a sleek, pleased-looking man who stares fixedly out at the viewer with a cool, haughty look, a man who is assured of his status. The portrait of Staniforth was painted during Wright's three-year residency in the thriving port city of Liverpool — a place teeming with wealthy customers. Wright brought a realism to portraiture that had been lacking before and he was in high demand. He also benefitted from his large number of influential friends and wealthy patrons, who included two of the great men of his age: Josiah Wedgwood and Richard Arkwright.

Wright was one of the first British painters to make artistic use of the Industrial Revolution. He was also fascinated — and repelled — by the great scientific discoveries of his age. He was friendly with a number of members of the Lunar Society, a group of scientists, thinkers and engineers. Wright's strongest artistic preoccupation, however, was how to paint such subjects using the techniques he had studied in the works of Caravaggio. His understanding of *chiaroscuro* reaches its peak in *An Experiment on a Bird in the Air Pump* (1768), in which Wright not only focused on the unpalatable face of science, he also demonstrated his superb portraiture skills and his unique talent for creating dramatic lighting effects. While the scientist conducts his experiment, two young girls stand in horror: with their father comforting them, the older girl shields her face, but the younger cannot help but stare at the doomed cockatoo. There are ten people in this painting, but these four are the people the viewer notices at once because the only internal light source, a single candle, highlights these four figures with a warm light but leaves the others in partial shadow.

In 1774, Wright married Ann Swift; they had two surviving daughters. Shortly after his marriage, Wright visited the most popular destination for an 18th-century artist, Italy. It was the height of the era of the Grand Tour when wealthy travellers flocked to buy evocative paintings as a memento of their journey. It was a lucrative place for an artist of Wright's ability and allowed him to use his landscape painting talents to their fullest Romantic capacities. Throughout the 1770s, Mount Vesuvius erupted several times. Wright was disappointed not to witness the spectacular eruption of 1777 for himself, but he examined the works of other artists, listened to vivid descriptions and created more than thirty views of the eruption, using his powers of *chiaroscuro* to truly dramatic effect.

In 1785, Wright had what was perhaps his greatest triumph, the exhibition of *The Lady in Milton's 'Comus'*, which was bought by Josiah Wedgwood. Wright commented that he had 'never painted a picture that was so universally liked'. Wright, an asthmatic, died in 1797, seven years after his wife. His physician was Dr Erasmus Darwin, one of the greatest figures in the British Enlightenment.

1734 Born 3 September in Derby, England
1751–53 Studies painting at the studio of Thomas Hudson in London
1756 Trains for a further 15 months at the studio of Thomas Hudson
1765 Exhibits work in London for the first time at the Society of Artists, where he exhibits *Three Persons Viewing the Gladiator by Candlelight*
1768–71 Lives in Liverpool; paints portraits of a number of prominent citizens and their families
1773 Marries Ann Swift
1773–75 Spends time in Italy; paints pictures of Mount Vesuvius
1778 Begins exhibiting at the Royal Academy of Arts in London
1781 Elected an Associate Member of the Royal Academy
1784 Declines an offer for full membership of the Royal Academy
1790 Ann Wright dies
1797 Dies in Derby

FURTHER READING
Alex Kidson and Elizabeth E. Barker, *Joseph Wright of Derby and the 'Dawn of Taste' in Liverpool*, New Haven, 2007

Joseph Wright of Derby, *Self-portrait*, c. 1780, oil on canvas, Yale Centre for British Art, Paul Mellon Collection, New Haven, CT

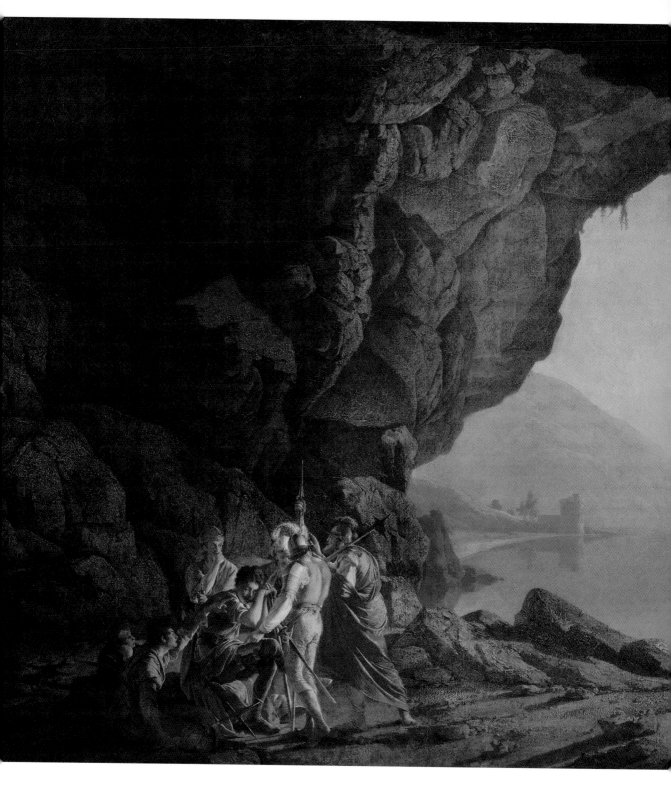

Joseph Wright of Derby, *A Grotto in the Kingdom of Naples, with Banditti*, c. 1778, oil on canvas, 122 x 172.7, Private Collection

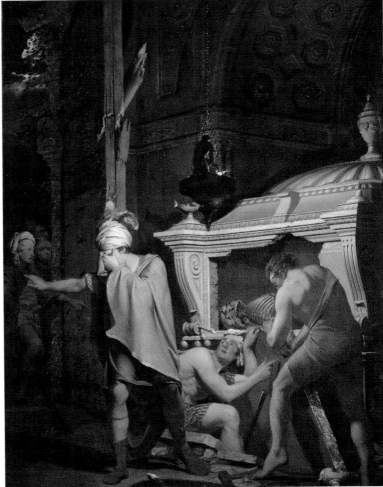

Joseph Wright of Derby, *Miravan
Breaking Open the Tomb of His Ancestors*,
1772, oil on canvas, 127 x 101.6 cm,
Derby Museum and Art Gallery

1711 Alexander Pope publishes
An Essay on Criticism

1728 Jean-Baptiste Siméon Chardin
admitted to the Royal Academy

1759 Birth of Mary Wollstonecraft

1776 George Washington leads troop
across the Delaware River

1781 Henry Fuseli paints
The Nightmare

1705 1710 1715 1720 1725 1730 1735 1740 1745 1750 1755 1760 1765 1770 1775 1780 1785 1790

William Blake, *And left a round globe of blood,
Trembling upon the Void*, 1794, colour-printed relief
etching with ink and watercolour, 24.5 x 18.1 cm,
Yale Centre for British Art, Paul Mellon Collection,
New Haven, CT

1818 Mary Shelley publishes *Frankenstein*

1834 Birth of James Abbott McNeill Whistler

1872–73 Claude Monet paints *Impression, Sunrise*

1823 William Sturgeon invents the electromagnet

1851 The Great Exhibition opens in London

1795 1800 1805 1810 1815 1820 1825 1830 1835 1840 1845 1850 1855 1860 1865 1870 1875 1880

WILLIAM BLAKE

'All things begin & end in Albion's ancient druid rocky shore'. William Blake brought to British art and poetry a powerful symbolism that spoke of his homeland but also drew on the international revolutions through which he lived.

Blake was born into a comfortable, well-educated family. His father was a merchant with a successful hosiery shop in London's Soho; his mother was an educated woman who tutored her children at home. William showed an aptitude for art and when he was ten years old he was sent to Henry Pars' school of drawing. At the age of 14 he began an apprenticeship with the engraver James Basire.

From childhood, Blake was a visionary: he saw visions of angels, monks and the Virgin Mary, and heard voices of long-dead historic figures and instructions from God's messengers. In later years, after nursing his younger brother Robert through consumption, Blake would see visions of Robert's ghost returning to him with insights into the supernatural world. He used these visions to inform his work and help him create astonishingly original and unusual paintings and illustrations. Many of Blake's works can be seen as a method of dealing with his own religious questions, queries that plagued him day and night. He believed fervently in the powers of good and evil and was a committed Christian, but his style of Christianity was vastly different from that accepted — and expected — by his peers. For this reason, his works are often described as 'apocalyptic'.

Because Blake's work was so different from that of his contemporaries, many erroneously believe him to be untutored; in reality he was a highly trained professional who made a decision to reject many of the methods and formulae he had learned, in favour of creating his own distinctive style. He studied Old Masters in detail, and Basire sent him out of the workshop to draw great works of architecture. For much of his life and long after his death, Blake was plagued with accusations of insanity and it is often suggested Basire sent him on these errands because the fellow apprentices did not like Blake. After seven years with Basire, Blake entered the Royal Academy schools; once again he did not fit in. Blake was little understood in his own time and when he held exhibitions of his work in London in 1808 and 1809, his paintings were ridiculed and reviled. Works such as *Nebuchadnezzar* (c. 1795) and *The Blasphemer* (c. 1800) were misunderstood, and even feared, by his peers.

Fascinated by engraving, Blake developed the technique now known as 'relief etching' and used it to produce many of his book illustrations. Blake was also a writer and poet, a skill he used to voice his disgust with social injustice. In 1783 he published his first book of poems, *Poetical Sketches*; ten years later he published *For Children: The Gates of Paradise* (1793). *Songs of Innocence* (1789) and *Songs of Experience* (1794) include some of his most famous poems including *The Tyger*, which begins 'Tyger! Tyger! burning bright / In the forests of the night' and *Auguries of Innocence* with its famous opening lines: 'To see a world in a grain of sand, / And heaven in a wild flower, / Hold infinity in the palm of your hand, / And eternity in an hour'. His poem *The Chimney Sweeper* rails against the injustice of a world in which children are sold into dangerous jobs while the adults who buy and sell them go to church and sing God's praises as though nothing is amiss. His book *Jerusalem* (1804–20) inspired what remains one of Britain's most iconic hymns. It also includes a passage that encapsulates Blake's philosophy towards his art: 'I must create a system, or be enslav'd by another man's. I will not reason and compare: my business is to create'.

1757 Born on 28 November in London, England
1767 Enrolled in Henry Pars' drawing school
1772–79 Apprenticed to the engraver James Basire
1779 Admitted as a student to the Royal Academy of Arts in London
1782 Marries Catherine Boucher
c. 1783 Publishes first collection of poems, *Poetical Sketches*
1784 Opens a print shop with fellow apprentice James Parker; begins working with radical publisher Joseph Johnson
1788 Begins experimenting with relief etching
1789 Publishes *Songs of Innocence*
1790 Publishes *The Marriage of Heaven and Hell*
1794 Publishes *Songs of Experience*
1800 Moves to Felpham in Sussex; begins working on *Milton: a Poem*
1804 Returns to London; begins to write and illustrate *Jerusalem*
1826 Commissioned by John Linnell to produce a series of engravings for Dante's *Divine Comedy*
1827 Dies on 12 August in London

FURTHER READING
David Bindman, *William Blake: The Complete Illuminated Books*, London, 2000
Joyce Townsend (ed.), *William Blake: The Painter at Work*, New Jersey, 2004

Watercolour of William Blake after Thomas Phillips' portrait, 1807

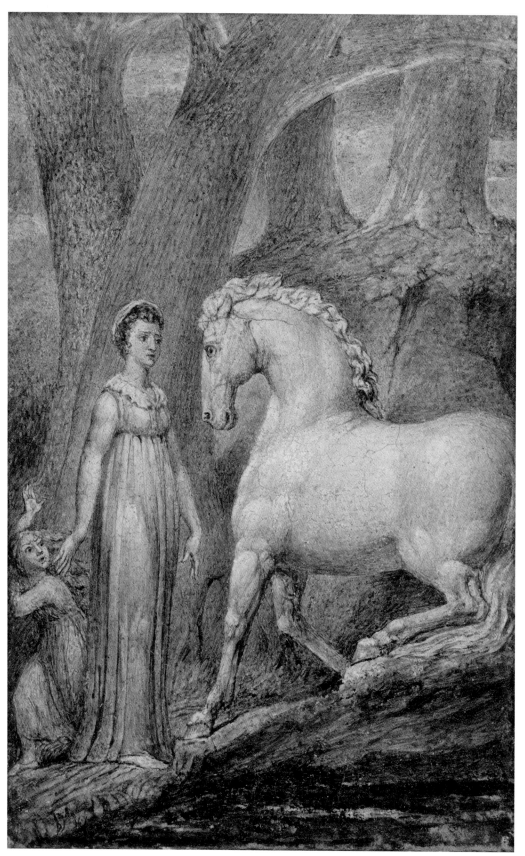

left
William Blake, *The Horse*,
from 'William Hayley's Ballads',
c. 1806–06, tempera with pen
and black ink on copper
engraving plate, 10.6 x 6.4 cm,
Yale Centre for British Art,
Paul Mellon Collection, New
Haven CT

right
William Blake, *The Red Dragon
and the Woman Clothed with the
Sun*, 1803–05, watercolour on
paper, 54.6 x 43.2 cm, Brooklyn
Museum of Art, Gift of William
Augustus White, New York

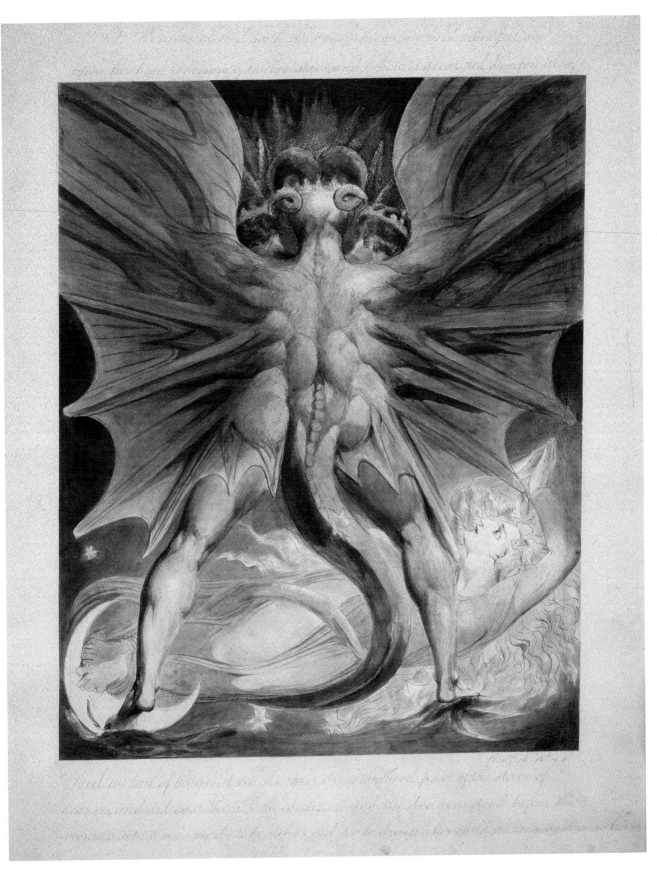

1705 1710 1715 1720 1725 1730 1735 1740 1745 1750 1755 1760 1765 1770 1775 1780 1785 1790

James Gillray, *The Coward Comforted*,
1789, coloured engraving, 25.1 x 34.7 cm,
Private Collection

792 Mary Wollstonecraft publishes
A Vindication of the Rights of Women

1817 Samuel Taylor Coleridge publishes
Biographia Literaria

1834 Birth of Edgar Degas

1851 Emanuel Gottlieb Leutze paints
Washington Crossing the Delaware

1869 Birth of Henri Matisse

1872 Birth of Piet
Mondrian

1795 1800 1805 1810 1815 1820 1825 1830 1835 1840 1845 1850 1855 1860 1865 1870 1875 1880

JAMES GILLRAY

James Gillray produced images of Georgian Britain which were daring, funny and often downright rude; and established political humour as a valid weapon for the contemporary artist.

The name Gillray has become synonymous with the word 'satire', yet he grew up in a subdued, non-witty, strictly religious home, where any idea of laughter or jollity was fervently frowned upon. Although Gillray was born in London, his father was from Scotland and a member of the Moravian Church, a rigidly Protestant community. Gillray and his siblings were banned from playing games, and any form of pleasure was strictly prohibited. By the time Gillray reached his twenties he had begun using his artistic talent to lampoon those amongst whom he had grown up. He would become the most famous satirist of his time.

His career began with an apprenticeship to an engraver, after which he enrolled as a student at the newly formed Royal Academy in London. In the 1770s, he began creating the caricatures which would make him famous: his favourite figures of fun were members of the royal family and politicians. He attended political debates, sitting as an observer in the House of Commons, so he could create a series of caricature figures based on British politicians. These became so well known that he was able to people entire scenes with these caricatures and know that his viewers would understand exactly who each of the subjects were. He was not, however, as impartial as his public would have liked to believe: he was in fact being paid secretly by William Pitt's Tory party to caricature the opposition Whig party. His caricatures of the royal family centred on King George III and his profligate son the Prince Regent (later King George IV). One of his most famous exposes of the prince is *A Voluptuary under the Horrors of Digestion* (1792). It says much for the democratic spirit of 18th-century Britain that Gillray was able to satirise the royal family — and repeatedly — and not risk being harmed.

Gillray also found inspiration in the Napoleonic Wars and the figure of Napoleon Bonaparte himself who, like the British royals, would come in for regular lampooning. The French Revolution of 1789 also had an enormous impact on Gillray's work. Initially, like many artists, writers and thinkers, Gillray felt empathy for the people of France, but as the revolution intensified, Gillray's opinion turned full circle. His earliest French Revolution prints celebrate such events as the storming of the Bastille; but after the events of 1793, Gillray depicted the executed monarch Louis XVI as a martyr.

As well as lampooning the influential and famous, Gillray made good use of the people he saw around him everyday. He was a keen observer of human nature and an inveterate listener to the gossip being whispered around London. His sense of humour was often cruel and his work became so popular and influential that when Gillray chose to parody someone, the subject would undergo an extremely public humiliation.

Although many of his ideas were popular, Gillray often found it difficult to support himself financially. He struggled throughout the 1770s and 1780s until he met Hannah Humphrey, a printer, publisher and print seller. She offered him a permanent job — working exclusively for her — as well as lodgings in her home. Gillray lived there for the rest of his adult life.

Perhaps as a reaction to his piously strict upbringing, Gillray became an alcoholic and by the end of his life he was deemed to be 'incurably insane'. In around 1807 his work began to lose its bite and his talent to fail. He produced nothing after 1809 and had a full mental breakdown in 1810. Hannah Humphreys cared for him throughout his ensuing illness, which lasted five years ending only with his death. While others, even those in awe of Gillray's work, pitied and avoided the artist, Hannah kept her lodger's talent in the limelight by running regular exhibitions of his work.

1757 Born 13 August in London
C. 1770 Apprenticed to the letter engraver Harry Ashby
1778 Becomes a student at the Royal Academy where he studies under Francesco Bartolozzi
1782 Begins producing political caricatures
AFTER 1791 Works exclusively for the print-seller Hannah Humphrey
1792 Produces *Fashionable Contrasts;—or—The Duchess's little Shoe yielding to the Magnitude of the Duke's Foot*
1793 Begins living with Hannah Humphrey
1795 Begins contributing to the Tory magazine *The Anti-Jacobin*
1799 Produces *The Gout*
FROM 1806 Unable to produce work to his previous standards due to failing eyesight
1809 Produces last print
1811 Tries to kill himself by jumping out the attic window of Hannah Humphrey's shop
1815 Dies 1 June in London

FURTHER READING
Richard T. Godfrey, Andrew Edmunds and Mark Hallett, *James Gillray and the Art of Caricature*, London, 2001
Frederic P. Miller, Agnes F. Vandome and John McBrewster (eds.), *James Gillray*, Beau Bassin, 2010

Charles Turner, *Mr. James Gillray*, 1819, colour mezzotint after James Gillray's *Self-portrait*

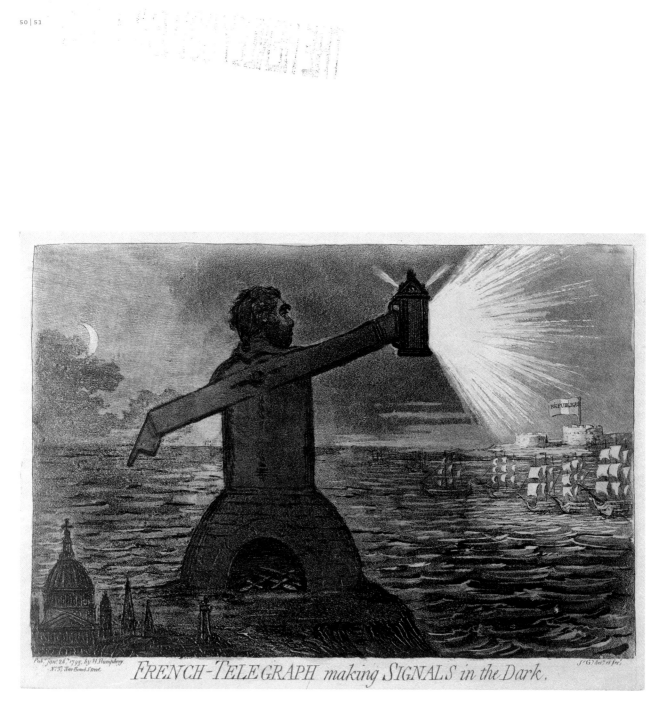

James Gillray, *French-Telegraph Making Signals in the Dark*, 1795, etching with aquatint, Private Collection

James Gillray, *Following the Fashion: St. James's giving the Ton, a Soul without a Body, Cheapside aping the Mode, a Body without a Soul,* 1794, colour engraving, Private Collection

J.M.W. TURNER ▬▬▬▬▬▬▬▬▬▬▬▬▬▬▬▬

THOMAS GIRTIN ▬▬▬▬▬▬▬▬▬▬▬▬▬▬▬

HOKUSAI ▬▬▬▬▬▬▬▬▬▬▬▬▬▬▬▬▬▬▬▬▬▬▬▬

1806 Birth of
Isambar
Kingdom
Brunel

1737 Birth of John Hancock **1752** British Empire adopts Gregorian calender

1793 Jacques-Louis David
paints *The Death of Marat*

| 1725 | 1730 | 1735 | 1740 | 1745 | 1750 | 1755 | 1760 | 1765 | 1770 | 1775 | 1780 | 1785 | 1790 | 1795 | 1800 | 1805 | 1810 |

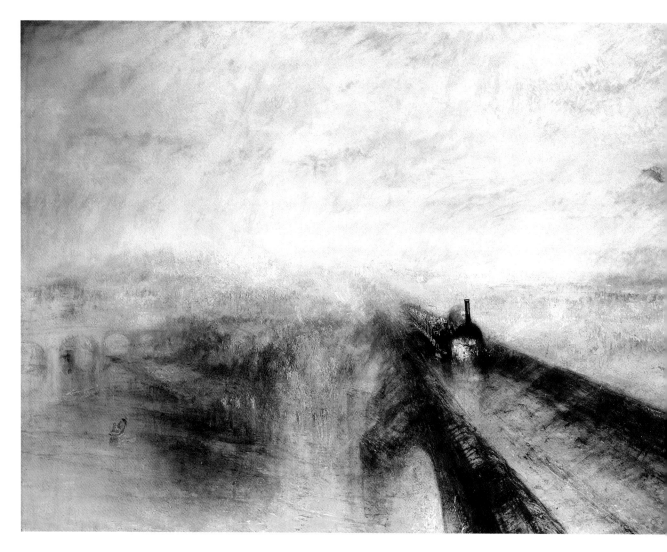

Joseph Mallord William Turner,
*Rain, Steam and Speed – The Great
Western Railway*, 1844, oil on canvas,
91 x 121.8 cm, National Gallery, London

Ludwig van Beethoven
composes *Für Elise*

1833 The Great Western Railway
is founded in England

1861–65 American Civil War

1821 Birth of Gustave Flaubert

1848 Karl Marx and Friedrich Engels publish
The Communist Manifesto

1871–74 Edgar Degas paints
The Dancing Lesson

1815 1820 1825 1830 1835 1840 1845 1850 1855 1860 1865 1870 1875 1880 1885 1890 1895 1900

J.M.W. TURNER

One of Britain's greatest Romantic painters, often described as 'the first Impressionist', J.M.W. Turner brought a new technical brilliance to depictions of both traditional landscapes and modern inventions.

In 1789, at the age of 14, 'Bill' Turner, the son of an impoverished London barber, became the youngest student to have entered the Royal Academy schools. He exhibited his first watercolour a year later, although it took several more years to master oil painting. He also took lessons from the topographical artist Thomas Malton, which set Turner on a course of sketching landscapes.

In 1796 Turner exhibited his first oil painting at the Royal Academy. *Fishermen at Sea* is a moonlit scene showing a small boat at the mercy of a swelling sea, with the recognisable coastline of the Isle of Wight in the background. Moonlight breaks through the clouds in a manner that evokes the groundbreaking work on light effects mastered by Turner's Romantic influences, including Joseph Wright of Derby. The painting was a turning point in Turner's career.

Throughout his career, Turner's work was compared to that of John Constable and a rivalry grew up between them. In 1832, Turner's *Helvoetsluys – The City of Utrecht, 64, Going to Sea* and Constable's *The Opening of Waterloo Bridge (Whitehall Stairs, June 18th, 1817)* were exhibited side by side. Convinced that, in a previous exhibition, Constable had manoeuvred to have Turner's works hung unfavourably, Turner made a last-minute addition to his painting. On 'varnishing day' — the artists' last chance to make any changes to their works — Turner painted in a small red buoy. It worked superbly, making the boats and the sea instantly appear more formidable. While Constable, underappreciated by his contemporaries, was struggling to add greater intensity to his works, Turner achieved it by the quick addition of a simple red circle. To all observers, Turner had won the unofficial competition.

Turner never overcame his need to prove himself or his desire to quash his rivals — real or perceived. He was a difficult man whose contemporaries, while admiring his talent, often disliked his personality.

Despite making a fortune from his works, he never managed to leave behind the fear that he would one day end up as impoverished as his parents; he spent very little and lived in what was described by some of his peers as 'squalor'. He had a deservedly high opinion of his own work, famous announcing 'I am the great lion of the day'.

One of Turner's greatest fans was John Ruskin, author of *Modern Painters*, who described Turner as a genius. Ironically Turner was not overly pleased: he and Ruskin had differing views, particularly on religion, and the elderly Turner commented sardonically that Ruskin saw 'more in my pictures than I ever painted'.

By the end of his life, Turner was widely acknowledged as Britain's greatest landscape artist. His most famous paintings include *Rain, Steam and Speed – The Great Western Railway* (1844) and *The Fighting Temeraire* (1839) which, in 2005, was voted 'Britain's greatest painting'. In his final years, Turner's style became increasingly abstract and works such as *Norham Castle, Sunrise* (c. 1845) would influence the French Impressionists. It is likely that this change was caused by failing eyesight and an increasing dependence on alcohol.

When Turner died, he bequeathed a large number of his works to the nation. In his will, this was stipulated as including all his finished oil paintings, which numbered around 100, but the wording left the will open to a legal challenge. Eventually the nation also received all the artist's unfinished works and around 19,000 drawings and watercolours. The 'Turner Bequest' is now housed at Tate Britain, which hosts the annual Turner Prize in his name.

1775 Born in London, England
1789 Admitted as a student to the Royal Academy of Arts in London
1790 Exhibits first watercolour at the Royal Academy, *The Archbishop's Palace, Lambeth*
1795 Commissioned to produce a series of drawings of Salisbury Cathedral and other buildings of that city
1796 Exhibits first oil painting at the Royal Academy, *Fishermen at Sea*
1799 Elected an Associate Member of the Royal Academy
1802 Elected Royal Academician; visits France and studies paintings in the Louvre
1804 Opens a gallery for his paintings at his house in Harley Street
1807 Elected Professor of Perspective at the Royal Academy
1819–20 Visits Italy for the first time
1839 Paints *The Fighting Temeraire*
1840 Meets John Ruskin for the first time
1844 Paints *Rain, Steam and Speed*
1845–46 Serves as acting President of the Royal Academy
1850 Exhibits for the last time at the Royal Academy
1851 Dies at his house in Chelsea

FURTHER READING
Inge Herold, *Turner on Tour*, Munich, 2004
Eric Shanes, *The Life and Masterworks of J.M.W. Turner*, London, 2008

J.T. Smith, *William Turner in the Print Room of the British Museum,* c. 1825, watercolour and pencil on paper, 22.2 x 18.2 cm, British Museum, London

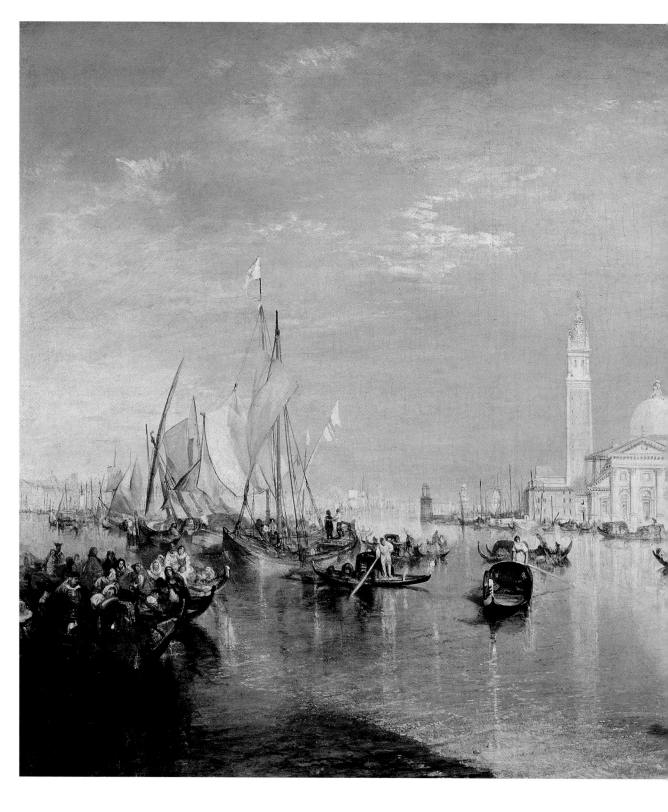

Joseph Mallord William Turner, *Venice,*
The Dogana and San Giorgio Maggiore,
1834, oil on canvas, 91.5 x 122 cm,
National Gallery of Art, Washington, DC

Joseph Mallord William Turner, *Venice with the Salute*, c. 1840–45, oil on canvas, 62 x 92.5 cm, Tate Gallery, London

FRANCESCO GUARDI

THÉODORE GÉRICAULT

1749–54 Liverpool Town Hall is built

1743 Birth of Thomas Jefferson

1773 Boston Tea Party

1783 First manned hot air
ballon flight in France

1795 John Trumbull paints *The Declarati
of Independence*

1725 1730 1735 1740 1745 1750 1755 1760 1765 1770 1775 1780 1785 1790 1795 1800 1805 1810

John Constable, *Ann and
Mary Constable*, oil on
canvas, Private Collection

1818 The Old Vic in London is founded **1832** Birth of Édouard Manet

1865 Slavery is abolished in the United States

1864 Opening of the Clifton Suspension Bridge in Bristol

1882 Tottenham Hotspur football club is founded

| 1815 | 1820 | 1825 | 1830 | 1835 | 1840 | 1845 | 1850 | 1855 | 1860 | 1865 | 1870 | 1875 | 1880 | 1885 | 1890 | 1895 | 1900 |

JOHN CONSTABLE

From magnificent watercolours such as Stonehenge *to oil paintings such as* The Hay Wain, *John Constable created an art of direct observation and honesty to subject matter which has never been surpassed.*

John Constable was the fourth child of Golding and Ann Constable, prosperous mill owners. As a young man, he worked with his father yet his first love was art and he taught himself to paint. He was notable for his hobby of painting outdoors — many years before the Impressionists made it fashionable. Constable painted his village constantly, making famous his father's mill and the cottage belonging to labourer Willy Lott. Although Constable longed to stay in Suffolk, he knew that becoming a professional artist meant moving to London. In 1795 he accepted a job there as a topographical draughtsman. Four years later he began studying at the Royal Academy.

Although best known as a landscape artist, Constable was also a highly accomplished portrait painter. Painting landscapes was his passion. He once commented: 'Landscape is my mistress', but it was his regular portrait commissions that earned him an income. He created over 100 portraits in a career spanning four decades. Landscape may have been his mistress, but his true love was Maria Bicknell. They became engaged in 1811, but the Bicknell family were strongly opposed to the match. The couple kept their love alive through an impassioned correspondence, but it would be five years before they married. None of Maria's family attended the wedding.

Constable's paintings reflect his inner world: when he was happy, his colour palette was warm and bright; during difficult times his palette became darker and the tones more cold. After Maria's death from tuberculosis in 1828 Constable wrote of a 'void … in my heart that can never be filled again in this world'. In the months following her death, he concentrated on painting ruined landscapes.

He exhibited *Hadleigh Castle* (c. 1828–29) in 1829: its sky is brooding and grey, the ruins desolate and the brushwork thick and angry. A similar anger and desolation can be seen in *Stonehenge* (1835), in which the sky appears to be smiting the toppled stones. In

1829 Constable was finally elected to full membership of the Royal Academy. He became one of the Academy's popular teachers yet, despite his students' enthusiasm, his work still received little acceptance from the British artistic establishment. In 1821 he had exhibited *The Hay Wain* at the Royal Academy; little interest had been shown and no buyer came forward. In 1824 when Constable exhibited several works at the Paris Salon *The Hay Wain* was awarded a gold medal by King Charles X. His appointment to the Royal Academy seems to have been the result of this interest shown by Paris: the London art world was reluctant to lose a British artist to France.

Constable was 52 years old by the time he was created a Royal Academician and the honour was further marred by the Academy's President, Thomas Lawrence, making him acutely aware that he was not Lawrence's first choice.

Constable's techniques brought about permanent changes in British painting. He used a freer, more natural style of brushstrokes than those advocated by the Royal Academy; he also used a palette knife to spread his paint in thick, textured layers. His style was not universally admired and many critics accused him of leaving his paintings unfinished, yet his groundbreaking style inspired succeeding generations, including the Impressionists. During the early 1820s Constable painted scores of studies of clouds, labelling each one with the time, date, location and other meteorological information; the paintings are still studied by scientists today.

Out of necessity, Constable lived in London for much of his life; during his wife's illness they spent months in Brighton and other places popular for invalids. He also travelled to France and Italy, but he returned as often as possible to the place he loved most, the Suffolk countryside.

John Constable, *Self-portrait*, 1806, pencil on paper, Tate Gallery, London

1776 Born 11 June in East Bergholt, Suffolk, England
1799 Enters the Royal Academy Schools in London as a probationer
1802 Exhibits at the Royal Academy for the first time
1806 Undertakes two-month tour of the Lake District
1811 Exhibits first major Suffolk landscape, *Dedham Vale, Morning*, at the Royal Academy
1816 Marries Maria Bicknell against the wishes of her family
1819 Exhibits *The White Horse* at the Royal Academy; elected an Associate Member of the Royal Academy
FROM 1820 Settles with his family in Hampstead, London; begins frequent visits to Brighton with Maria, who is suffering from tuberculosis
1825 Loses an outlet for his paintings in France after an argument with the Parisian dealer John Arrowsmith
1829 Elected to full membership of the Royal Academy
1836 Delivers a series of public lectures on the History of Landscape Painting at the Royal Institution in London
1837 Dies on 31 March in London

FURTHER READING
Michael Rosenthal, *Constable*, London, 1987
Anthony Bailey, *John Constable: A Kingdom of His Own*, London, 2007

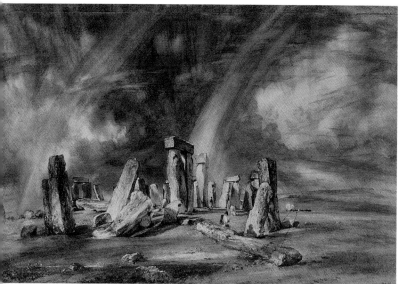

John Constable, *Stonehenge*, 1835,
watercolour on paper, 38.7 x 59.1 cm,
Victoria & Albert Museum, London

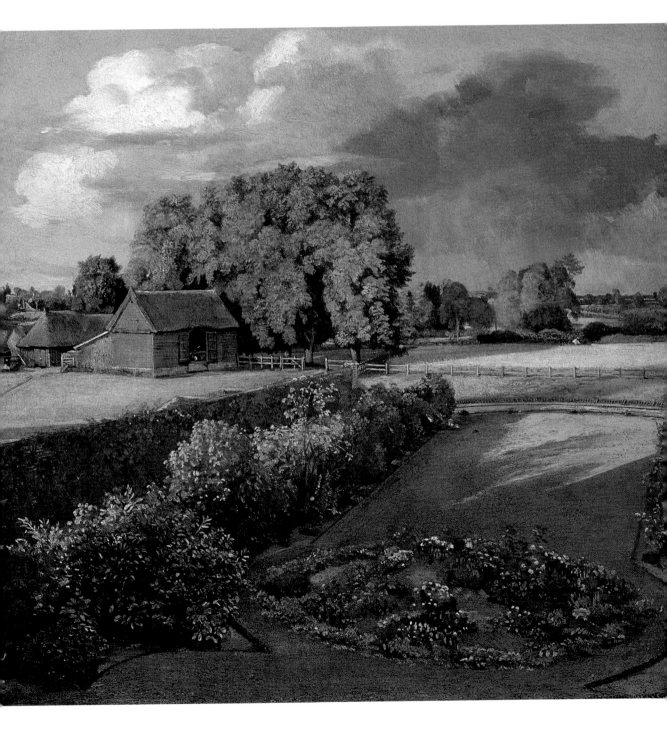

1762 Jean-Jacques Rousseau publishes
The Social Contract

1755 Birth of Marie Antoinette

1811 Venezuela declares
independence from
Spain

1735 1740 1745 1750 1755 1760 1765 1770 1775 1780 1785 1790 1795 1800 1805 1810 1815 1820

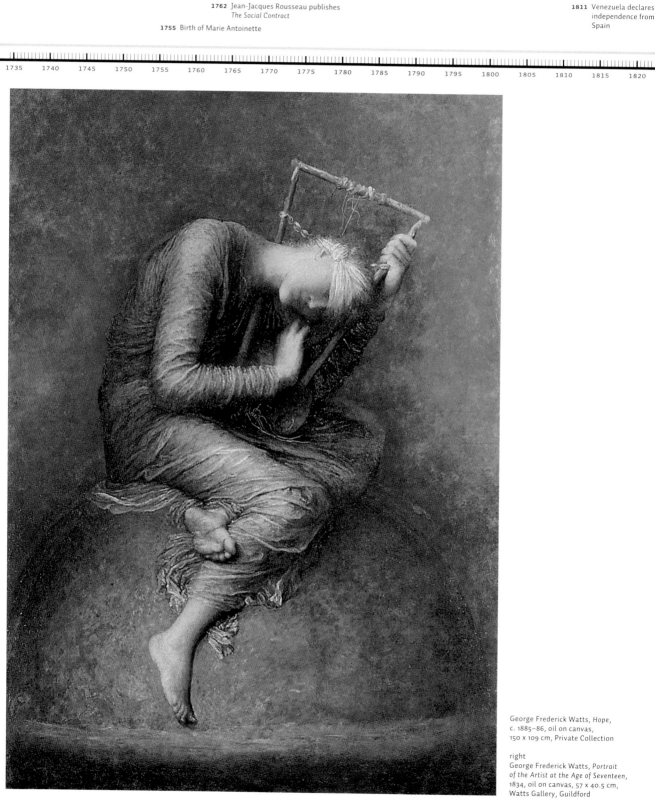

George Frederick Watts, *Hope*,
c. 1885–86, oil on canvas,
150 x 109 cm, Private Collection

right
George Frederick Watts, *Portrait
of the Artist at the Age of Seventeen*,
1834, oil on canvas, 57 x 40.5 cm,
Watts Gallery, Guildford

1879 Birth of Albert Einstein

21 Death of John Keats **1843** John Ruskin publishes *Modern Painters* **1870** Metropolitan Museum of Art opens in New York

1867 Death of Charles Baudelaire **1884** Birth of Max Beckmann

1868 Académie Julian established in Paris

1825 1830 1835 1840 1845 1850 1855 1860 1865 1870 1875 1880 1885 1890 1895 1900 1905 1910

GEORGE FREDERICK WATTS

Regarded by some as the greatest painter of the Victorian era, G.F. Watts' work, in particular his 1866 painting Hope, *has inspired artists and writers for over 100 years*

G. F. Watts began learning sculpting, under the tutelage of William Behnes (1794–1864), at the age of ten. Eight years later, he enrolled in the Royal Academy School — a monumental step forward for a child born into an impoverished household, the son of a piano tuner. The privations he experienced, or witnessed in others as a child, remained with him, and Watts would go on to create art that forced its viewers to stop and think about the harsher realities of Victoria's England.

His later life was a world away from his childhood. He moved in the highest echelons of society, mixing with aristocrats, royalty, travellers and explorers, and the artistic, musical and theatrical elite. He became known to his friends and acquaintances as 'The English Michelangelo' and was one of the most popular and highly paid artists of his era.

In 1842 Watts entered a competition to decorate the new Houses of Parliament in London. *Caractacus Led in Triumph Through the Streets of Rome* won a prize of 300 guineas, which enabled Watts to achieve his dream of travelling around Italy and studying Italian art, including the art of fresco painting. It was in Italy that he met the couple who would propel him into the limelight and become his long-term patrons, Lord and Lady Holland.

After returning to England, Watts moved to Holland Park, a fashionable and artistic area of West London. Lord Holland had leased one of his properties, Little Holland House, to Henry 'Thoby' Prinsep and his wife Sara, who took Watts into their exclusive, artistic and very wealthy circle. They called him 'Il Signor' and invited him to stay and paint in their home. As Sara Prinsep later recalled, 'He came to stay three days. He stayed 30 years'. Watts later built himself a studio in Holland Park; his neighbour was Frederic, Lord Leighton and the area around their homes grew up into an artistic enclave.

In 1884, already one of the most famous men in the British art world, Watts became the first living artist to be given a one-man show at the Metro-politan Museum of Art in New York. In 1893, he exhibited *Love and Life* at the World's Fair in Chicago; he then presented the painting to the US. Initially, it was displayed in the White House, but this was swiftly vetoed by the Women's Christian Temperance Union who considered the painting's nudity offensive.

Watts was married twice. In 1864 he married his muse, the teenaged actress, Ellen Terry (1847–1928), 30 years his junior. The marriage lasted less than a year. In 1886, he married Mary Fraser Tytler (1849–1938), who was 32 years younger than he. Following Watts's death in 1904, Mary continued his work of setting up a gallery at their Arts and Crafts home in Compton, Surrey.

Watts' style changed considerably during his lengthy career. His earliest paintings emulated the great names of the Italian Renaissance, the Northern Renaissance and the British Classical era. His later works moved through the eras of Pre-Raphaelitism, Aestheticism and Symbolism — of which he was an integral part — yet he refused to be bound by any single artistic niche. His socially conscious paintings, including *Found Drowned* (c. 1848–50), and *The Irish Famine* (c. 1850), were created in the same spirit in which William Hogarth produced his etchings and Charles Dickens produced his novels — intended to shock, educate and pro-mote social reform. Watts created paintings and sculptures that remain internationally famous, such as the magnificent equestrian sculpture *Physical Energy* (begun 1870), which can be seen today in London, Cape Town and Harare; and the iconic painting *Hope* (1886), of which Nelson Mandela had a copy in his prison cell and which was used by Barack Obama in his campaign for the US presidency. Watts described himself as 'a thinker, who happens to use a brush instead of a pen'.

1817 Born in London
1835–37 Studies at the Royal Academy of Arts in London
1837 Exhibits *The Wounded Heron* at the Royal Academy
1843 *Caractacus Led in Triumph through the Streets of Rome* wins first prize in a competition to design murals for the reconstruction of the Houses of Parliament at Westminster; uses prize money to fund a visit to Italy
1847 Returns to London
1848–53 Paints the fresco *The Red Cross Knight Overcomes the Dragon* for the Hall of the Poets in the Houses of Parliament
1864 Marries the actress Ellen Terry
1867 Elected Royal Academician
1875 Moves to the Isle of Wight
1884 Becomes first living artist to have a solo exhibition at the Metropolitan Museum of Art, New York
1886 Marries Mary Fraser Tytler
1891 Purchases land in Compton, near Guildford; begins construction of the Watts Gallery nearby
1894 Declines a second offer of a baronetcy
1902 Awarded Order of Merit
1904 Opening of the Watts Gallery; dies in Compton

FURTHER READING
Hugh Macmillan, *The Life-Work of George Frederick Watts, R. A.*, London, 1903
Barbara Bryant, *G. F. Watts Portraits*, London, 2004

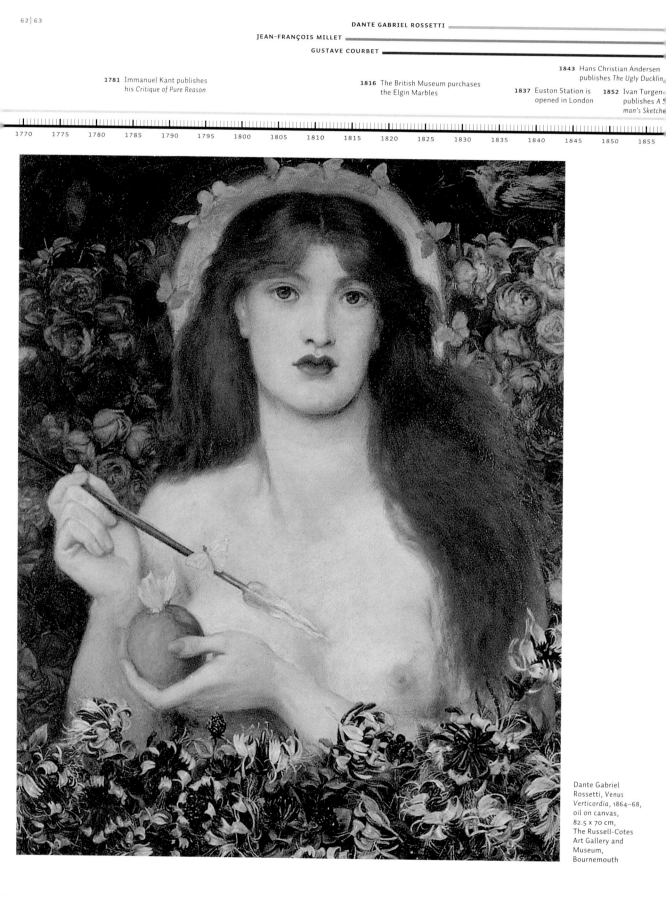

1781 Immanuel Kant publishes
his *Critique of Pure Reason*

1816 The British Museum purchases
the Elgin Marbles

1843 Hans Christian Andersen
publishes *The Ugly Duckling*

1837 Euston Station is
opened in London

1852 Ivan Turgen
publishes *A S
man's Sketche*

| 1770 | 1775 | 1780 | 1785 | 1790 | 1795 | 1800 | 1805 | 1810 | 1815 | 1820 | 1825 | 1830 | 1835 | 1840 | 1845 | 1850 | 1855 |

Dante Gabriel
Rossetti, *Venus
Verticordia*, 1864–68,
oil on canvas,
82.5 x 70 cm,
The Russell-Cotes
Art Gallery and
Museum,
Bournemouth

1872 The Mary Celeste is discovered
abandoned in the Atlantic Ocean

1863 Alexandre Cabanel paints
The Birth of Venus

1884 Georges-Pierre Seurat paints
Bathers at Asnières

1912 Birth of Jackson Pollock

1938 France host
FIFA World
Cup

1860 1865 1870 1875 1880 1885 1890 1895 1900 1905 1910 1915 1920 1925 1930 1935 1940 1945

DANTE GABRIEL ROSSETTI

'She hath the apple in her hand for thee/Yet almost in her heart would hold it back;/She muses, with her eyes upon the track/Of that which in thy spirit they can see.' Dante Rossetti's Venus Verticordia *embodies the symbolism, sexuality and seductiveness that pervade his work.*

Dante Rossetti's parents emigrated to London to escape political persecution in Italy. His father, an academic, taught at King's College in London. His mother brought up four remarkable children and, when finances were tight, attempted to set up a school (which failed through lack of pupils).

There were four Rossetti siblings including Dante: Maria, who became an Anglican nun; Christina, who became a renowned poet; and William, the only non-artist member of the Pre-Raphaelite Brotherhood and chronicler of the Pre-Raphaelite movement. William had dreamt of becoming a doctor, but when Dante refused to give up art in order to find a paying job and support the family, William left school for a job at the tax office.

While studying at the Royal Academy Rossetti became friendly with John Everett Millais and William Holman Hunt. The three men discovered a shared frustration with the restrictive and old-fashioned teachings of the Royal Academy. Inspired by his father's stories of secret Italian brotherhoods, such as the Illuminati, Rossetti put forward the idea of an artistic brotherhood. In 1848, they recruited another four friends and founded the Pre-Raphaelite Brotherhood (PRB). When the secret of the PRB was leaked to the newspapers, these seven idealistic young men were reviled for their arrogance and their work stopped selling, but within a few years Rossetti had become one of the most sought-after new artists in London. The PRB only lasted for five years, but it spawned the long-lasting Pre-Raphaelite movement.

Rossetti's style changed dramatically over the years, leaving his Pre-Raphaelite roots far behind him. Although he spent almost his entire life in England, seldom travelling, he was inspired by Italy, most notably the works of his namesake, the medieval Florentine poet Dante Alighieri. The simplicity of Rossetti's early paintings, such as *The Girlhood of Mary Virgin* (1849) contrasts markedly with the sumptuous voluptuousness of his later

works, such as *The Blessed Damozel* (1875–79). In addition to the Pre-Raphaelites, he was also allied to the Symbolist and Aesthetic movements. The remembrance of what it was like to be unable to afford studio space, canvas or paints, never left Rossetti. When he was wealthy and financially secure, with a beautiful home and studio in Chelsea, he allowed impoverished artists to share his studio space for free and often paid them to work as his assistants.

One of the most striking aspects of Rossetti's paintings are the models he used. He had a number of favourites, including Annie Miller, Alexa Wilding, Jane Morris and Fanny Cornforth. The most famous of all his models, however, was Lizzie Siddal (1829–62), whom he met for the first time around 1850 and who became his muse, his obsession, his lover and, eventually, his wife. Although he and Lizzie were unofficially engaged by 1851, Rossetti resisted marriage for almost ten years. He was repeatedly unfaithful. Lizzie was addicted to the opiate laudanum, and their relationship was stormy and manipulative, on both sides. After years of alternate happiness and misery, the couple married in 1860. A year later, Lizzie gave birth to a stillborn daughter. She would never recover and, in 1862, she committed suicide. Rossetti was devastated. He spent six years painting a memorial picture, *Beata Beatrix* (1864–70) and threw himself into his work and other women. He had a destructive long-term affair with Jane Morris, the wife of William Morris, one of his closest friends. Jane was the model for some of Rossetti's most famous paintings, including *Proserpine* (1874). Rossetti's mental health deteriorated following the shock of Lizzie's death. In 1872 he attempted suicide. By the end of the 1870s his health had become increasingly debilitated; he died on Easter Day 1882.

1828 Born Gabriel Charles Dante Rossetti on 12 May in London, England
1841–45 Studies at Henry Sass's Drawing Academy in London
1845–48 Studies at the Royal Academy of Arts in London
1848 Studies under Ford Madox Brown; establishes the Pre-Raphaelite Brotherhood with William Holman Hunt and John Everett Millais
1850 Meets Elizabeth Siddal
1857–59 Paints murals for the Oxford Union with William Morris and Edward Burne-Jones
1860 Marries Elizabeth Siddal
1861 Publishes *The Early Italian Poets*
1862 Death of Elizabeth Siddal; Rossetti buries many of his early poems with Siddal at Highgate Cemetery
1869 Exhumes early poems from Elizabeth Siddal's grave
1870 Paints *Beata Beatrix*; publishes *Poems by Dante Gabriel Rossetti*
1877 Completes work on *Venus Astarte*
1882 Dies in Birchington-on-Sea, Kent

FURTHER READING
David Rodgers, *Rossetti*, London 1996
Lisa Tickner, *Dante Gabriel Rossetti*, London 2003

Dante Gabriel Rossetti, *Self-portrait*, 1847, pencil on paper, 19.7 x 17.8 cm, National Portrait Gallery, London

JOHN EVERETT MILLAIS

FREDERIC EDWIN CHURCH

CLAUDE MONET

1783 City of Sevastopol founded on Crimean peninsula of Russian Empire

1798 Samuel Taylor Coleridge and William Wordsworth publish *Lyrical Ballads*

1811 Paraguay declares independence from Spain

1843 Charles Dickens publishes *A Christmas Carol*

1852 First Edition of R‹ Thesaurus is publ‹

1775　1780　1785　1790　1795　1800　1805　1810　1815　1820　1825　1830　1835　1840　1845　1850　1855　1860

John Everett Millais, *The Black Brunswicker*,
1859–60, oil on canvas, 104 x 68.5 cm,
Lady Lever Art Gallery, Port Sunlight

1871 Lewis Carroll publishes
Through the Looking-Glass

1893 Edvard Munch paints *The Scream*

1906 André Derain paints
Charing Cross Bridge, London

1933 Bauhaus school in Berlin
closed by the Nazis

1942 Capitol Records
is founded

1865 1870 1875 1880 1885 1890 1895 1900 1905 1910 1915 1920 1925 1930 1935 1940 1945 1950

JOHN EVERETT MILLAIS

Millais' death came just seven months after he was elected President of the Royal Academy — a superb irony for the man who had begun his career in a blaze of publicity about his rebellious, anti-Royal Academy, artistic brotherhood.

John Everett Millais grew up in privileged homes on the island of Jersey and in Southampton. When he was seven years old, his parents showed Millais' work to an artist friend. He was so astonished that he advised them to contact Sir Martin Archer Shee, President of the Royal Academy. Shee suggested the family move to London and Millais attend the Royal Academy Schools.

Millais attended Sass's, the RA's preparatory school, from the age of nine, the same age at which he won his first artistic prize, a silver medal. Two years later, aged 11, he became the youngest ever pupil to enter the Royal Academy Schools — undercutting the previous record holder, J. M. W. Turner, by three years. His early years at the Academy were not idyllic: known by the disparaging nickname of 'the child', he was bullied mercilessly by students, jealous of his precocious talent.

In 1848, together with Dante Rossetti and William Holman Hunt, Millais became a founder member of the Pre-Raphaelite Brotherhood, a movement that rebelled against the Royal Academy. The first meeting of the PRB was held at Millais' family home, 83 Gower Street, in central London, where Millais had his own, perfectly appointed studio. In common with his Pre-Raphaelite brethren, much of Millais' art was created outside the studio. In 1849 he began work on *Christ in the House of his Parents* ('The Carpenter's Shop') (1849–50) for which he hired a genuine carpenter's shop. This painting became the most notorious work of art in London. It was derided in the newspapers, but its most vociferous critic was Charles Dickens, who wrote a very witty but utterly scathing article about it. For some time, Millais' career, and that of several of his Pre-Raphaelite friends, went into decline. The artists were saved by the timely intervention of John Ruskin, who wrote articles and letters defending Pre-Raphaelitism. In 1852, the painting that would make Millais famous, as opposed to infamous, was exhibited: *Ophelia*, modelled by Lizzie Siddal. Although the figure of

Ophelia was painted in the studio, the background and river in which she drowns were all painted *en plein air. Ophelia* was an instant success and propelled Millais back into the limelight.

Throughout the 1850s and 1860s Millais' style evolved from Pre-Raphaelitism through many different forms, some very conventionally Victorian and sentimental, others more serious and intellectual. In the 1870s, Millais made a conscientious decision to focus on portraiture. It was an intelligent move, as he became the most highly paid portrait painter in Britain. Towards the end of his life, Millais would spend more time on landscapes — he was particularly inspired by his wife's native Scotland. His style evolved and matured, at times growing more realistic, at other times reverting to a softer, more mythical, romantic style.

As a young man, Millais had been deeply idealistic, especially where women were concerned. He hero-worshipped his friends, including Rossetti and Ruskin, and was sorely disappointed when they proved to be merely human. With Ruskin, who was acting as Millais' agent, the disappointment came when Millais discovered Ruskin's wife, Effie, was miserable and their marriage a sexless, emotionally abusive sham. To complicate matters, Millais fell in love with Effie. The solution was for Effie to ask for an annulment and marry Millais. The resulting court case, in which it had to be proved that Mr and Mrs Ruskin had never consummated their marriage, was a scandal which all three parties found difficult to live down. Ruskin and Effie separated legally in 1854; Millais and Effie were married in 1855 and had eight children. In August 1896 John Everett Millais died of throat cancer.

1829 Born 8 June in Southampton, England
1840 Studies at the Royal Academy of Arts in London, where he meets William Holman Hunt and Dante Gabriel Rossetti
1846 Exhibits *Pizarro Seizing the Inca of Peru* at the Royal Academy
1848 Forms the Pre-Raphaelite Brotherhood with Hunt and Rossetti
1850 Causes controversy with his realistic portrayal of the Holy Family in *Christ in the House of his Parents*; develops a close friendship with John Ruskin
1852 Paints *A Huguenot*, which receives critical acclaim; paints *Ophelia*
1853 Elected an Associate member of the Royal Academy
1855 Marries Effie Gray after the annulment of her marriage to John Ruskin
1869 Recruited as an artist for the newspaper *The Graphic*
1870–92 Focuses on painting landscape scenes
1885 Granted a baronetcy
1896 Elected President of the Royal Academy; dies 13 August in London
1905 Memorial statue installed outside the National Gallery of British Art (now Tate Britain)

FURTHER READING
Debra N. Mancoff (ed.), *John Everett Millais: Beyond the Pre-Raphaelite Brotherhood*, New Haven, 2001
Christine Riding, *John Everett Millais*, London, 2005

John Everett Millais, *Self-portrait*, 1880, oil on canvas, Galleria degli Uffizi, Florence

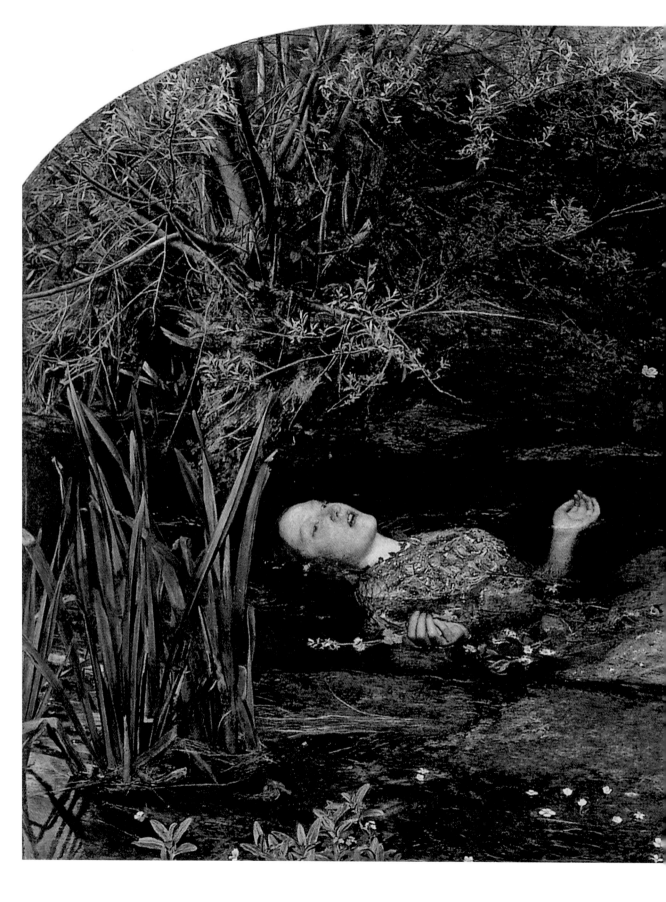

John Everett Millais, *Ophelia*,
1851–52, oil on canvas, 76.2 x 111.8 cm,
Tate Gallery, London

1848 Washington Monument
is established

1779 David Hume publishes *Dialogues*
Concerning Natural Religion

1828 Death of Francisco Goya | **1843** First tunnel under the
Thames River is finished

1853 Battle of Sinop

| 1775 | 1780 | 1785 | 1790 | 1795 | 1800 | 1805 | 1810 | 1815 | 1820 | 1825 | 1830 | 1835 | 1840 | 1845 | 1850 | 1855 | 1860 |

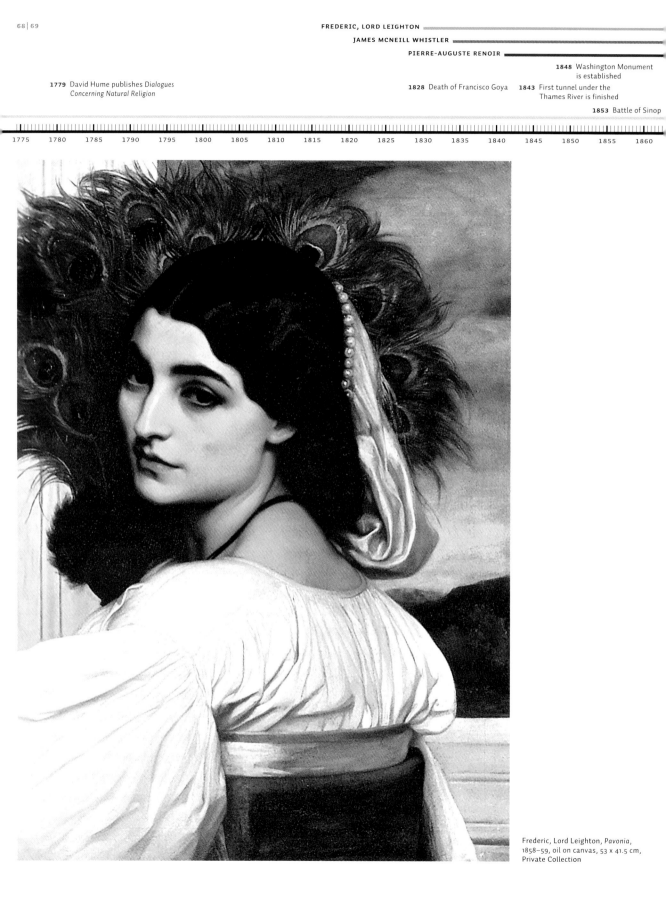

Frederic, Lord Leighton, *Pavonia*,
1858–59, oil on canvas, 53 x 41.5 cm,
Private Collection

1885 Vincent van Gogh paints *The Potato-Eaters*

1873 Arthur Rimbaud publishes *A Season in Hell*

1898 H. G. Wells publishes *The War of the Worlds*

1912 Omega Workshops are founded by members of the Bloomsbury group

1939 New York World's Fair

1865 1870 1875 1880 1885 1890 1895 1900 1905 1910 1915 1920 1925 1930 1935 1940 1945 1950

FREDERIC, LORD LEIGHTON

Nicknamed 'Jupiter Olympus' by his friend Burne-Jones, Frederic, Lord Leighton endowed Victorian art and culture with a European grandeur and elegance.

Leighton was born in Scarborough, in Yorkshire, but spent much of his childhood travelling around Europe. He went to school in London and studied art in Germany, Italy and France. In the early 1850s he was living in Italy, where he began working on the painting that would make his reputation. When *Cimabue's Celebrated Madonna Carried in Procession Through Florence* (1853–55), a five-metre-long canvas, was exhibited in London, it came to the attention of Queen Victoria. As the queen recorded, 'Albert was enchanted with it — so much so that he made me buy it'; she paid 600 guineas. Leighton was just 25 years old.

During his time in Italy Leighton became friendly with the poets Robert Browning and Elizabeth Barrett Browning and the author William Thackeray; through them he became interested in the work of the Pre-Raphaelites and, on his return to London, in 1858, made contact with them. Leighton was welcomed into the London art world and became renowned for his painting skills. Two years later, he demonstrated an equal ability in the world of sculpting: following Elizabeth Barrett Browning's death her husband commissioned Leighton to sculpt her tomb.

In 1864 Leighton commissioned the Aesthetic architect George Aitchison to build him a house, a 'palace of art', in London's Holland Park. The stunning Arab Hall is decorated with hundreds of tiles brought back from countries including Syria, Turkey and Persia, both by Leighton (who travelled as often as possible) and by his friend, the explorer Richard Burton. Leighton moved into the house in 1866 (although Aitchison's work continued until 1881) and became renowned for hosting some of the best parties in London, to which artists, writers, musicians and actors flocked.

In 1877 Leighton's sculpture *Athlete Struggling with a Python* astonished the art world. Via the teachings of his father and grandfather, both of whom were physicians, Leighton had a superb understanding of anatomy. *Athlete* is imbued with movement, every muscle in the bodies of the man and snake are rigid with tension. Through his works and those of his pupils, who included William Hamo Thornycroft and Alfred Gilbert, Leighton brought a new realism, beauty and emotion to British sculpture; it was a similar revolution to that which Rodin was creating in France. In the following year, Leighton beat his friend and rival John Everett Millais to become President of the Royal Academy, was knighted by Queen Victoria and was awarded the Légion d'honneur, the highest order in France.

Leighton was allied to the Pre-Raphaelites and the Aesthetic movement; he is called an Aesthete, High Victorian artist and an Olympian. During his lifetime, his work never waned in popularity. He did not marry, but had a wide circle of friends and acquaintances and several rumoured lovers. A generous and genial man, he encouraged struggling artists, taking on a large number of studio assistants and paying regular salaries even when there was not enough work for them all. One of his most famous paintings, *Flaming June*, was completed shortly before his death. The identity of the model is uncertain, but is likely to have been his favourite, Dorothy Dene (whose real name was Ada Pullen). Leighton wanted to elevate Dene from her lowly status, paying for her education, including elocution lessons. This relationship is claimed to have inspired George Bernard Shaw to write *Pygmalion*.

On 24 January 1896, Leighton was created Baron Leighton of Stretton. It was an extremely short-lived peerage as he died the following day. His funeral was held at St Paul's Cathedral, where he is buried. The year after his death, the Royal Academy held a memorial exhibition of his work.

Frederic, Lord Leighton, *Self-portrait*, 1880, Galleria degli Uffizi, Florence

1830 Born 3 December in Scarborough, Yorkshire, England
1838 Enrols at University College School, London
1840 Visits Rome, where he is given drawing lessons by Francesco Meli
1841 Takes lessons in art in Florence
1842 Studies at the Academy of Art in Berlin
1846–48 Studies at the Städelsches Kunstinstitut in Frankfurt
1855 Exhibits *Reconciliation of the Montagues and Capulets* at the Exposition Universelle in Paris; exhibits *Cimabue's Celebrated Madonna* at the Royal Academy of Arts in London, where it is purchased by Queen Victoria
1871 Begins work on the *Arts of Industry* murals for the South Kensington Museum (now the Victoria & Albert Museum)
1873 Elected Corresponding Member by the Académie des Beaux-Arts in Paris
1878 Elected President of the Royal Academy of Arts in London; receives knighthood; receives medal of the first class for sculpture at the Paris Salon
1896 Becomes first artist ever to be raised to the peerage; dies on 25 January in London

FURTHER READING
Margot Th. Brandlhuber and Michael Buhrs (eds.), *Frederic Lord Leighton: 1830–1896 Painter and Sculptor of the Victorian Age*, Munich, 2009

1833 Aleksandr Pushkin publishes
Eugene Onegin

1855 Gustave Courbet exhibits work
in a tent outside Paris Salon

1863 Birth of Edvard Munch

1886 Birth of Oskar Kokoschka

1823 Oxford Union is founded

1815 1820 1825 1830 1835 1840 1845 1850 1855 1860 1865 1870 1875 1880 1885 1890 1895 1900

Walter Richard Sickert, *Off to the Pub*, 1912,
oil on canvas, 49.5 x 30.5 cm, Leeds City Art Gallery

1911–13 Camden Town Group

1908 Dublin City Gallery is founded

1943 Warsaw Ghetto Uprising begins

1936 John Maynard Keynes publishes *The General Theory of Employment, Interest and Money*

1962 *Mona Lisa* exhibited in United States for the first time

1905 · 1910 · 1915 · 1920 · 1925 · 1930 · 1935 · 1940 · 1945 · 1950 · 1955 · 1960 · 1965 · 1970 · 1975 · 1980 · 1985 · 1990

WALTER SICKERT

Many people cite Walter Sickert's fascination with a notorious Camden Town murder in 1907 as 'proof' of his serial-killer credentials. But Sickert was simply painting the mood of the time.

Walter Sickert, the son of a Danish father and Anglo-Irish mother, was born in Germany, went to school in England, travelled throughout Europe and studied in France, yet he became a quintessentially London painter. He was a mercurial genius, not always liked but always grudgingly admired, who forced British art to leave the confines of the Victorian era and embrace the 20th century.

Sickert was not always destined for the art world: his original intention was to become an actor and he spent several years in a touring theatre company. It was after meeting J. A. M. Whistler, who looked at the young actor's paintings and encouraged him, that Sickert decided to train as an artist. After a brief — and fairly unsatisfactory — time at the renowned Slade School of Fine Art in London, he entered Whistler's studio.

Although Sickert had spent much of his life drawing and painting in an amateur fashion, the earliest known painting it is possible to attribute to him dates from after he had begun working with Whistler, a self-portrait from December 1882. The methods Sickert acquired from Whistler can still be discerned even in Sickert's much later works when his style and conception of art had changed; these lessons and influences were passed on via Sickert to those he inspired, including the Camden Town Group and the Euston Road School.

Sickert painted landscapes, portraits and figurative scenes. He has been called an Aestheticist, an Impressionist and a Post-Impressionist — in essence, he created his own style, importing techniques he learned from Whistler and Edgar Degas (for whom he worked as an apprentice in Paris) as well as from studying the works of old and current masters and in learning the art of engraving. Aside from his superbly evocative and richly coloured paintings of London's music halls, many of his London scenes were created with a darkly pessimistic colour palette, expressive of darker periods in Sickert's life; these differ greatly in style from the vivid colours he used for his paintings of Venice and Dieppe.

Sickert lived in London for much of his adult life, but he was by nature a traveller and took regular trips to France and Italy. Inspired by his mentors, Sickert moved to Dieppe in 1898, where he lived for seven years. He returned to London in 1905 and settled in Camden Town, an area he would make famous. When Sickert moved into Camden he was told by his landlady that she was convinced a previous occupant of his studio had been the serial killer Jack the Ripper. Sickert used this in his now infamous painting *Jack the Ripper's Bedroom* (1908).

The American fiction writer Patricia Cornwell spent many years and large amounts of money trying to prove her theory that Sickert was actually Jack the Ripper (despite the fact that Sickert is known to have been in France when several of the five known Ripper murders took place). The theories are flawed and incomplete, but her sensational book has blighted Sickert's reputation.

During his lifetime, Sickert was both feted and reviled; his known love of practical jokes, his morbid sense of humour and his love of the macabre all worked against him. The conventional world saw Sickert as an avant-garde agitator who was desperate to court controversy; yet by the end of his life his earliest strivings to lead British art into a new era were celebrated. During World War I, an extremely difficult period for a British man who had been born in Bavaria, Sickert settled in Bath. He returned to London after the war and, in 1934, was elected a Royal Academician.

1860 Born in Munich, Germany
EARLY 1880S Apprentice to James Abbott McNeill Whistler
1881–82 Studies at Slade School of Art, London
1885 Marries Ellen Melicent Ashburner Cobden
1887–99 Paints scenes of music halls and theatres
1888 Joins New English Art Club
1899 Organises and exhibits work in *The London Impressionists* at the Goupil Gallery in London; divorces Cobden
1908–12 Teaches at Westminster School of Art
1908–09 Produces series of paintings based on Jack the Ripper's Camden Town murders
1911 Establishes the Camden Town Group; marries Christine Drummond Angus
1915–18 Teaches at Westminster School of Art
1920–22 Death of Christine Drummond Angus; lives and works in Dieppe
1924 Elected Associate Member of the Royal Academy of Arts in London
1926 Marries Thérèse Lessore
1927–29 President of the Royal Society of British Artists
1934 Elected Royal Academician
1942 Dies in Bath, England

Walter Richard Sickert, photograph by George Charles Beresford

FURTHER READING
Wendy Baron and Richard Shone (eds.), *Walter Sickert*, New Haven, 1992
Edward King, Matthew Sturgis, Hannah Neale, *Walter Richard Sickert: The Human Canvas*, Kendal, 2004

ROGER FRY

ÉDOUARD VUILLARD

EMIL NOLDE

1844 Alexandre Dumas completes
The Count of Monte Christo

1863 Death of Eugène Delacroix

1880 Auguste Rodin begins working on
The Gates of Hell

1841 Birth of Pierre-Auguste Renoir

1859 Charles Darwin publishes
On the Origin of Species

| 1815 | 1820 | 1825 | 1830 | 1835 | 1840 | 1845 | 1850 | 1855 | 1860 | 1865 | 1870 | 1875 | 1880 | 1885 | 1890 | 1895 | 1900 |

Roger Eliot Fry, *Virginia Woolf*, oil on board, 54.5 x 87.5 cm, Leeds City Art Gallery

1912 Jean Metzinger and Albert Gleizes
 publish first major treatise on Cubism

1951 Willem de Kooning paints *Woman I*

1970 Robert Smithson produces *Spiral Jetty*

1910 E. M. Forster publishes
 Howards End

1928 Amelia Earhart flies across
 the Atlantic Ocean

1905 1910 1915 1920 1925 1930 1935 1940 1945 1950 1955 1960 1965 1970 1975 1980 1985 1990

ROGER FRY

Through his work as a designer, critic, painter and international exhibitions curator Roger Fry espoused the cause of modern art, bringing Cézanne and Matisse in particular to the attention of the British public.

Roger Fry's was born into a devout Quaker family. As a child, he showed a natural aptitude for sciences and he gained a first in Natural Sciences from King's College, Cambridge. It was a bitter disappointment to his parents when he became an artist. He was encouraged by his friend, Slade professor J. H. Middleton, and took his first lessons at Francis Bates's art school in west London. He spent a brief period at the Académie Julian in Paris. He travelled around Europe, most notably to Italy, and became an expert on French Impressionism and the Post-Impressionists, making his name as a critic, art historian and accomplished writer. He spent five years as a critic for the *Athenaeum* and, in 1903, helped found the *Burlington Magazine*.

In 1910, Fry made the acquaintance of the sisters Vanessa Bell and Virginia Stephen (soon to become Virginia Woolf). It was a year of emotional upheaval for Fry, who was now in his forties. In 1896 he had married a fellow artist, Helen Coombe, with whom he had two children, but her mental health was precarious and by 1910 she had been declared incurably insane. That year, Fry was forced to make the terrible decision to have his wife committed to an asylum. He had also decided to resign from his position as European Advisor to the Metropolitan Museum of Art in New York.

Fry had held solo exhibitions of his work in 1903, 1907 and 1909 and was involved with a number of 'fringe' galleries in London, including the Whitechapel Art Gallery. The founders of the Bloomsbury Group were intrigued to meet him, so he was invited to speak at Vanessa Bell's Friday Club in 1910. The following year, Fry joined Vanessa and Clive Bell on a holiday to Turkey during which he and Vanessa began an affair which lasted for two years. Fry was heartbroken when Vanessa left him in 1913 for Duncan Grant.

Fry promoted the cause of French art in Britain and British art in France. He organised two Post-Impressionist exhibitions in London (1910 and 1911) and, in 1912, organised an exhibition of British painting at the Galeries Barbazanges in Paris. In 1913, he opened the Omega Workshops at 33 Fitzroy Square, Bloomsbury. The workshops were a direct descendant of William Morris's 'Morris & Co'. Although some of Omega's artists were famous names, Fry ran the workshops on a democratic footing: no matter how exalted or lowly the artist, everyone was paid exactly the same wages and no one was allowed to sign their work. Initially seen as a valid artistic ideal, this policy lead to frustration from artists who wanted their work to be recognised. Percy Wyndham Lewis had a furious row with Fry and left, taking several Omega artists with him, to found the rival Rebel Arts Centre. The Omega workshops were badly affected by World War I and closed down in 1919. Young artists who enhanced their careers at the Omega Workshops included Dora Carrington, Winifred Gill and Nina Hamnett (who was also Fry's lover). In 1920, Fry published *Vision and Design* a groundbreaking collection of essays; together with his monograph on Cézanne in 1927, it defined him as the most influential critic of his generation.

Fry's personal life continued to be troubled. Following his affair with Hamnett, he fell in love with Josette Coatmellac, but their affair ended with her suicide. By the end of his life, he was living with Helen Anrep, a much younger artist, who was also married. When he died, the casket in which Roger Fry's ashes were interred was designed by Vanessa Bell. In 1940, Virginia Woolf published his biography.

1866 Born 14 December in London
LATE 1880S Graduates from King's College, Cambridge University
1891–92 Travels to Italy; studies painting at the Académie Julian in Paris
1896 Marries Helen Coombe
EARLY 1900S Teaches Art History at the Slade School of Fine Art, University College London; writes art criticism for the publication *Athenaeum*
1906 Appointed Curator of Paintings at the Metropolitan Museum of Art in New York; develops an interest in the work of Paul Cézanne
1910 Organises the exhibition *Manet and the Post-Impressionists* at the Grafton Galleries in London; meets Vanessa Bell, Clive Bell and Virginia Woolf; Helen Coombe is committed to a mental institution
1913 Establishes the Omega Workshops in London's Fitzroy Square with Vanessa Bell and Duncan Grant
1933 Appointed Slade Professor at Cambridge University
1934 Publishes *Reflections on British Painting*; dies 4 September in London

FURTHER READING
Virginia Woolf, *Roger Fry*, London, [1940] 2003
Frances Spalding, *Roger Fry: Art and Life*, Norwich, 1999

Roger Eliot Fry, *Self-portrait*, 1928, oil on canvas, 45.7 × 37.1 cm, Private Collection

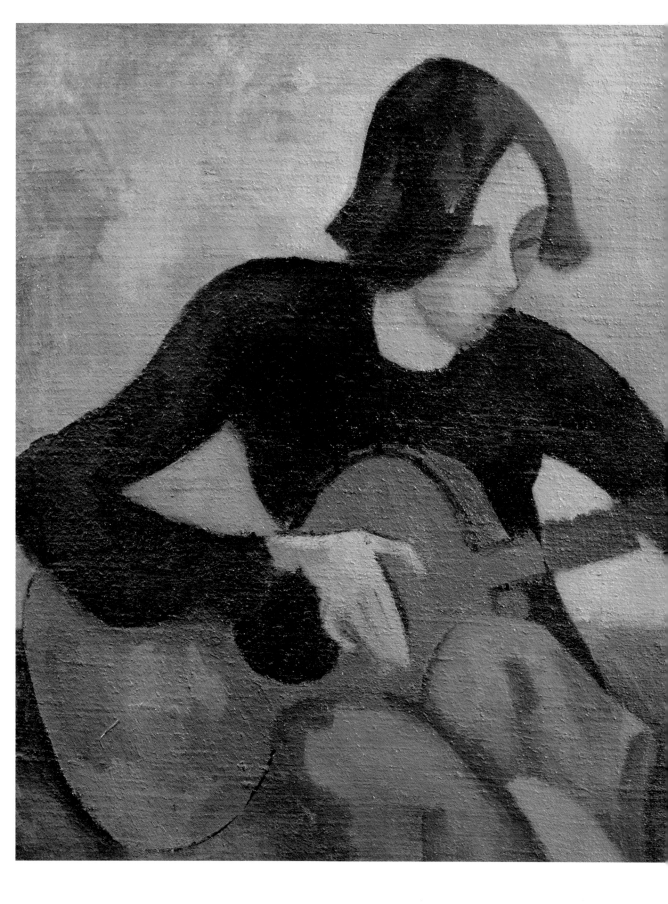

Roger Eliot Fry, *Nina Hamnett with Guitar*, c. 1917/1918, oil on canvas, 50 x 61 cm, Private Collection

CHARLES RENNIE MACKINTOSH

LOUIS COMFORT TIFFANY

HENRI DE TOULOUSE–LAUTREC

1845–52 Great Famine in Ireland

1869 Leo Tolstoy publishes *War and Peace*

1831 Victor Hugo publishes
The Hunchback of Notre Dame

1863 Édouard Manet paints
Le Déjeuner sur l'herbe

1890–1905 Art Nouveau

1871 George Eliot publishes *Middlemarch*

1815 1820 1825 1830 1835 1840 1845 1850 1855 1860 1865 1870 1875 1880 1885 1890 1895 1900

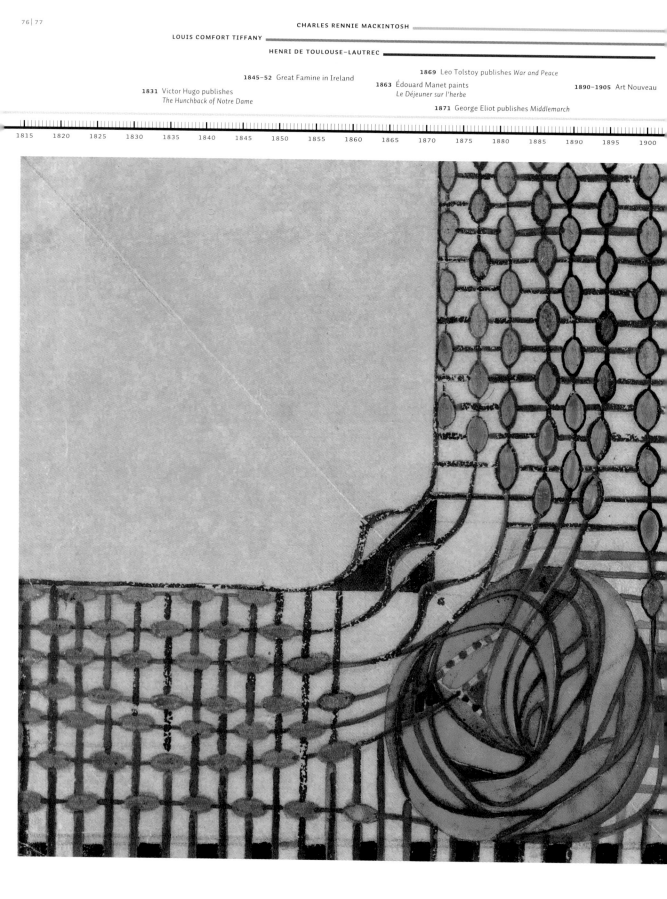

CHARLES RENNIE MACKINTOSH

Architect, designer and artist who is credited with creating the Glasgow style, and thereby launching his home town into the international artistic arena.

As a child Charles Rennie Mackintosh was notably artistic and his parents enrolled him, at the age of nine, into a private school, with the intention he should become an architect. At the age of 15, Mackintosh started evening classes at the Glasgow School of Art. A year later, he began an apprenticeship with architect, John Hutchison. In 1890 he would win the Alexander Thomson Travelling Studentship, enabling him to travel to Italy and study architecture.

Mackintosh worked with Hutchison five years before moving to a larger, more prestigious architectural practice, Honeyman and Keppie; he was made a partner in 1903. Throughout his career, Mackintosh would design what became some of Glasgow's most iconic public buildings. In 1893 his designs for the *Glasgow Herald* building made use of the latest technology, including fire-resistant concrete and a hydro-pneumatic lift. In 1896, Mackintosh received a commission that was close to his heart and which would make him famous outside and well as within his native city. He won a competition to design a new building for the Glasgow School of Art, the same building in which he had taken his teenaged art lessons. Mackintosh allowed his imagination free rein. Using a bold mix of new and traditional materials, he designed a building that melded elements from traditional Scottish Baronial architecture with the exciting new style of Art Nouveau.

Mackintosh was a polymath who saw architecture as an integral part of fine art, not separate from it. He embraced a holistic view of architecture, designing not only the buildings themselves, but also the interior decor and furniture. In the 1890s he had met three fellow artists: James McNair and the sisters Margaret and Frances Macdonald. They became known as The Four. In 1899 McNair and Frances got married; the following year, Mackintosh and Margaret did the same. They worked together: Mackintosh's style was very much in keeping with the modern age and his designs caused particular

excitement elsewhere in Europe, notably in Austria, Germany and France. He was invited to participate in the 8th Secessionist exhibition in Vienna and was closely associated with the Art Nouveau movement in France.

In 1904 he designed one of his most famous domestic buildings, The Hill House in Helensburgh, created for the publisher Walter Blackie and his family. The design seems deceptively simple: spacious rooms to accommodate the whole family let the natural light flood in. Every part of the house was completed to Mackintosh's design; he even suggested how to lay out the garden. In the same year he designed another of his most famous buildings, the Willow Tea Rooms for one of his most important patrons, Catherine Cranston. Mackintosh designed everything about the tea rooms, down to the cutlery and the waitresses' uniforms.

After enjoying such sudden and continued success, it was a shock when Mackintosh began to fall out of favour with the Scottish artistic establishment. His last public commission in Glasgow was for Scotland Street School in 1906. Eight years later, Mackintosh and Margaret left Scotland for London — but the year was 1914 and World War I made the idea of creating new buildings impossible. He undertook a few private commissions, but he never regained his former glory. In 1923, finding life in London far too expensive, Mackintosh and Margaret moved to Port Vendres in the South of France, where he devoted himself to painting instead of architecture. They returned to London in 1927, where Mackintosh died a few months later.

1868 Born 7 June in Glasgow, Scotland
1884–89 Apprenticed to architect John Hutchison; attends evening classes at Glasgow School of Art; meets Margaret Macdonald, Frances Macdonald and James Herbert McNair
1889 Begins working at the architectural practice of Honeyman and Keppie as a draughtsman
1890s With Margaret, Francis and James, exhibits works in London, Vienna and Glasgow
1890–91 Wins Alexander Thomson Travelling Studentship; tours Italy
1893 Designs offices of the Glasgow Herald
1896 Wins competition to design new building for the Glasgow School of Art
1900 Marries Margaret Macdonald
1903 Designs Willow Tea Rooms; designs Scotland Street School
1913 Resigns from Honeyman, Keppie and Mackintosh
1915 Moves with Margaret to London
1916 Re-designs house of engineer W.J. Bassett-Lowke in Northampton
1923 Moves with Margaret to Port Vendres, France
1928 Dies 10 December in London

FURTHER READING
John McKean, *Charles Rennie Mackintosh*, Grantown on Spey, 2009
James Macaulay, *Charles Rennie Mackintosh*, New York, 2010

left
Charles Rennie Mackintosh, *Design for a printed textile*, c. 1915, watercolour on tracing paper, Victoria & Albert Museum, London

right
Charles Rennie Mackintosh, photograph, 1893

1844 Alexandre Dumas' *The Three Muskateers* is serialised

1863 Birth of Paul Signac

1890–91 Claude Monet paints series of haystacks

1832 Alfred Tennyson publishes *The Lady of Shalott*

1820 1825 1830 1835 1840 1845 1850 1855 1860 1865 1870 1875 1880 1885 1890 1895 1900 1905

Gwen John, *The Student*, 1903, oil on canvas, 56.1 x 33.1 cm, Manchester City Art Gallery

1919 Weimar Republic established

1932 Courtauld Institute of Art is founded in London

1957 Soviet Union launches *Sputnik 1*

1961 United States severs diplomatic and consular relations with Cuba

1973 Pink Floyd release *The Dark Side of the Moon*

1984 John Updike publishes *The Witches of Eastwick*

| 1910 | 1915 | 1920 | 1925 | 1930 | 1935 | 1940 | 1945 | 1950 | 1955 | 1960 | 1965 | 1970 | 1975 | 1980 | 1985 | 1990 | 1995 |

GWEN JOHN

'I am not myself except in my room', Gwen John wrote to her lover, Rodin. Gwen's understated compositions expressing space and character have increased in popularity over the years and enhanced her reputation.

In 1942, the successful artist Augustus John commented '50 years after my death I shall be remembered as Gwen John's brother'. His words would prove prophetic. Although often overshadowed in her lifetime by her younger brother's fame, today Gwen John is recognised as a truly remarkable artist.

Gwen John was born and brought up in Wales. In addition to Augustus, she had an older brother, Thornton, and a younger sister, Winifred. Their mother died when Gwen was eight years old and her relationship with their father was difficult. The four siblings grew very close. In 1894, Augustus left for London to study at the Slade School of Art; the following year Gwen joined him. Winifred also came to London, to study music, and they shared lodgings in a building that had previously been a brothel.

At the Slade, Gwen was taught by Henry Tonks, who encouraged her talent for portraiture. In 1898, she moved to Paris and became a student of James Abbott McNeill Whistler. She travelled regularly between Paris and London, exhibiting in both cities. In 1900 she showed her paintings at the New English Art Club, encouraged by Whistler — who had been an early member — and her brother; three years later she and Augustus exhibited together at the Carfax Gallery in London. She was, however, making little money from her art and supplemented her income by working as an artist's model. By the early 1900s, Gwen had become an essential part of the inner circle that surrounded the sculptor Auguste Rodin. They became lovers and Gwen was the model for Rodin's *The Muse* (intended as a monument for Whistler's tomb). Their affair began when Rodin was 64 and Gwen was 28; it lasted, erratically, for around decade, despite Rodin's other lovers. For her, their affair became an obsession, for Rodin it was much less serious.

In 1910, Gwen moved to Meudon, on the outskirts of Paris, where she became fascinated by the local convent and inspired to convert to Catholicism. She grew close to the nuns and, in 1913, they com-

missioned her to paint the portrait of their founder, the 18th-century nun Mère Poussepin. Gwen also painted portraits of several of the nuns, showing to the world a human face looking out from beneath the wimple. Her portraits are sympathetic studies of intelligent, thoughtful women, whose lifestyle the artist obviously admired. Her portraits of the sisters are even more poignant when considered alongside her other portraits, often of nudes. These are never salacious or titillating, but serious, empathetic — and occasionally challenging — portraits of young women. The identities of many of her models are unknown. Gwen chose a reclusive life and, between 1914 and 1925, devoted her time to painting and to her new religion, yet she never found painting easy. In 1911, she wrote in a letter, 'I paint a good deal, but I don't often get a picture done — that requires, for me, a very long time of a quiet mind, and never to think of exhibitions'. Following the death, in 1924, of her most prominent patron, John Quinn, her output began to decline. She exhibited at the Paris Salon for the last time in 1925.

In 1926 she fell in love again, as passionately as she had been with Rodin. This time, the object of her obsession was a woman, Vera Oumancoff; it ended unhappily. In 1939, just days after the outbreak of World War II, Gwen John collapsed in Dieppe. Why she was in Dieppe is unknown. In the possessions she had taken with her were her will and her wishes about how she wanted to be buried.

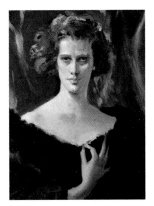

1876 Born 22 June in Haverfordwest, Wales
1895–98 Studies at the Slade School of Art, University College London, where her younger brother Augustus John has begun studying a year earlier
1898–99 First visit to Paris; studies under James Abbott McNeill Whistler at the Académie Carmen
1900 Begins exhibiting at the New English Art Club
1903–05 Travels to France with Dorelia McNeill; models for Auguste Rodin in France and becomes his lover
1910 Moves to Meudon, a suburb of Paris
1911 Stops exhibiting at the NEAC; Rodin ends their relationship; comes under the patronage of John Quinn
1913 Received into the Catholic Church
1919 First Paris exhibition at the Salon d'Automne
1924 Death of John Quinn
1926 First and only solo exhibition at the New Chenil Galleries in London
1939 Dies on 18 September in Dieppe

FURTHER READING
Alicia Foster, *Gwen John* (*British Artists Series*), London, 1999
Sue Roe, *Gwen John*, London, 2002

Augustus Edwin John, *Gwen John*, chalk on paper, Private Collection

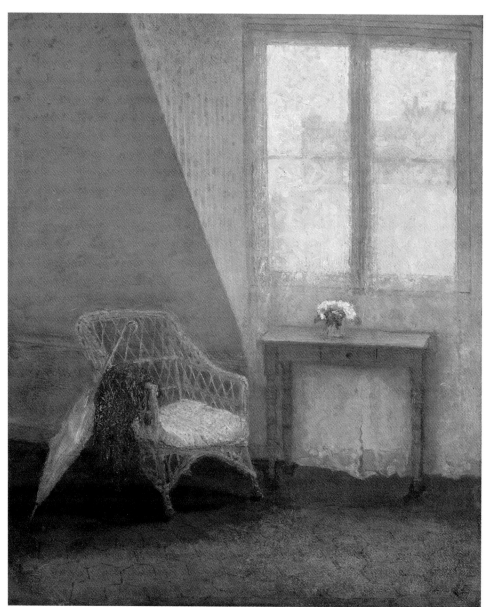

left
Gwen John, *A Corner of the Artist's Room,
Paris*, c. 1907–09, oil on canvas,
31.7 x 26.7 cm, Sheffield Galleries and
Museums Trust

right
Gwen John, *Mother Marie Poussepin*,
c. 1915–20, oil on canvas, 60.5 x 45.3 cm,
The Barber Institute of Fine Arts,
University of Birmingham

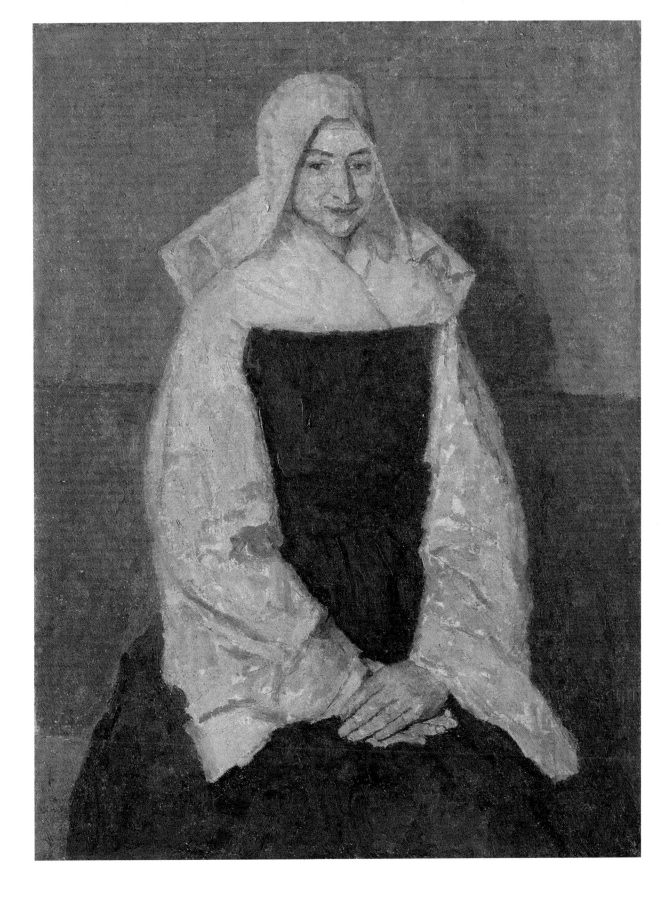

1845 Friedrich Engels publishes
*The Condition of the Working
Class in England in 1844*

1876 Pierre-Auguste Renoir paints
Dance at Le Moulin de la Galette

1868–69 Louisa May Alcott
publishes *Little Women*

1893 United States Supreme Court legally
declares tomato to be a vegetable

1911 First International
Women's Day

1835 1840 1845 1850 1855 1860 1865 1870 1875 1880 1885 1890 1895 1900 1905 1910 1915 1920

1937 First science fiction convention
held in Leeds, England

1949 George Orwell publishes
Nineteen Eighty-Four

1972 Watergate Scandal

1983 Christo and Jeanne-Claude
complete *Surrounded Islands*

1986 First Martin Luther King Jr. Day

| 1925 | 1930 | 1935 | 1940 | 1945 | 1950 | 1955 | 1960 | 1965 | 1970 | 1975 | 1980 | 1985 | 1990 | 1995 | 2000 | 2005 | 2010 |

LAURA KNIGHT

Well-known for her paintings of performers — from music hall to the Ballets Russes — Laura Knight was a skilled and versatile artist who worked in many media. Her backstage portraits render movement and colour with great sensitivity.

Laura Johnson was born in 1877, in a small Derbyshire town, to a family whose finances were already precarious. After the death of her father, when Laura was six years old, the family struggled even further. Laura's mother was a talented amateur artist who worked as an art tutor and also taught her children. Laura's talent was notable and, at the age of 13, she was awarded an artistic scholarship that paid her fees at the Nottingham School of Art. She was the school's youngest recorded pupil.

When Laura was in her early twenties, she and her sister Eva moved to the town of Staithes in North Yorkshire. Three years later, Laura married Harold Knight, whom she had met at Nottingham. It was under the name of Laura Knight that her work became famous. *Mother and Child No.1* was the first of her paintings to be exhibited at the Royal Academy, in 1903.

Laura and Harold Knight joined an artists' colony in Staithes; it was a style of living that would remain important to them throughout their marriage. They would also spend time at an artists' colony in Holland and at the Lamorna colony, in Cornwall. They moved to Cornwall in 1908, where they remained for ten years. In Cornwall, Laura's work developed a new awareness of colour; she began working more often in watercolour and gouache, as well as in oils. In Cornwall, the Knights became close to Samuel 'Lamorna' Birch and his wife, 'Mouse'. Laura also became very close to Alfred Munnings. Despite Harold Knight's jealousy of his wife's friendship with Munnings, it seems unlikely they were having an affair.

When World War I ended in 1918, the Knights returned to London, where they remained until 1939. The carefree atmosphere of the Lamorna colony had been devastated not only by the events of the war, but also by the suicide of Alfred Munning's new wife, Florence. In Staithes and Lamorna, much of Laura's work had been images of children or families, such as *Dressing the Children* (c. 1907) and

Two Fishers (1912). On her return to London, Laura began painting images of the theatre, ballet and circus, including *A Dressing Room at Drury Lane* (c. 1952) and *Ballet* (1936). During the 1930s she began painting images of horses and gypsies.

At the start of World War II, the Knights left London for Worcestershire. During the war she was appointed an Official War Artist. She began painting portraits of women working in the new wartime occupations, including *Corporal J. M. Robins, MM, WAAF* (1941) and the painting that keeps the name of Laura Knight famous in the 21st century, *Ruby Loftus Screwing a Breech Ring* (1943). In 1946 she was commissioned to paint portraits at the Nuremberg Trials. In addition to her paintings, she created etchings, designed stained-glass windows and worked with the jewellery designer Ella Naper (who was also one of the artist's favourite models). Knight also published several books, *Oil Paint and Grease Paint* (1936), *A Proper Circus Omie* (1962) and *The Magic of a Line* (1965).

Laura Knight was one of the most remarkable artists of her time, repeatedly honoured by her peers and the establishment. She was made an associate of the Royal Academy in 1927, became the first female artist to be made a Dame of the British Empire in 1929, and in 1932 she was elected as President of the Society of Women Artists. Four years later she became the first woman to be made a full Royal Academician since the 18th century. In 1965 the Royal Academy held a retrospective of her work; it was the first time the RA had honoured a woman with a solo exhibition.

1877 Born Laura Johnson 4 August in Long Eaton, Derbyshire, England
1890 Begins studying at Nottingham School of Art, one of the youngest students ever to join
1903 Marries Harold Knight; exhibits *Mother and Child No.1* at the Royal Academy of Arts in London; begins exhibiting regularly at the Royal Academy
1907 Moves with Harold Knight to an artist's colony in Newlyn, Cornwall
1913 Paints *Self-Portrait with Nude*
AFTER 1918 Moves to London with Harold Knight; begins producing paintings of the theatre, ballet and circus
1929 Awarded DBE
1936 Becomes first woman elected to the Royal Academy; publishes *Oil Paint and Grease Paint*
1939–45 Receives various commissions via the War Artists Advisory Committee
1945–46 Serves as Official War Artist at the Nuremberg Trials; paints *The Dock*, Nuremberg
1961 Death of Harold Knight
1965 Publishes *The Magic of a Line*
1970 Dies 7 July

FURTHER READING
Janet Dunbar, *Laura Knight*, London, 1975
Caroline Fox, *Dame Laura Knight*, Oxford, 1988

left
Laura Knight, *A Dressing Room at Drury Lane*, c. 1952, oil on canvas, 76.2 x 63.6 cm, Atkinson Art Gallery, Southport, Merseyside

right
Laura Knight, photograph

1857 Jean-François Millet paints
The Gleaners

1843 Søren Kierkegaard publishes
Fear and Trembling

1873 Jules Verne publishes *Around the
World in Eighty Days*

1912 Marcel Duchamp
paints *Nude
Descending a
Staircase, No. 2*

1835 1840 1845 1850 1855 1860 1865 1870 1875 1880 1885 1890 1895 1900 1905 1910 1915 1920

1939 Billie Holiday records *Strange Fruit*

1960 Federico Fellini's *La Dolce Vita* is released

1978 Death of Norman Rockwell

1929 Ernest Hemingway publishes *A Farewell to Arms*

1952 The Independent Group founded in London

1968 Eddie Adams photographs General Nguyên Ngoc executing Viet Cong officer Nguyên Vǎn Lém

| 1925 | 1930 | 1935 | 1940 | 1945 | 1950 | 1955 | 1960 | 1965 | 1970 | 1975 | 1980 | 1985 | 1990 | 1995 | 2000 | 2005 | 2010 |

VANESSA BELL

With Duncan Grant, Vanessa Bell created the Bloombury Group's retreat, Charleston, in Sussex, whose house and gardens stand as a memorial to sixty years of the artists' creativity.

Vanessa Stephen was the first child of Sir Leslie Stephen and his wife Julia; both had been widowed previously, so Vanessa was raised with four older half-siblings. Through her mother, who was born Julia Jackson and became Julia Duckworth on her first marriage, Vanessa was connected by blood or friendship to a vast circle of artistic, literary and intellectual giants, including Julia Margaret Cameron (her great aunt), Valentine Prinsep, G. F. Watts and Rudyard Kipling. Her father's first wife was the youngest daughter of William Thackeray.

The family lived at 22 Hyde Park Gate, London, a very fashionable address. The Stephen children grew up in an intellectual and minorly aristocratic world, but when Vanessa was just 16 years old, their lives changed dramatically. The death of their mother was followed by the death of their half-sister, Stella Duckworth, and Vanessa found herself in charge of her three younger siblings, Thoby, Virginia and Adrian.

Her artistic training began under the tutelage of Arthur Cope, before beginning three years at the Royal Academy Schools, where she was taught by John Singer Sargent. She wrote of Sargent, 'He generally tells me that my things are far too grey'. At the start of her career, Vanessa was greatly influenced by the works of Sargent, J.A.M. Whistler and the Impressionists. Although she began drawing and painting at a young age, she must have destroyed her earliest works as almost nothing of her *oeuvre* exists from before 1907.

In 1902, Vanessa visited Italy for the first time; she returned with her siblings and half-brother, Gerald Duckworth, following her father's death in 1904. She would keep travelling to Italy throughout her life, inspired by its vibrancy, colours and sunshine to paint light-dappled landscapes, such as *Hotel Garden, Florence* (1909). It was after Sir Leslie Stephen's death that his four youngest children moved to the area of London known as Bloomsbury. They lived together at 46 Gordon Square, where

Vanessa began The Friday Club, a place for artists to discuss their work. The group held shows in 1907 and 1908. Vanessa's paintings from this time include the sensitive, evocative portrait *Saxon Sydney Turner at the Piano* (c. 1908).

The sudden death of Thoby in 1906 affected Vanessa deeply. In the previous year, she had refused a proposal of marriage from Clive Bell, but after her brother's death she wanted to be married. Following the wedding, Virginia and Adrian moved to another Bloomsbury address, 29 Fitzroy Square, where Virginia set up a literary and artistic group on Thursdays. These two clubs were the beginning of The Bloomsbury Group, of which Vanessa Bell and Virginia Woolf (as she became after her marriage) remained the primary figures.

Vanessa and Clive Bell had two sons, Julian and Quentin and, in 1918, Vanessa gave birth to a daughter, Angelica. Although known as Angelica Bell, she was actually the daughter of Vanessa's lover and artistic collaborator, Duncan Grant.

Vanessa Bell and Duncan Grant remained close throughout their lives, although she always felt her work to be inferior: 'His are so gay and lovely — mine rather dull and stupid'. Her paintings were not universally admired: works such as *Studland Beach* (1911) were too radical for the era in which she lived to be generally accepted, although her portraits — mostly of friends and relations — received more favourable criticism. For many years, much of Vanessa Bell's fame stemmed from being Virginia Woolf's sister. In recent decades she has been rediscovered as a hugely talented and inspirational artist in her own right.

1879 Born Vanessa Stephen on 30 May in London
1901–04 Studies at the Royal Academy, where she is taught by John Singer Sargent
1905 Exhibits at New Gallery and receives her first portrait commission
1907 Marries Clive Bell
1909 *Iceland Poppies* exhibited at the New English Art Club, winning praise from Sickert
1910–11 Attends *Manet and the Post-Impressionists* at the Grafton Gallery, organised by Roger Fry; begins an affair with Fry
1912 Exhibits work in the *Exposition de Quelques Indépendants Anglais* at Galerie Barbazanges in Paris; sells first painting, *The Spanish Model*
1913 Made co-director, with Duncan Grant, of Fry's Omega Workshops
1915 Begins a relationship with Grant
FROM 1916 Divides time between Charleston Farmhouse in Firle, Sussex, and London
1922 First major solo exhibition at the Independent Gallery in London
1940–43 Works with Grant, Angelica and Quentin Bell on murals for Berwick Church, Sussex
1961 Dies 7 April in Charleston Farmhouse

left
Vanessa Bell, *Portrait of Angelica*, 1934, oil on hardboard, 13 x 13 cm, Pallant House Gallery, Chichester

right
Vanessa Bell, photograph

FURTHER READING
Richard Shone, *The Art of Bloomsbury: Roger Fry, Vanessa Bell and Duncan Grant*, New Jersey, 2001
Frances Spalding, *Vanessa Bell*, Stroud, 2006

1843–54 Gustave Courbet paints
Self-portrait (The Desperate Man)

1862 Birth of Gustav Klimt

1873–74 Paul Cézanne paints
A Modern Olympia

1888 Paul Sérusier paints *The Talisman*

1900 British Labour Party is formed

| 1835 | 1840 | 1845 | 1850 | 1855 | 1860 | 1865 | 1870 | 1875 | 1880 | 1885 | 1890 | 1895 | 1900 | 1905 | 1910 | 1915 | 1920 |

Eric Gill, *Dancing Couple*, stone, h. 41 cm,
Private Collection

ERIC GILL

Eric Gill created art whose clean linearity places him firmly at the centre of British Modernism. Yet his personal philosophy and the ancient symbolism which his work employs lift his oeuvre *into a timeless realm.*

When Eric Gill was born, his father Rev. Arthur Tidman Gill, was working as a non-conformist minister in a curious Christian sect known as 'The Countess of Huntingdon's Connexion'. As a child and adolescent, Gill was closely involved in his father's religious community.

Gill was born in the Sussex seaside town of Brighton. When the family moved to Chichester the teenaged Gill enrolled in the Chichester Technical and Art School; it was here that he developed a passion for lettering, encouraged by his tutor, George Herbert Catt. When he left Sussex for London in 1900, it was for a job with the ecclesiastical architectural firm of W.D. Caroe, but the call of sculpture became too loud for Gill to settle. He began taking evening classes in stonemasonry, sculpture and calligraphy and, in 1903, gave up his architectural job to become a designer and mason. A year later he married his muse, Ethel, with whom he rapidly had children. The family moved back to Gill's native Sussex, where they began an artistic community in the village of Ditchling. His earliest stone work often included producing lettering for other sculptors. In 1910 he followed Brancusi's example and began direct carving, creating his first stone figures. Gill achieved his first public success just two years later, with *Mother and Child* (1912).

The religious atmosphere that pervaded his childhood partially shaped Gill's adult life and, throughout his career, he would be inspired by Christian iconography. This created a dichotomy in the mind of a man who was intensely sexual. As he recalled in his autobiography, once he had discovered sex 'I lived henceforth in a strange world of contradiction: something was called filthy which was obviously clean...something was called ugly which was obviously lovely. Strange days and nights of mystery and fear...'.

The struggle to overcome religious strictures and embrace his sexuality is explicit in his works, such as the beautifully simple and exquisitely erotic torso

Eve (1926), the languidly homoerotic sculpture *St Sebastian* (1920) and the controversial illustration *Stay Me With Apples* (1925), an image of two haloed figures making love. He also worked on a number of religious commissions, including the *Stations of the Cross* series for Westminster Cathedral in London, which he began in 1914, a year after converting to Catholicism. At the end of World War I, Gill helped found an artistic and religious colony, The Guild of St Joseph and St Dominic. Its core idea was to return to the medieval style of tradespeople's guilds, and was a similar ideology to that which had inspired William Morris to found the Arts and Crafts Movement.

The circle in which Gill moved was one of artistic excitement and exploration. He was also a sexual adventurer, constantly cheating on Ethel, who nonetheless remained with him. He slept with his friends, his friend's wives, his wife's friends and reportedly committed incest with several members of his family. Yet he and Ethel remained together, and in 1924 they set up another artists' colony, at Capel y Ffin, in Wales. They struggled for four years in the remote ruined monastery they had made their home, before finally conceding defeat, and moving back to England, living a few miles outside London.

Gill was a polymath whose work encompassed engraving, calligraphy, letter-cutting, typographic design, writing and teaching, as well as his sculpting. One of his most famous legacies is the Gill Sans typeface, widely available today as a computer font. He described his sculptures as 'Not only born but conceived in stone, they are stone in their innermost being as well as their outermost existence'.

1882 Born 22 February in Brighton, England
1897 Studies at Chichester Technical and Art School
1899 Attends Central School of Arts and Crafts, London
1899–1903 Works at the architectural offices of the Ecclesiastical Commissioners
1904 Marries Ethel Moore
1910 Carves first stone figure; begins to concentrate on sculptural projects
1914 Exempted from military service to work on the *Stations of the Cross* for Westminster Cathedral
1918 Spends four months of non-active service in the RAF
1925 Makes a pilgrimage to Rome
1926 Designs Gill Sans typeface
1928 Begins working on sculptures for the London Underground Railway headquarters
1929 Commissioned to carve sculptures for the façade of Broadcasting House in London
1933 Becomes a founder member of the Artists International
1937 Elected Associate Member of the Royal Academy of Arts in London
1938 Completes panels for the League of Nations building in Geneva
1940 Dies 17 November in Uxbridge

FURTHER READING
Fiona MacCarthy, *Eric Gill*, London, 2003
Anthony Hoyland, *Eric Gill: Nuptials of God*, Kent, 2008

Eric Gill, photograph

1843 Charles Dickens publishes
A Christmas Carol

1855 Gustave Courbet paints
The Artist's Studio

1892 Paul Cézanne paints
The Card Players

| 1840 | 1845 | 1850 | 1855 | 1860 | 1865 | 1870 | 1875 | 1880 | 1885 | 1890 | 1895 | 1900 | 1905 | 1910 | 1915 | 1920 | 1925 |

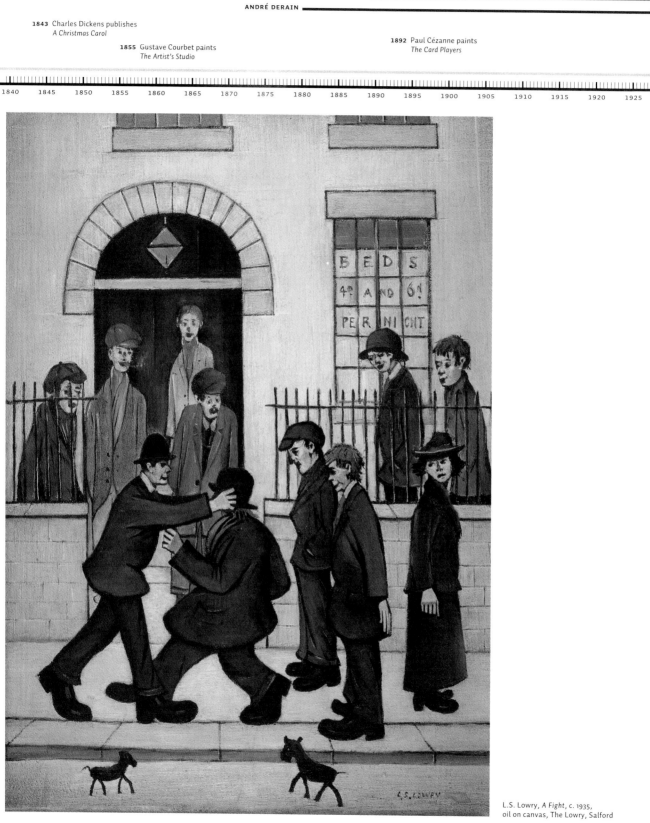

L.S. Lowry, *A Fight*, c. 1935,
oil on canvas, The Lowry, Salford

L. S. LOWRY

The painter of 'matchstick men', L.S. Lowry made art that celebrated the modest lives of his fellow Northerners. He was also a masterly creator of seascapes, landscapes and portraits.

Often ridiculed for the 'simplicity' of his paintings, Laurence Stephen Lowry fought off his detractors to become one of Britain's best-loved painters. The artist grew up in and around Manchester, a town that had been changed forever by the Industrial Revolution. The first part of his childhood was spent in a leafy, pretty suburb, but when his father ran into financial difficulties, the family moved to a poorer part of town. Lowry grew used to the sight of streets dominated by factories beneath smog-filled skies, and to watching crowds of labourers trekking to and from work. As a teenager, Lowry knew he wanted to become an artist. On leaving school he applied to — and was rejected by — the Manchester Municipal College of Art, so he took a job with a firm of chartered accountants and began taking private art lessons from the painter Reginald Barber.

Lowry was often dismissed as a self-taught painter who knew nothing about art, but the truth was very different. In 1905, he began ten years of evening classes at the Manchester Municipal College of Art, where he was taught by Adolf Valette, a French-born artist nicknamed 'the Manchester Impressionist'. From the time he left school until his retirement in 1952, Lowry worked by day as a clerk and, eventually, as a rent collector, but he always painted in the evenings and at weekends. In 1915 he began another ten years of tuition, at the Salford School of Art. It was during this time that Lowry had his first break — in 1919 three of his paintings were exhibited at the Manchester City Gallery's annual exhibition.

In 1930, *An Accident* became the first of Lowry's paintings to be bought for a public art collection; it was bought by the Manchester Art Gallery. Two years later, Lowry was accepted to exhibit at the Royal Academy in London for the first time and two years after that he was elected to the Manchester Academy and the Royal Society of British Artists — yet his unique style was still being widely criticised. He became famous for his urban landscapes, crowds

of simple figures against a backdrop of industrial buildings and a haze of smog, painted in a consciously two-dimensional style. He was a loner whose art reflects feelings of isolation; he commented in later life that it was his loneliness that enabled him to paint the scenes he did. At the end of the 1930s, his mother died: she had been a widow for some time and Lowry — her only child — nursed her to the end. In 1938 he painted an anguished self-portrait *The Man With Red Eyes*, also in a consciously two-dimensional style. The look on his furrowed face is one of sheer anguish, painful for the viewer to behold.

Just before the outbreak of World War II, Lowry was invited to hold his first one-man show, in London. Although the exhibition was quite poorly received, by 1943 he had been appointed an Official War Artist. In the last year of the war he held his second solo exhibition, this time it was hailed as a success; in the same year he was awarded an honorary MA from the University of Manchester.

In 1955, Lowry was made an Associate of the Royal Academy, seven years later he was named a Royal Academician. The following year, in 1963, Lowry turned 77; his birthday was marked by a special concert performed by the Hallé Orchestra. Lowry's works had made Salford famous and in 1965 he was presented with the Freedom of the City. Following Lowry's death from pneumonia, the Royal Academy held a retrospective of his paintings.

1887 Born 1 November in Stretford, Lancashire, England

1905–15 Attends drawing and painting classes at Manchester Municipal College of Art; studies under painter Pierre Adolf Valette

1915–25 Attends art classes at the Salford School of Art; develops interest in industrial landscapes

FROM 1919 Exhibits at the Manchester Academy of Fine Arts; submits paintings to the Paris Salon

1943 Serves as an Official War Artist

1953 Appointed Official Artist at the coronation of Elizabeth II

1957 Befriends unrelated schoolgirl Carol Ann Lowry after she writes to him for advice on how to become an artist

1961 Awarded Honorary Doctor of Letters degree by the University of Manchester

1962 Elected Royal Academician

1965 Given freedom of the City of Salford

1976 Dies on 23 February of pneumonia at the Woods Hospital in Glossop, Derbyshire; leaves estate to Carol Ann Lowry; Royal Academy holds memorial exhibition of his work

2000 Opening of the Lowry Centre in Salford Quays

FURTHER READING
Mervyn Levy, *The Paintings of L. S. Lowry: Oils and Watercolours*, London, 1975
Michael Leber and Judith Sandling (eds.), *L. S. Lowry*, Oxford, 1987

L.S. Lowry, photograph

MARK GERTLER

NORMAN ROCKWELL

AMEDEO MODIGLIANI

1868 Édouard Manet paints
Portrait of Émile Zola

1891 Henri de Toulouse-Lautrec produces
the poster *Moulin Rouge – La Goulue*

1857 Jean-François Millet paints
The Gleaners

1886 Friedrich Nietzsche publishes
Thus Spake Zarathustra

1907 Gustav Klimt paints *The Kiss*

1840 1845 1850 1855 1860 1865 1870 1875 1880 1885 1890 1895 1900 1905 1910 1915 1920 1925

Mark Gertler, *The Pond at Garsington*,
1916, oil on canvas, 63.3 x 63.3 cm,
Leeds City Art Gallery

1939 First *Batman* comic book published

1959 Cuban Revolution

1965 Bob Dylan releases *Like a Rolling Stone*

1975 End of Vietnam War

1989 Tiananmen Square protests

1930 1935 1940 1945 1950 1955 1960 1965 1970 1975 1980 1985 1990 1995 2000 2005 2010 2015

MARK GERTLER

Praised by D.H. Lawrence and immortalised in the writings of the Bloomsbury set, Mark Gertler's work deals with the realities of the early 20ᵗʰ century such as war and anti-semitism in ways which go far beyond his social success.

Mark Gertler enrolled in art school as a teenager, but when his family needed him to earn money he began to work during the day for a stained glass manufacturer and take evening classes in art. Gertler's parents were Polish Jews who had emigrated to England before their youngest son's birth. He was born in a slum in Spitalfields, in the East End of London, and grew up in a deeply impoverished home. Desperate to become an artist and leave the tedium of his job, he appealed to the Jewish Education Aid Society and, in 1908, was awarded a scholarship to the Slade School of Art in London. His teachers included Walter Sickert's friend and pupil Philip Wilson Steer (1860–1942) and the doctor-turned-artist Henry Tonks (1862–1937).

The Slade propelled Gertler into a world of artists and their cliques. He studied alongside Paul Nash, Christopher Nevinson, Dora Carrington and Stanley Spencer. He became a prominent member of the Bloomsbury Group and associated with the New English Art Club, the London Group, the Camden Town Group and the Euston Road Group. Although he proclaimed himself 'disgusted' by the pretensions, and the abundance of 'isms' in modern art, Gertler was unable to escape flirting with many of these styles. His work shows the influences of Vorticism, Futurism, Cubism, abstraction, Realism, Modernism, the Bloomsbury set and Roger Fry's Omega Workshops.

Gertler's work was lauded by his fellow Bloomsburies. In his 1915 novel *The Rainbow*, D.H. Lawrence wrote a description of Gertler's *The Creation of Eve* (1914): 'Adam lay asleep as if suffering, and God, a dim, large figure, stooped towards him… and Eve, a small, vivid, naked, female, was issuing like a flame towards the hand of God…'. Gertler also inspired Katherine Mansfield and Aldous Huxley. In his novel *Chrome Yellow* (1921) Huxley's artist Gombauld is based on Gertler: 'Gombauld was altogether and essentially human…a black-haired young corsair of thirty, with flashing teeth and luminous large dark

eyes. Denis looked at him enviously. He was jealous of his talent: if only he wrote verse as well as Gombauld painted pictures!'. The society hostess and Bloomsbury patron Lady Ottoline Morrell invited Gertler to be artist-in-residence at her country manor house, Garsington.

Gertler did produce at least one piece of sculpture, *Acrobats* (1917), but it is his paintings for which he is best known. His most famous is the 1916 painting, *Merry-Go-Round*. Gertler was a conscientious objector during World War I and *Merry-Go-Round* exemplified his belief in the futility of war: riding on a militaristic carousel of conflict are brightly — but brutally — painted figures destined to an eternity of spinning around together.

Throughout the 1920s and early 1930s, Gertler's work became softer and he began painting more portraits, often of voluptuous, attractive women, including a series of nudes. Ever since the Slade, Gertler had been in love with Dora Carrington, but his love was unrequited and, in 1930, he married Marjorie Greatorex Hodgkinson, another Slade student. In 1932, Gertler's mother died, Marjorie gave birth to a son and, two months after her adored friend Lytton Strachey died of cancer, Dora Carrington shot herself. Gertler, who suffered regularly from depression, was devastated by the deaths. He made a number of suicide threats and at least one real attempt. In 1939, unable to cope with her husband's depression, Marjorie left him. Gertler's work was not selling, he had been suffering from tuberculosis, he was aware of the terrifying rise of anti-Semitism around Europe and the world was on the brink of another war. In June 1939, he blocked the door to his studio and gassed himself. In a poignant diary entry, Virginia Woolf asked 'With his intellect and interest, why did the personal life become too painful?'.

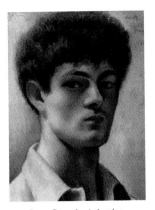

1891 Born 9 December in London
1906–07 Attends art classes at Regent Street Polytechnic, but is forced to drop out after a year for financial reasons; apprenticeship at Clayton and Bell, a stained glass company; attends evening classes at the Regent Street Polytechnic
1908 Awarded scholarship from the Jewish Education Aid Society; enrols at the Slade School of Art in London with the support of William Rothenstein
1916 Paints Merry-Go-Round
1918 Invited by Roger Fry to work at his Omega Workshops
1920 Diagnosed with tuberculosis
1930 Marries Marjorie Greatorex Hodgkinson
1931 Begins teaching part-time at Westminster Technical Institute
1932 Birth of his son, Luke Gertler
1934 Solo exhibition at the Leicester Galleries in London is critically derided
1939 Commits suicide on 23 June in his London studio

FURTHER READING
Sarah MacDougall, *Mark Gertler*, London, 2002

Mark Gertler, *Self-portrait*, 1920, oil on canvas, 42.5 x 29.2 cm, Arts Council Collection, Southbank Centre, London

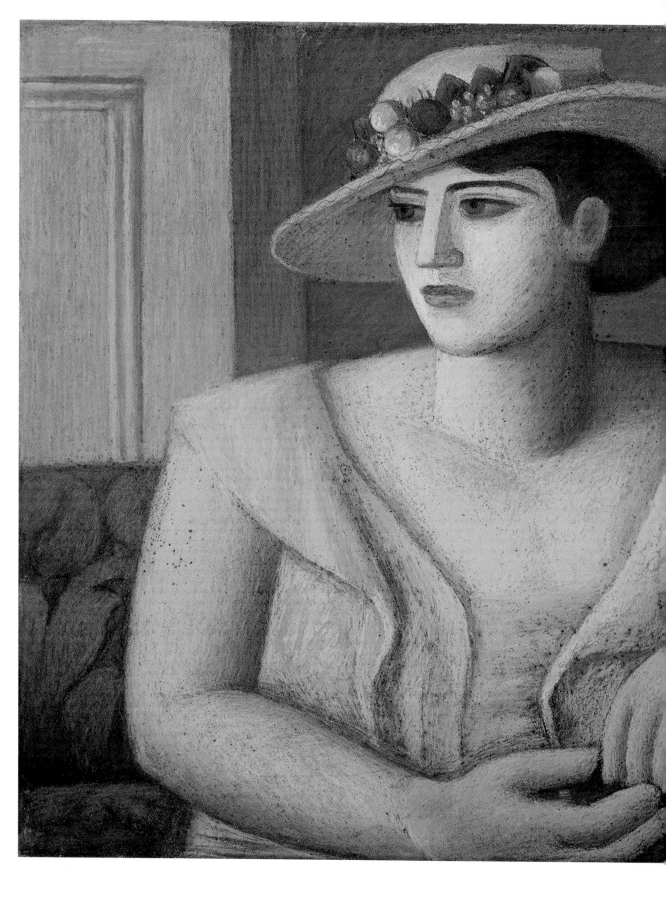

Mark Gertler, *Portrait of Marjorie Gertler*,
1933, pastel on paper, 68.3 x 88.4 cm,
Abbot Hall Art Gallery, Kendal

1881 United States Tennis Association
is established

1850 Jean-François Millet
paints *The Sower*

1867 Édouard Manet paints *The Execution
of the Emperor Maximilian of Mexico*

1893 Edvard Munch paints
The Scream

1914–18 World War 1

| 1840 | 1845 | 1850 | 1855 | 1860 | 1865 | 1870 | 1875 | 1880 | 1885 | 1890 | 1895 | 1900 | 1905 | 1910 | 1915 | 1920 | 1925 |

Stanley Spencer, *Sunbathers at Odney*, 1935,
oil on canvas, 76.2 x 50.8 cm, Stanley Spencer
Gallery, Cookham

1951 W. V. O. Quine publishes his paper
Two Dogmas of Empiricism

1939 Nazi Germany invades Poland

1970–71 David Hockney paints
Mr and Mrs Clark and Percy

1965 Bob Dylan releases
Highway 61 Revisited

1989 Mona Hatoum exhibits *The Light At the End*
at the Showroom Gallery in London

| 1930 | 1935 | 1940 | 1945 | 1950 | 1955 | 1960 | 1965 | 1970 | 1975 | 1980 | 1985 | 1990 | 1995 | 2000 | 2005 | 2010 | 2015 |

STANLEY SPENCER

The intimate nature of the scenes Stanley Spencer chose to depict, often in hyperreal detail, brought a melding of ancient and modern worlds — and controversy. 'It is as if a Pre-Raphaelite had shaken hands with a Cubist', wrote one critic.

In 1908, Stanley Spencer began four years at the Slade School of Fine Art in London. He would become one of its most extraordinary students. Spencer was born in 1891 in the Berkshire village of Cookham. Throughout his time at the Slade, where he was taught by Henry Tonks, he commuted to and from Cookham every day. He used the village as the inspiration for his paintings, often portraying it as a biblical paradise.

At the Slade, Spencer came into contact with the Bloomsburies, most notably Roger Fry, and the Neo-Primitives. His work from this time is predominantly religious, such as *The Nativity* (1912), though he also painted idyllic scenes of rural English life, including *Swan Upping* (1915–19), which he began in the halcyon era before he found himself embroiled in World War I.

In 1915 Spencer enlisted in the Royal Army Medical Corps. He served in Britain and Macedonia, before being named an Official War Artist. His experiences of the fighting would reappear in his works, most memorably in *The Dug Out* (1927–32), in Spencer's series of murals for the Sandham Memorial Chapel in Hampshire. The idea for the painting had come to him as a soldier, when he had found himself thinking 'how marvellous it would be if one morning, when we came out of our dug-outs, we found that somehow everything was peace and the war was no more'.

Spencer's work changed markedly after World War I: the idealism of his earlier years had been challenged and his vision of the world had altered dramatically. In 1927, the year in which he began the Hampshire murals, Spencer held his first solo exhibition. At the show, *The Resurrection, Cookham* (1924–26) was hailed as a work of genius. The *Times'* art critic described Spencer's style as a melding of Pre-Raphaelitism and Cubism and the painting as 'the most important picture painted by any English artist in the present century'.

Throughout the 1930s, Spencer suffered a series of crises, convinced his unique vision and style had left him. In 1935 he was devastated when the two pictures he had submitted to the Royal Academy were rejected by the Summer Exhibition selection committee. In addition to his artistic crisis, his decade-long marriage was failing. In 1925 he had married Hilda (née Carline) a fellow artist and sister of one of his friends, but by 1934 he had become obsessed with the aspiring artist Patricia Preece, who was in a lesbian relationship with the artist Dorothy Hepworth. In 1937 Spencer divorced Hilda; just four days later, he married Patricia. His works from the 1930s onwards are centred around sex, anger and betrayal, one of the most famous being his double portrait *Self-Portrait with Patricia Preece* (1936). Patricia lies naked on the bed, her face contemplative and unhappy while Spencer gazes at her, seemingly an unwelcome voyeur, kneeling by the side of her bed. Within months of their wedding, Patricia had returned to Dorothy. Spencer's paintings reflected his mental turmoil, with both Hilda and Patricia sometimes appearing on the same canvas. His paintings and drawings became so extreme in their exploration of sexuality in all its forms that he was later reported to the police for obscenity. Spencer destroyed many of his works from this time.

During World War II he was hired once again as an Official War Artist, creating memorable images of shipbuilding on the Clyde (1940–46). He also returned to his religious scenes: *Sunbathers at Odney* is part of his Baptism of Christ series from the 1940s. By the time of his death in 1959, Spencer had been knighted and had been re-elected to the Royal Academy (which he had left in a fury in 1935).

1891 Born 30 June in Cookham, Berkshire, England
1908–12 Studies at Slade School of Art, London
1915 Volunteers for Royal Army Medical Corps
1918 Approached by the War Artists Advisory Committee to paint what will become *Travoys Arriving with Wounded at a Dressing Station at Smol, Macedonia, September 1916*
1925 Marries Hilda Carline
1927 First one-man show at Goupil Gallery in London
1932 Elected Associate Member of Royal Academy of Arts in London
1935 Resigns as an Associate Member of the Royal Academy after hanging committee reject *St Francis and the Birds* and *The Dustman*
1937 Divorces Carline; marries Patricia Preece
1940 Commissioned to produce paintings of Lithgow Shipbuilding Yard in Port Glasgow, Scotland
1950 Rejoins Royal Academy
1955 Major retrospective held at Tate Gallery in London
1959 Dies of cancer on 14 December at Canadian Red Cross Memorial Hospital on the Cliveden Estate, Taplow, Buckinghamshire

FURTHER READING
Duncan Robinson, *Stanley Spencer*, Oxford, 1990
Fiona MacCarthy, *Stanley Spencer An English Vision*, Washington, DC, 1997

Stanley Spencer, *Self-portrait*, 1914, oil on canvas, 63 x 51 cm, Private Collection

HENRY MOORE

NAUM GABO

JEAN TINGUELY

1869 Invention of the
submarine

1881 Billy the Kid is killed by
Sheriff Pat Garrett

1872 John Gast paints
American Progress

1895 Oscar Wilde's *The Importance of
Being Earnest* premieres in London

1939 Clement C
berg publ
*Avant-Gar
Kitsch*

1855	1860	1865	1870	1875	1880	1885	1890	1895	1900	1905	1910	1915	1920	1925	1930	1935	1940

1961 Construction begins on Berlin Wall

1949 Jorge Luis Borges publishes
El Aleph

1979 The Clash release *London Calling*

1986 Chernobyl disaster

1951 Death of Ludwig Wittgenstein

1945 1950 1955 1960 1965 1970 1975 1980 1985 1990 1995 2000 2005 2010 2015 2020 2025 2030

HENRY MOORE

Henry Moore's work challenged traditional perceptions of beauty and forged a new language of sculptural and graphic forms that drew on non-Western art and organic forms.

Instead of emulating the European sculptors lauded by his tutors, Henry Moore — the darling of the British sculpting scene for a large chunk of the 20th century — looked to non-Western art for his inspiration. His works changed the face of British sculpture and the British public's perception of modern art.

Moore was born into a mining family in Castleford, Yorkshire. He was an obviously intelligent child and his primary school encouraged him to apply for a scholarship to the local grammar school. When he finished his education, the school offered him a teaching post. By this time Europe was firmly embroiled in World War I and in 1917, after just a year of teaching, Moore travelled to London to enlist in the army. It was on this trip that he visited the British Museum for the very first time. He was instantly enthralled by the collection of art and artefacts from far-flung corners of the world.

As a member of the 15th London Regiment, Moore was sent to fight in France. He returned to Yorkshire in 1919, after recovering from the effects of being gassed and of being injured in the fighting. Freed from military service, Moore enrolled at Leeds School of Art, where he insisted he study sculpture, although no student at Leeds had done so before. Within two years he had been awarded a scholarship to the Royal College of Art in London, which he attended at the same time as Barbara Hepworth.

By the mid 1920s, Moore was working regularly as a teacher, which saw his style and his unique technique of direct carving being passed on to his students. His work was selling and he had been awarded a travelling scholarship that allowed him to visit France and Italy. He held his first one-man show in 1928. In the same year he received his first commission for a public work of art, for the headquarters of London Underground: *The West Wind Relief*, made in Portland stone. His monumental works were unlike anything previously produced by a British sculptor. The majority of his works feature the human body and include themes he returned to

again and again, such as *King and Queen*, *Mother and Child* and reclining figures. In 1929, Moore married the artist Irina Radetsky. They lived in a world of artists, numbering Hepworth, Naum Gabo and Ben Nicholson amongst their close friends.

As the prospect of another war began to loom and as Spain became embroiled in a devastating civil war, Moore's work became haunted and angry. During the 1930s, he was a member of the 7 and 5 Society, the London Group and Unit One, and also began working with the Surrealists, exhibiting at the International Surrealist Exhibitions in London and Paris. He was not solely a sculptor, but also produced a large collection of drawings and paintings. During World War II he was an Official War Artist, producing evocative images of Londoners trying to carry on their lives amid the trauma of the bombing raids. In *Tube Shelter Perspective* (1941), two densely packed lines of ghostly reclining figures, in attitudes very similar to his sculptures of the same name, fill an underground tunnel. Moore used watercolour, pencil, ink and wax to create this haunting image, which was described in an exhibition catalogue of 1941 as 'a terrifying vista…helpless yet tense… imaginative poetry of a high order'.

Moore's favoured media were stone, wood and bronze. His works are monumental in scale and seductively tactile in nature and show the great influence primitive art exerted over him. Although Moore died in 1986, his works continue to seduce the public and exhibitions of his works are staged regularly.

1898 Born 30 July in Castleford, Yorkshire, England
1916–19 Serves with Civil Service Rifles
1919 Enrols at Leeds School of Art; meets Barbara Hepworth
1921 Wins scholarship to Royal College of Art in London
1922 Makes first Madonna and Child carvings and *Head of a Virgin*
1928 First one-man show at Warren Gallery in London
1929–30 Completes first public commission, *West Wind*; marries Irina Radetsky
1931 Begins teaching at the Chelsea School of Art
1940 Appointed Official War Artist
1948 Wins International Prize for Sculpture at Venice Biennale
1955 Awarded the Companion of Honour
1963 Awarded the Order of Merit
1967 *Nuclear Energy* installed at University of Chicago
1977 Henry Moore Foundation inaugurated at Much Hadham
1982 Inauguration of Henry Moore Sculpture Gallery and Centre for the Study of Sculpture at Leeds City Art Gallery
1986 Dies 31 August at Much Hadham

FURTHER READING
David Sylvester, *Henry Moore*, London, 1968
Claude Allemand-Cosneau, Manfred Fath and David Mitchinson (eds.), *Henry Moore: From the Inside Out*, Munich, 2009

left
Henry Moore, *King and Queen*, 1952/1953, bronze, h. 170 cm, W. J. Keswick Collection, Glenkiln

right
Henry Moore working on a sculpture in the garden of Burcroft, Kent, photograph, 1937

LOUISE BOURGEOIS

LEE KRASNER

1871 James Abbott McNeill Whistler
paints *Nocturne: Blue and Gold –
Old Battersea Bridge*

1894 Manchester City Football Club
is formed

1914 Giorgio de Chirico paints
The Song of Love

1933 End of Weimar
Republic

1866 Fyodor Dostoevsky publishes
Crime and Punishment

| 1855 | 1860 | 1865 | 1870 | 1875 | 1880 | 1885 | 1890 | 1895 | 1900 | 1905 | 1910 | 1915 | 1920 | 1925 | 1930 | 1935 | 1940 |

Barbara Hepworth, *Mother
and Child*, 1934, ancaster
stone, 31 x 22 x 20 cm,
Wakefield Museums and
Galleries, West Yorkshire

1960 Yves Klein performs *Le Saut dans le Vide*

1972–73 R. B. Kitaj paints *The Autumn of Central Paris (after Walter Benjamin)*

1952 John Cage's 4'33" premieres in Woodstock, New York

1967 The Beatles release *Sgt. Pepper's Lonely Hearts Club Band*

1989 Fall of Berlin Wall

1945　1950　1955　1960　1965　1970　1975　1980　1985　1990　1995　2000　2005　2010　2015　2020　2025　2030

BARBARA HEPWORTH

Associated with the St Ives community of artists as they rose to international fame after World War II, Barbara Hepworth drew on pre-war ideas of abstraction to produce universal sculptural forms.

Barbara Hepworth helped bring a new abstract, monumental style to English sculpture. Educated at Leeds School of Art and the Royal College of Art in London, she went against the popular style of the 1920s and chose to carve her works, instead of moulding in clay and plaster. She began her career carving her works out of wood and stone; in later years she would also choose to work with bronze. Hepworth's decision to carve was controversial but it was reinforced during two years in Italy, where she studied with the master marble carver, Giovanni Ardini.

Hepworth had her first success in 1927 when the collector George Eumorfopoulos bought two of her works: *Seated Figure* and *Mother and Child*. The latter was the first of Hepworth's several sculptures on the subject of maternal love. It was created shortly after her marriage, and she would return to the theme at crucial moments throughout her life. A year after her sale to Eumorfopoulos, Hepworth took part in her first major exhibition, at the Beaux Arts gallery in London. Initially, she was criticised for her unconventional style and abstract forms, but as she explained in 1934, 'I do not want to make a stone horse that is trying to and cannot smell the air …. In the contemplation of nature we are perpetually renewed … it gives us the power to project into a plastic medium some universal or abstract vision of beauty'.

In 1929 Hepworth gave birth to her first child, Paul. Two years later she separated from her husband John Skeaping and began a relationship with the painter Ben Nicholson. In 1934 she completed *Mother and Child*; it was entirely different from the sculpture of the same name created in 1927. In 1934 she and Nicholson were about to become parents to triplets, and this fluid, abstract sculpture was created during her pregnancy. *Mother and Child* (1934) exemplified Hepworth's new style; since around 1931 she had been experimenting with the techniques she could achieve by carving holes into

her abstract forms, using the holes to exploit fully her medium's shape and texture and to make the holes themselves a sculptural space. The first example of this style was *Pierced Form* (1931; destroyed).

Hepworth was born in Yorkshire and studied at the Leeds School of Art. She moved to London in 1921, and she remained there for many years, working from her studio, The Mall. During the bombing of London in 1940, the studio was damaged and all the works inside it destroyed. Despite her strong connections with Yorkshire, her years spent in London and numerous trips to France and Italy, Hepworth is most closely associated with Cornwall.

Hepworth, Nicholson and the children moved to Cornwall in 1939, initially to visit their friends Adrian Stokes and Margaret Mellis in St Ives. Less than a week after their arrival, World War II began and the family remained in the safety of the seaside village. Ten years after moving to St Ives, Hepworth finally found the studio in which she would remain until the end of her life, Trewyn Studio, 'a sort of magic … a yard and garden where I could work in open air and space'.

In 1954 Hepworth returned to the theme of mother and child while mourning the death of Paul, who had been killed in an aeroplane crash in Thailand. In memory of her eldest child, Hepworth carved *Madonna and Child* for the church in St Ives. *Madonna and Child* is figurative, not abstract, the facial features of both mother and child carefully carved. The sorrowing Madonna has deeply expressive eyes; she holds her baby close but there is still a distance, an awareness that she will be unable to save him. The baby Jesus reaches up to his mother and kisses her cheek in a protective manner, aware that it is he who is giving comfort, not the other way around.

Dame Barbara Hepworth seated in her garden next to one of her sculptures, photograph by Peter Kinnear

1903 Born 10 January in Wakefield, Yorkshire, England

1920–21 Studies at Leeds School of Art, where she meets Henry Moore

1921–24 Studies at Royal College of Art, London

1924 Wins West Riding Scholarship for foreign travel; travels to Italy and lives mainly in Florence

1925–26 Marries the sculptor John Skeaping; lives at the British School in Rome and learns the techniques of marble-carving

1932–33 Exhibits with the 7 and 5 Society; with Ben Nicholson, visits the studios of Picasso, Braque, Brancusi in Paris; joins the Abstraction-Création group; divorces John Skeaping

1934 Exhibits with the Unit One group

1938 Marries Ben Nicholson

1950 Represents Britain at the Venice Biennale

1954 Major retrospective at Whitechapel Gallery, London

1963 Commissioned to produce *Winged Figure* for the John Lewis department store in London

1965 Awarded DBE

1968 Retrospective at Tate Gallery, London

1975 Dies 10 May in accidental fire in her St Ives studio

FURTHER READING
Abraham Marie Hammacher, *Barbara Hepworth*, London, 1987
Penelope Curtis, *Barbara Hepworth*, London, 1999

1880 Fyodor Dostoevsky publishes
The Brothers Karamazov

1881 University College Dublin
is established in Ireland

1903 Death of James Abbott
McNeill Whistler

1936 Walter Benjamin publishes
*The Work of Art in the Age of
Mechanical Reproduction*

1865 1870 1875 1880 1885 1890 1895 1900 1905 1910 1915 1920 1925 1930 1935 1940 1945 1950

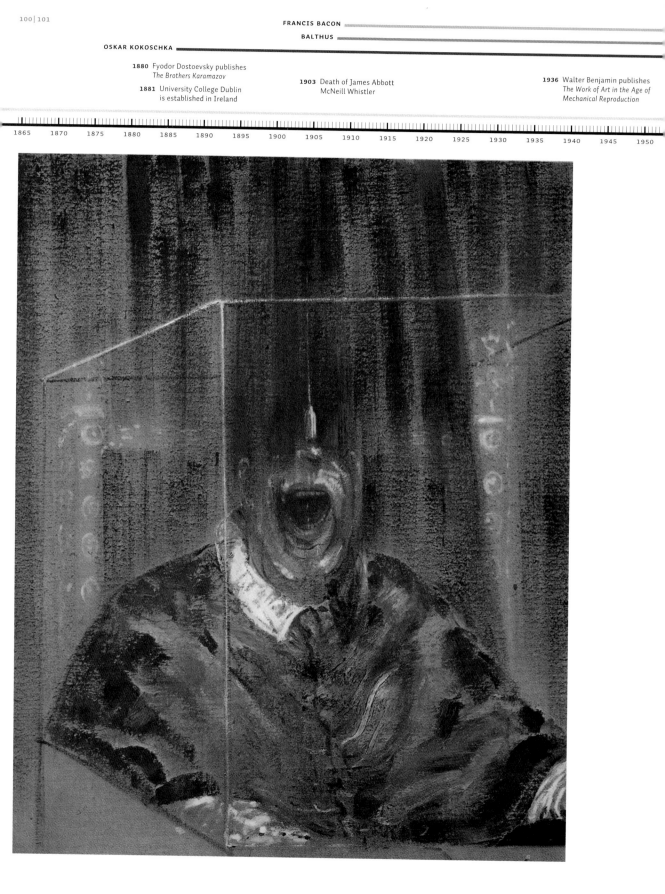

FRANCIS BACON

'I've always hoped ... to be able to paint the mouth like Monet painted a sunset.' Francis Bacon's comment to David Sylvester reveals how the artist placed the human body at the centre of his aesthetic universe. Bacon's vision of existence as violent and often solitary speaks powerfully to late 20th-century preoccupations.

Francis Bacon began his series of 'Head' paintings after World War II, questioning the so-called 'humanity' of the human race. In *Head I* (1948) a distorted man's face is fused with a baboon baring its teeth, in what could be either hatred or agony. Bacon's paintings are often unsettling, his style often criticised, his difficult personality often evoked, but his legacy and contribution to mid 20th-century British art cannot be doubted.

Bacon was born in Dublin to English parents, but he fled to London at the age of 16, before being enticed by 1920s' Berlin. Growing concerned about the way Germany was heading, he left for Paris, before eventually settling in London. He produced his first paintings around 1930 and in 1934 held his first exhibition; it was so badly received that he destroyed most of his work.

As a chronic asthmatic, Bacon was spared army conscription. While stories about the Holocaust made their way to England, Bacon produced his triptych *Three Studies for Figures at the Base of a Crucifixion* (1944). The paintings, influenced by Picasso's *Guernica* and Salvador Dalí, were exhibited in 1945 at London's Lefevre Gallery. The public and critics were horrified, recoiling from this misery and distortion. The triptych, now hailed as a work of genius, proclaimed a new style of angry British art. Bacon became an iconic figure in the London art world and the bohemian haunts of Soho. He was also a regular visitor to Morocco and a key member of the artistic and literary world of Marrakech and Tangier in the 1950s and 1960s.

Bacon was inspired by earlier artists, including Rembrandt, Goya, Poussin, the filmmaker Sergei Eisenstein and the photographer Eadweard Muybridge. *Head VI* was an ironic homage to Velázquez (1599–1660) and formed the basis of Bacon's *Study after Velázquez's Portrait of Pope Innocent X* (1953), nicknamed 'The Screaming Pope'. Bacon's memories of his childhood in a rigidly Catholic Ireland included flashbacks of being locked screaming in a cupboard. Instead of a throne, Bacon's pope sits in an electric chair, his mouth open in terror, the fear felt by those Bacon believed were victims of the Vatican's policies. Bacon's series of pope paintings relate to his fury at the Vatican's collusion with the Nazis. Bacon took this subversion and magnified it, raging at the horrors of religion through the ages. In *Head VI* the top of the pope's head is missing, making the focal point of the painting the wide, yelling mouth — is it screaming or is it sucking the life out of the world?

Religion was one of Bacon's greatest loathings. As a gay man he lived in a world that reviled him for his sexuality. In defiance of Britain's homosexuality laws, he produced many homoerotic paintings including *Untitled (Two Figures in the Grass)* (1952) and *Untitled (Crouching Figures)* (c. 1952). His work formed an essential part of the struggle to change the law, but ironically Bacon was embroiled in a violent relationship with former fighter pilot, drug addict and sadist Peter Lacy.

Famed as much for his alcoholism and personality as he was for his art, Bacon often plagiarised his own life. When his muse and former lover George Dyer committed suicide in Paris in 1971 — two days before a Parisian exhibition of Bacon's work — Bacon created *Triptych May-June 1973*, showing Dyer's death as lonely and unglamorous.

In 1992 Bacon died of a heart attack while on holiday, aged 82. His heir was his long-term companion (although never his lover), John Edwards. When Edwards died in 2003, he left his legacy to the Hugh Lane Gallery in Dublin, the city of Bacon's birth.

left
Francis Bacon, *Head VI*, 1949, oil on canvas, 93 x 77 cm, Arts Council Collection, Southbank Centre, London

right
Francis Bacon photographed by Jorge Lewinski, 1968, Private Collection

1909 Born 28 October in Dublin, Ireland
1927–28 Travels to Berlin and Paris; works as an interior decorator and begins to sketch and paint in watercolours
1937 Exhibits in *Young British Painters* at Agnew's in Bond Street
1948 *Painting 1946* acquired by Alfred H. Barr, Jr. for Museum of Modern Art in New York
1949 First professional solo exhibition at Hanover Gallery in London
1954 With Ben Nicholson and Lucien Freud, represents Britain in the 27th Venice Biennale
1955 First retrospective at Institute of Contemporary Arts in London
1958 Represents Britain at Carnegie International Exhibition of Contemporary Painting and Sculpture in Pittsburgh
1963 Retrospective at Guggenheim Museum, New York
1967 Awarded Rubens Prize; awarded painting prize of the Pittsburgh International Series; refuses to accept any future prizes
1981 Exhibition *A New Spirit in Painting* at Royal Academy of Arts in London
1985 Major retrospective at Tate Gallery, London
1992 Dies 28 April in Madrid

FURTHER READING
Margarita Cappock, *Francis Bacon's Studio*, London, 2005
Wieland Schmied, *Francis Bacon: Commitment and Conflict*, Munich, 2006

GIORGIO DE CHIRICO

MAX ERNST

1937 Pablo Picasso paints *Guernica*

1877 Claude Monet paints
La Gare Saint-Lazare

1903 Wassily Kandinsky paints
The Blue Rider

1921 Albert Einstein awarded
Nobel Prize for Physics

1947 Jackson Poll
produces fir
Drip Painting

| 1865 | 1870 | 1875 | 1880 | 1885 | 1890 | 1895 | 1900 | 1905 | 1910 | 1915 | 1920 | 1925 | 1930 | 1935 | 1940 | 1945 | 1950 |

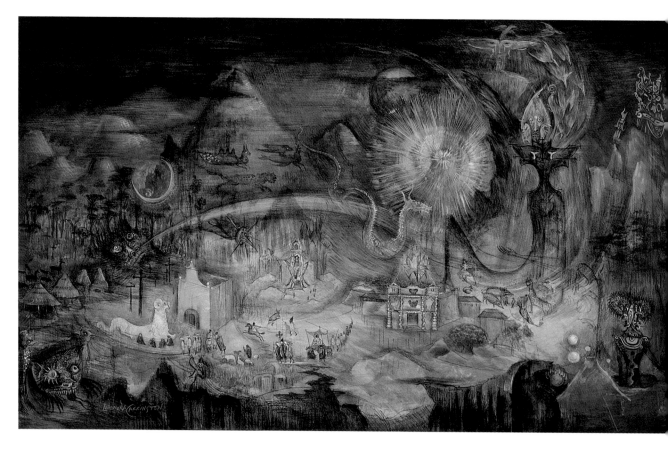

Leonora Carrington, *The Magic World
of the Mayans*, 1963, oil on canvas,
63.5 x 106.5 cm, Galeria Arvil, Mexico

1971 Rothko Chapel is built in Houston, Texas
1980 John Lennon is shot dead in New York City
1970 Death of Bertrand Russell 1991–95 Yugoslav Wars
1977 World's first personal computer
produced by Commodore

1955 1960 1965 1970 1975 1980 1985 1990 1995 2000 2005 2010 2015 2020 2025 2030 2035 2040

LEONORA CARRINGTON

Recent exhibitions have re-discovered Leonora Carrington's work and celebrated her astonishing life. Her place in the history of Surrealism and the canon of women artists is now assured.

Although she has lived in Mexico for most of her adult life, Leonora Carrington was born in Lancashire, England, at the height of World War I. She was the daughter of wealthy parents: her father had made his money in the textile industry, and Carrington grew up in a country mansion, Crookhey Hall, surrounded by fields and cared for by servants. One of her most important childhood influences was her Irish nanny, whose tales would inspire Carrington's art.

Carrington was troubled, even as a child. Her Irish mother was a strict Catholic who found her daughter's rebellious behaviour unfathomable. Carrington was sent to boarding school twice; both times she was expelled for unruly behaviour. After stints at finishing schools in France and Italy — where she spent as much of her time as possible in art galleries — her parents agreed to allow her to study art. She attended Chelsea Art School and the newly created Ozenfant Academy for Art.

As a debutante, Carrington was presented to King George V and had a lavish coming-out ball at The Ritz, but instead of finding herself a suitable husband, Carrington fell in love with someone else's husband and ran away to Paris to live with him. Her lover was the Surrealist Max Ernst, more than 20 years her senior. Her first 'true' Surrealist painting was *Self-Portrait (Inn of the Dawn Horse)* (1938). Many of her works feature horses. Other popular subjects include magnificent birds, figures that are half-human and half-animal, sinister beings in masks, and coven-like groups of woman, often cooking together. The world she painted was a realm of mystery, myth and magic, a glimpse into the deepest recesses of her imagination. Her paintings reflect her life and her emotions — at times evoking a sinister, frightening atmosphere, at other times appearing nurturing and kindly.

At the start of World War II, Ernst was arrested by the Nazis and imprisoned; he escaped and fled to America with his new lover, Peggy Guggenheim.

Carrington's mental health had never been strong and the loss of Ernst coupled with the war pushed her into a breakdown. Her elopement had led to her family disowning her and she was alone and friendless. Fleeing the Nazis, she arrived in Spain via a violent and terrifying journey. She was declared insane and incarcerated in a brutal and inept psychiatric hospital; the experience would inform her art for years to come.

Carrington is also an author. She has written a number of short stories and the novellas *The Hearing Trumpet* and *The Stone Door*. Her memoirs, *Down Below*, have the same title as one of her paintings — both works referred to her life in the asylum.

After escaping from the asylum, by climbing out of a window, Carrington sought out the Mexican diplomat and poet Renato Leduc, a friend of Picasso's whom she had met in Paris. They married and Carrington immediately left Europe. In Mexico, Carrington divorced Leduc and, within a few years, had married the photographer Chiki Weisz, with whom she had two sons.

In 1943, Carrington's work was exhibited in New York; in 1948 she had her first solo show. Since then her art has continued to be shown across the world, especially in her adopted country of Mexico, although she is far less famous in her native Britain than her Surrealist friends, who included Man Ray, Joan Miró, Lee Miller, Pablo Picasso and Salvador Dalí.

Throughout her career, Carrington has made a living from selling her art; her millionaire father left his rebellious daughter nothing in his will. In 2000, Carrington was awarded an OBE. In 2009, her most famous painting, *The Giantess*, sold for the record price of US$1.5 million.

1917 Born 6 April in Clayton Green, Lancashire, England
1936 Visits International Surrealist Exhibition in London and sees the work of Max Ernst; enrols at the Amédée Ozenfant Academy for Art in London
1937 Begins a relationship with Max Ernst after meeting at a party in London; moves to Paris with him
1938 Moves with Ernst to Saint Martin d'Ardèche in the South of France
1940 Suffers mental breakdown and enters asylum in Santander, Spain, after Ernst is interned by the French government as a German National
1941–42 Moves to New York; active in the Paris Surrealist Group
1942 Moves to Mexico City; meets Remedios Varo
1948 Solo exhibition at Pierre Matisse Gallery, New York
1960 Retrospective at Museo Nacional de Arte Moderno in Mexico City
1972 Begins working on posters for feminist groups in Mexico and the US
1980s Lives in Chicago where she contributes to the activities of the Chicago Surrealist Group
1992 Returns to Mexico

FURTHER READING
Susan L. Aberth, *Leonora Carrington: Surrealism, Alchemy and Art*, London, 2010
Stefan van Raay, Joanna Moorhead and Teresa Arcq, *Surreal Friends: Leonora Carrington, Remedios Varo and Kati Horna*, London, 2010

Leonora Carrington, photograph

1883 The Brooklyn Bridge is completed

1915–23 Marcel Duchamp produces *The Bride Stripped Bare by Her Bachelors, Even*

1905 Henri Matisse paints *Portrait of Madame Matisse (The Green Line)*

1925 F. Scott Fitzgerald publishes *The Great Gatsby*

1946 Founding UNESCO

1865 1870 1875 1880 1885 1890 1895 1900 1905 1910 1915 1920 1925 1930 1935 1940 1945 1950

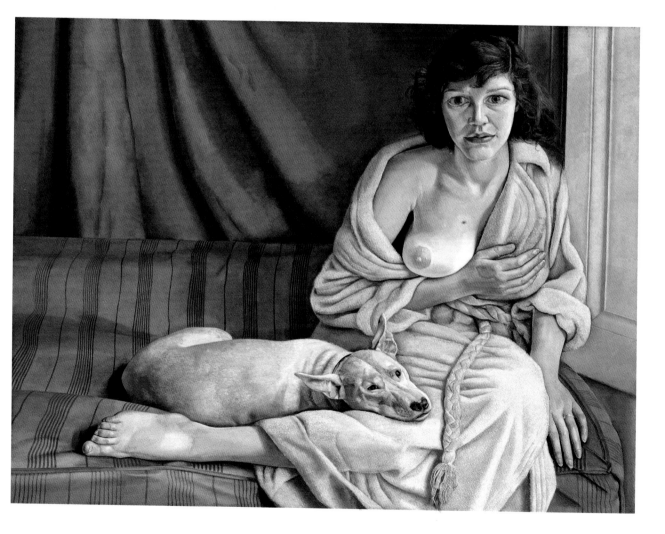

Lucian Freud, *Girl with a White Dog*,
1950–51, oil on canvas, 76.2 x 101.6 cm,
Tate Gallery, London

1974 Joseph Beuys performs *I Like America and America Likes Me*

1991 The World Wide Web is released for general use

1993 Peter Doig paints *Blotter*

1959 Opening of the Solomon R. Guggenheim Museum in New York

1984 Malcolm Morley wins first Turner Prize

1955 1960 1965 1970 1975 1980 1985 1990 1995 2000 2005 2010 2015 2020 2025 2030 2035 2040

LUCIAN FREUD

'As far as I am concerned the paint is the person. I want it to work for me just as flesh does.' Lucien Freud paints portraits and nudes in ways which emphasize the fragile, transient human condition. He is considered by many to be the greatest living figurative painter of our age.

Lucian Freud, the grandson of Sigmund Freud, was born in Berlin in 1922. His family emigrated to England in the early 1930s. He studied at the Central School of Arts in London and the East Anglian School of Painting and Drawing in 1939 — the same year in which he was granted British nationality. Two years later he joined the Merchant Navy, which he was forced to leave through ill health in 1942. For the next two years he concentrated on his painting, holding his first solo exhibition at London's Lefevre gallery in 1944. He would go on to become a visiting tutor at the Slade School of Fine Art and, in 1954, he was chosen to represent Britain at the Venice Biennale.

When World War II was over, Freud spent several months travelling through Europe. On returning to London, he moved in a world of creative, often pretentious people, a clique into which he was welcomed for his famous name, as well as his art. His earliest works were often compared to the Surrealists, partly through a lack of available models which forced him to paint inanimate objects, but by the early 1950s, he had begun to concentrate on portraiture: 'I paint people not because of what they are like...but how they happen to be'. He also painted landscapes, usually urban scenes, such as *Interior in Paddington* (1951), which was awarded a prize at the Festival of Britain.

Shortly after his return to England, Freud fell in love with Kitty Garman, the niece of one of his former lovers; she was also the daughter of Jacob Epstein. They married in 1948 and Kitty became, for a while, his muse. She appears in a number of his paintings, including *Girl with a White Dog* (1950–51) in which she seems intensely vulnerable, her right breast exposed and a look of shock and sadness on her face. Her left hand rests limply at her side, displaying her simple wedding ring. The dog's expression is as contemplative as its owner's. By the time of this painting, the marriage was in trouble. The couple had two children, but their relationship

was doomed by Freud's obsessive need to chase other women, as well as his addiction to gambling. By 1952 he was divorced from Kitty whereupon he married Lady Caroline Blackwood. The marriage lasted for just four years. As a result of numerous affairs, Freud is known to have fathered at least 16 children. *Pregnant Girl* (1960–61) shows his mistress Bernardine Coverley pregnant with his daughter Bella.

Obsession was not confined to his sex life: Freud became equally obsessed with subjects and themes, resulting in a number of famous series of paintings. In the 1970s he painted his mother again and again, in a variety of poses, many of which emphasise the depression into which she had sunk as well as her isolation as a widow and as the mother of children who were refusing to speak to one other. Some years later Freud began a series of portraits of Australian transvestite performance artist Leigh Bowery.

For over half a century, Lucian Freud conducted a very public dispute with both of his brothers, Stephen Freud, the owner of a hardware business, and journalist and radio presenter Sir Clement Freud. In 2008 the artist claimed he had rejected a knighthood because 'my younger brother has one of those'. Seven years earlier he had painted a celebrated — if unflattering — portrait of Queen Elizabeth II. He gave it to the monarch in gratitude for Britain's welcome of his family, when they arrived as Jewish refugees fleeing the Nazis: 'If it wasn't for [the queen] I would have ended up in the ovens'.

1922 Born 8 December in Berlin, Germany
1933 Moves with his family to England to escape the Nazis
1938–39 Studies at the Central School of Arts in London
1939 Has drawings published in *Horizon* magazine; becomes a British citizen
1941–42 Serves as merchant seaman
1942–43 Studies part-time at Goldsmiths College, London
1944 First solo exhibition at the Alex Reid & Lefevre Gallery in London
1949–54 Appointed visiting tutor at the Slade School of Fine Art, University College London
EARLY 1950S Associated with group referred to as The School of London by R.B. Kitaj; begins painting portraits and nude studies
1951 *Interior at Paddington* wins the Arts Council Prize at the Festival of Britain
LATE 1960S Focuses on the female nude
1974 First retrospective organised by the Arts Council of Great Britain at the Hayward Gallery in London
LATE 1970S Focuses on the male nude
1989 Shortlisted for the Turner Prize
1993 Awarded Order of Merit
2002 Large retrospective at Tate Britain

FURTHER READING
Robert Hughes, *Lucian Freud: Paintings*, London, 1989
William Feaver, *Lucian Freud*, New York, 2007

Lucian Freud, photograph by Harry Diamond, Private Collection

1889 Paul Gauguin paints
The Yellow Christ

1902 Gustav Klimt paints
the *Beethoven Frieze*

1928 *Plane Crazy*, first Mickey
Mouse cartoon

1894 Rudyard Kipling publishes
The Jungle Book

1938 Jean-Paul Sartre publishes
La Nausée

1865　1870　1875　1880　1885　1890　1895　1900　1905　1910　1915　1920　1925　1930　1935　1940　1945　1950

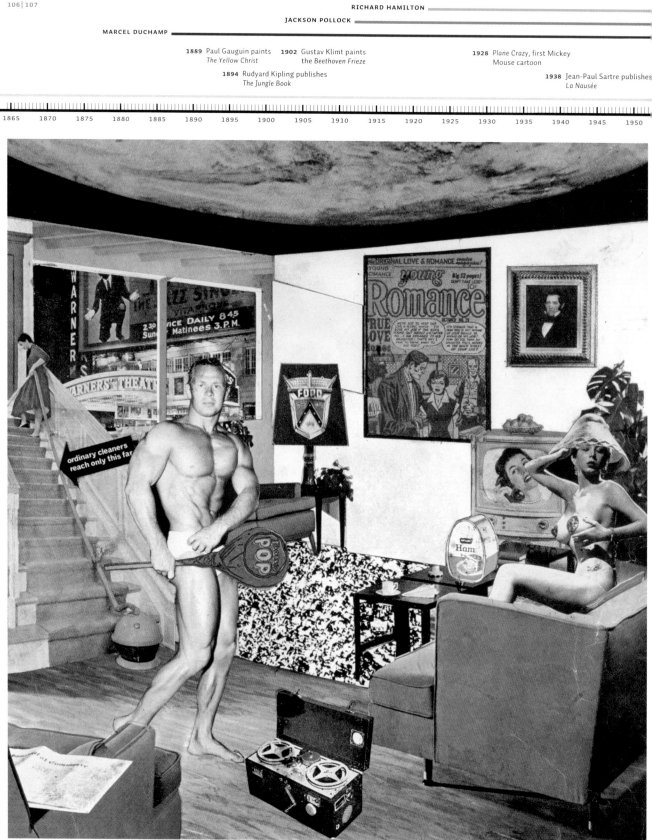

1969 First Concorde flight

1962 Andy Warhol has first solo exhibition at the Ferus Gallery in Los Angeles

1985 Robert Zemeckis' *Back to the Future* is released

1992 Death of John Cage

1977 Jenny Holzer begins working on *Truisms*

1955 1960 1965 1970 1975 1980 1985 1990 1995 2000 2005 2010 2015 2020 2025 2030 2035 2040

RICHARD HAMILTON

A seminal British Pop artist, Richard Hamilton's work from the very beginning understood the powerful role of images in the contemporary world of media and marketing.

At the age of 16, London-born Richard Hamilton entered the Royal Academy schools. He had already taken evening classes at Westminster Technical College and he felt confident of a glittering career — he was already earning money as a freelance artist in the world of advertising — but his artistic dream was interrupted. Hamilton had enrolled at the RA schools in 1938, the year before Britain went to war with Germany; two years later he had his 18th birthday and was recruited by a government training centre. He was trained as an engineering draughtsman and worked for the government until 1945.

At the age of 24, with the war finally over, Hamilton went back to the Royal Academy, attempting to start at the point where his career had been interrupted. He was not considered perfect RA material, infuriating his tutors by the lack of interest he showed in the drawing classes; within a few months he had been expelled. In 1948 Hamilton enrolled at the more progressive Slade School of Fine Art, where he remained for three years. During this time, he held his first one-man show, an exhibition of his engravings, at Gimpel Fils in London in 1950.

Two years after this solo exhibition, Hamilton teamed up with a group of fellow young artists and founded the Independent Group, also known as the IG. The group was formed at the Institute of Contemporary Arts (ICA) in London and was composed of artists, architects and writers; his fellow members included Eduardo Paolozzi, Nigel Henderson and William Turnbull. They were amongst the first artists in Britain to embrace Pop art and Hamilton would become one of its most famous British exponents. The Independent Group held its first exhibition, *Parallel of Art and Life* in 1953; three years later it staged *This is Tomorrow*, the exhibition that forced the artists' names into the public consciousness. The work that catapulted Hamilton to fame was his 1956 collage *Just what is it that makes today's homes so different, so appealing?* It was created originally as the poster for *This is Tomorrow*, but it

became a work of art in its own right and is often described as the very first work of British Pop art. Hamilton became more famous after designing the cover for The Beatles' much-coveted *White Album* (1968).

Hamilton's influence was disseminated out to a younger generation through his teaching. He taught in London, at the Central School of Arts and Crafts, as well as at the university in Newcastle-upon-Tyne. One of his own major influences was Marcel Duchamp, whom Hamilton came to know well. A couple of years before Duchamp's death, they worked together on a version of Duchamp's *The Bride Stripped Bare by her Bachelors, Even*.

Throughout his career, Hamilton has produced controversial, irreverent and witty works, such as *Swingeing London* (1967–72), *The Citizen* (a series about IRA hunger strikes) and *Shock and Awe* (2007), which saw Tony Blair as a cowboy. Throughout the 1960s, Hamilton experimented with photography and painting; in the 1980s he began working with computers. He always kept up his love of printmaking and, in 1983, he won the World Print Council Award.

In 1991, Hamilton married his long-term partner, fellow artist Rita Donagh. The next year, in honour of the artist's 70th birthday, the Tate gallery held a major retrospective of his work. Hamilton later commented 'almost every critic hated it', but in the following year he was chosen to represent Britain at the Venice Biennale. In 2003, Hamilton collaborated on a show with the Museum Ludwig in Cologne; the exhibition was called *Introspective*. In 2010, the Serpentine Gallery in London hosted *Modern Moral Matters*, an exhibition that encompassed his work from 1963 into the 21st century.

1922 Born 22 February in London, England
1938–40 Studies at the Royal Academy of Arts in London
1941–45 Works as an industrial designer
1948–51 Studies at the Slade School of Art in London
1952 Introduced to Eduardo Paolozzi's collage work at the first Independent Group meeting at the Institute of Contemporary Arts in London
1953–66 Teaches Fine Art at Durham (later Newcastle) University
1957–61 Teaches at the Royal College of Art where he promotes David Hockney and Peter Blake
1966 Organises retrospective of Marcel Duchamp's work at the Tate Gallery in London
LATE 1960S Produces sleeve design and poster collage for The Beatles' *White Album*
1981 Begins producing work based on the conflicts in Northern Ireland
1992 Major retrospective at the Tate Gallery
1993 Represents Britain at the Venice Biennale, where he is awarded the Golden Lion
2002 Exhibition of illustrations of James Joyce's *Ulysses* at the British Museum in London

left
Richard Hamilton, *Just what is it that makes today's homes so different, so appealing?*, 1956, collage, 26 x 23.5 cm, Kunsthalle Tübingen

right
Richard Hamilton, photograph

FURTHER READING
Richard Hamilton, *Richard Hamilton: Painting by Numbers*, London, 2007
Hal Foster, *Richard Hamilton (October Files)*, Cambridge, Massachusetts, 2010

1937 Howard Hughes sets record time for
flying from Los Angeles to New York

1953 Edward Hoppe
Office in a Sma

1899 A. C. Milan is founded

1914 Beginning of World War I

1945 United States drop atomic bomb
on the Japanese cities of Hirosh
and Nagasaki

1875	1880	1885	1890	1895	1900	1905	1910	1915	1920	1925	1930	1935	1940	1945	1950	1955	1960

Eduardo Luigi Paolozzi, *Head of an Actor
(for Luis Buñuel)*, 1984, bronze, h. 33 cm,
The Sherwin Collection, Leeds

1995 South Africa wins Rugby World Cup

1979 Douglas Adams publishes
The Hitchhiker's Guide to the Galaxy

2002 Francis Alÿs organises
When Faith Moves Mountains

1990–91 First Gulf War

1986 Pixar Animation Studios is opened

| 1965 | 1970 | 1975 | 1980 | 1985 | 1990 | 1995 | 2000 | 2005 | 2010 | 2015 | 2020 | 2025 | 2030 | 2035 | 2040 | 2045 | 2050 |

EDUARDO PAOLOZZI

His public works are well-loved in Scotland and England, from his sculpture outside the British Library to the doors of Glasgow's Hunterian Gallery. Eduardo Paolozzi brought European, and particularly Surrealist, influences into his oeuvre.

Eduardo Paolozzi was born in Leith, Scotland, the son of Italian immigrants; he grew up above his parents' ice-cream shop, where, alongside the hours he spent serving customers as a child, he discovered a love of drawing. He intended to become a commercial artist, but with the coming of World War II, Paolozzi's world changed forever. His father, a fervent admirer of Mussolini who retained strong ties with his native Italy, was placed under arrest as an 'enemy alien' and, together with the artist's grandfather and uncle, was deported to Canada. All three men died when the ship carrying them to Canada was torpedoed. Eduardo Paolozzi, who was just 15 when the war began, was also regarded as an enemy alien and held in Saughton Prison in Edinburgh for three months. On his release, Paolozzi joined the Royal Pioneer Corps, a regiment that was actively recruiting Austrians, Germans and Italians who had made Britain their home before the war.

His military career was shortlived and, in 1943, Paolozzi was able to start on the road he had planned several years earlier; he began attending evening classes at the Edinburgh College of Art. A year later he moved to London, at the height of the bombing raids on the city, to attend St Martin's School of Art. A year later, he was accepted into the Slade School of Fine Art (which had relocated to Oxford during the war). He was an artistic polyglot: a sculptor, a painter, a mosaicist, a printmaker, a collagist and a filmmaker, as well as an accomplished writer.

Paolozzi remained at the Slade for two years, until 1947, the year in which his first solo exhibition was held, at the Mayor Gallery in London. In the same year he left England for Paris. He studied at the Ecole des Beaux-Arts for a short time, but Paris's main influence on the young artist was not its art schools, but the people he met, including the artists Alberto Giacometti, Jean Arp and Constantin Brancusi, and the soldiers of several nations still stationed in the city to deal with the aftermath of

the German occupation. Paolozzi's two years in Paris were an international education, a rich source of artistic subject material.

He returned to Britain in 1949, settling in London where he began teaching and became a prominent member of the Independent Group, he was also one of the first artists to bring Pop art to Britain — albeit a very individual style of Pop art, largely influenced by the American servicemen he met while living in Paris. The Independent Group was formed at the ICA in the winter of 1952–53. Paolozzi worked closely with the group, especially Nigel Henderson and William Turnbull; he also shared a studio with Lucian Freud.

Two years after returning to Britain, Paolozzi married the textile designer Freda Elliott; the couple had three daughters. Married to an Englishwoman and living mainly in London, Paolozzi was determined to make the British people aware of his name and work and undertook hundreds of commissions for public works of art. These include the mosaics at Tottenham Court Toad tube station in central London (1980) and the Kingfisher shopping centre in Redditch (1983), as well as the monumental statue of Newton outside the rebuilt British Library (1995). In 1960 he was chosen to represent Britain at the Venice Biennale. In 1989 he was honoured by a knighthood from the queen. In 1994, to mark Paolozzi's 70th birthday, the Yorkshire Sculpture Park held an exhibition of his works.

Paolozzi died at the age of 81, after battling a long illness. The last time he went out in public was to a retrospective of his own work, at the Flowers East Gallery, in London's West End in April 2005.

1924 Born 7 March in Edinburgh, Scotland

1940 Interned at Saughton Prison when Italy declares war on Britain

1943 Studies at Edinburgh College of Art

1944–47 Studies at the Slade School of Fine Art, London

1947–49 Lives in Paris; meets Giacometti, Brancusi and Braque

1952 Co-founds the Independent Group in London; Paolozzi displays his collage *I was a Rich Man's Play Thing* at the ICA in London

1955–88 Teaches sculpture at St Martin's School of Art

1956 Contributes to *This is Tomorrow* exhibition at Whitechapel Gallery, London

1964 Solo exhibition at the Museum of Modern Art in New York

1977–81 Serves as a Professor in Ceramics at the Fachhochschule in Cologne, Germany

1979 Elected Royal Academician

1980–86 Designs mosaic patterns for Tottenham Court Road Station

1999 National Galleries of Scotland open the Dean Gallery where Paolozzi's gifted works are held

2005 Dies 22 April in London

FURTHER READING
Daniel Herrmann, Robin Spencer and Richard Cork, *Eduardo Paolozzi: Projects 1975–2000*, London, 2005
Fiona Pearson, *Paolozzi*, Edinburgh, 1999

Eduardo Luigi Paolozzi, photograph by Jorge Lewinski

1899 F. C. Barcelona is founded

1902 Joseph Conrad publishes
Heart of Darkness

1922 Benito Mussolini becomes
Prime Minister of Italy

1944 Birth of writer Alice Walker

1953 Death of
Joseph Stalin

1875	1880	1885	1890	1895	1900	1905	1910	1915	1920	1925	1930	1935	1940	1945	1950	1955	1960

Elisabeth Frink, *Seated Man*,
bronze, Private Collection

1968 Marcel Broodthaers presents *Musée d'Art Moderne, Départment des Aigles*

1991 Boris Yeltsin becomes the first President of the Russian Federation

1981 Richard Serra produces *Tilted Arc*

1982 Lebanon War

1975 Jorge Luis Borges publishes *El libro de arena*

1965 1970 1975 1980 1985 1990 1995 2000 2005 2010 2015 2020 2025 2030 2035 2040 2045 2050

ELISABETH FRINK

Elisabeth Frink's aesthetics were greatly influenced by the experience of World War II. Her depictions of the human and the animal world express both the vulnerability and nobility of wartime.

Elisabeth Frink was born into a military family who lived in rural Suffolk. Her father was an officer in the 7th Dragoon Guards and had previously served in India. She grew up close to an airbase and, as a child during World War II, was terrified by a German raid on the airbase which rained bombs around her home. At the end of the war she was traumatised by watching footage from the freed concentration camps. These horrors never left her, and as an adult she became actively involved in fighting social injustice and was an active member of Amnesty International.

The countryside childhood that Frink enjoyed left her with a lifelong love of animals. She learned to ride at a very young age and horses appear again and again in her work, as do dogs, birds and the male body — she made very few portraits or sculptures of women, as she commented in later life, 'I have focused on the male because to me he is a subtle combination of sensuality and strength with vulnerability'. Her earliest work, still scarred by war, focuses on subjects such as wounded birds and fallen riders.

At the age of 17, Frink enrolled in the Guildford School of Art, where she remained for two years. In 1949, she began four years at the Chelsea School of Art, where she was taught by Bernard Meadows. While still a student, at the age of 22, she held her first major exhibition, at the Beaux Arts Gallery in London. The exhibition was well received and Frink's talent recognised by the art dealers; *Bird* (1952) was bought by the Tate Gallery. She became in great demand as a teacher as well as an artist. When she graduated, in 1953, she was immediately offered a teaching post at Chelsea; she also taught concurrently at St Martin's School of Art and the Royal College of Art.

In 1952, Frink was associated with a group of fellow sculptors including Eduardo Paolozzi and Kenneth Armitage, who had become known as the 'Geometry of Fear school'. The name had been created by critic Herbert Read following the exhibition of British sculpture displayed at the Venice Biennale in 1952. Frink always resisted, however, being labelled as part of any particular group.

One of Frink's favourite themes was *Running Man* — sculptures of tall, lithe virile nudes, 'my *Running Men* are not athletes: they are vulnerable, they are running away from something, or towards it'. Frink also took inspiration from art she encountered on her travels, such as ancient Greek and Roman sculpture and paintings by Aboriginal Australian artists. In 1967, Frink moved to France, where she remained for five years, before returning to her native England. Wherever she was living, she became passionate about the local landscape and was strongly in favour of creating sculpture gardens.

In addition to sculpting, Frink was a talented graphic artist, painter and etcher. She also created book illustrations of *The Iliad*, *The Odyssey*, *Aesop's Fables* and *The Canterbury Tales*. Frink was married three times. She married Michael Jamnet in 1955, with whom she had a son; the marriage lasted for six years. In 1964, she married Edward Pool; they divorced ten years later. Her third husband was Alex Csaky, whom she married in 1975. They moved to Dorset, a place she grew to love as much as Suffolk. They remained together very happily for 18 years, until Csaky died from cancer in 1993; Frink died, also of cancer, a few months later.

1930 Born November 14 in Thurlow, Suffolk, England

1953–61 Teaches at Chelsea School of Art

1954–62 Teaches at St Martin's School of Art, London

1955 First solo exhibition at St George's Gallery in London

1958 Joins Waddington Galleries in London

1965–67 Serves as a visiting lecturer at the Royal College of Art, London

1967–70 Lives in France; begins working on 'goggled heads' series

1968 Produces illustrations for *Aesop's Fables*

1969 Awarded CBE

1972 Produces illustrations for Geoffrey Chaucer's *The Canterbury Tales*

1982 Awarded DBE

1985 Retrospective at the Royal Academy of Arts in London

1993 *Risen Christ* installed at Liverpool Cathedral; dies 18 April in Blandford, Dorset, England

1996 Frink School of Figurative Sculpture opens in Longton

2005 Frink School of Figurative Sculpture closes in Tunstall

FURTHER READING
Bryan Robertson, *Elisabeth Frink: Sculpture*, Salisbury, 1985
Edward Lucie-Smith, *Elisabeth Frink: Sculpture Since 1984 and Drawings*, London, 1994

Elisabeth Frink, photograph by Jorge Lewinski, 1973

1918 End of World War 1

1938 Constantin Brâncuși creates
The Endless Column

1891 New Scotland Yard becomes the HQ
of the London Metropolitan Police

1923 First issue of *Time* magazine
published

1954–55 Jasper Johns
paints *Flag*

1880	1885	1890	1895	1900	1905	1910	1915	1920	1925	1930	1935	1940	1945	1950	1955	1960	1965

Bridget Riley, *Untitled (screenprint)*,
screenprint, 100 x 77 cm, Imperial
College Healthcare Charity Art
Collection, London

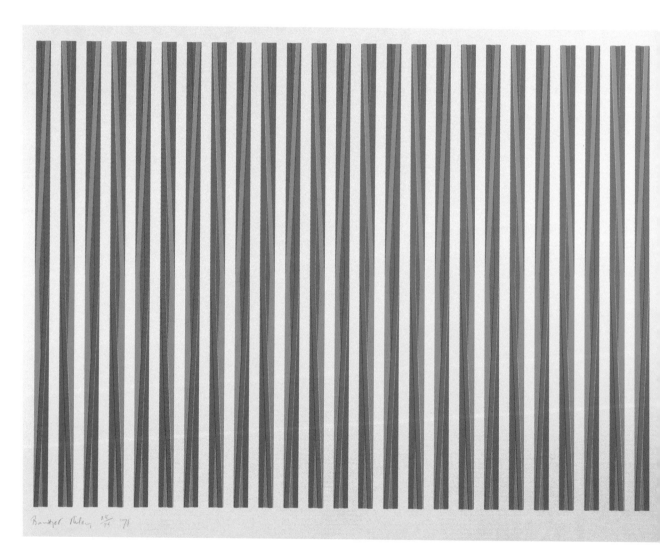

1972 Vito Acconci performs *Seedbed*
1987 *The Simpsons* first broadcast
1976 Apple Computer Company is founded
1992 Death of Isaac Asimov
1982 Canada gains independence from United Kingdom

1970　1975　1980　1985　1990　1995　2000　2005　2010　2015　2020　2025　2030　2035　2040　2045　2050　2055

BRIDGET RILEY

In a career lasting over half a century so far, Bridget Riley's work has defined high Modernism both in Britain and internationally. Her themes of colour, geometry and visual experimentation are rendered in forms which have a timeless appeal.

Bridget Riley was born in London but spent her childhood in Cornwall, Buckinghamshire and Cheltenham, nurturing a love of nature. The change-ability of the natural world is something she seeks to recreate in her art: 'The eye can travel over the surface in a way parallel to the way it moves over nature…. One minute there will be nothing to look at and the next second the canvas seems to refill, to be crowded with visual events'.

At the age of 18, Riley returned to London to study at Goldsmiths College of Art, where she was taught by Sam Rabin. In 1952, she graduated to the Royal College of Art. Riley was fascinated with the idea of optical illusions, the way in which art can be used to trick the eye and mind and how images can be manipulated; it is perhaps unsurprising that one of her first employers was the advertising agency J. Walter Thompson. By the end of the 1950s, Riley had developed a passion for overseas travel and, in 1964, she used her Peter Stuyvesant Foundation Travel Bursary, to spend time in Greece. Initially Riley's artistic journeys were confined to Europe, but during the 1970s she began to journey further afield, making regular trips to Asia. In 1979–80 Riley visited Egypt, where she became fascinated by ancient Egyptian art and the role it played in their rituals of life and death.

Riley became famous as one of the first exponents of the 1960s phenomenon Op Art ('Op' being short for 'optical'). Often relying on geometrical shapes, intense monochrome or challengingly bright colours, Op Art confuses the viewer's eye, draws the viewer in and challenges optical perceptions. Works such as *Hidden Squares* (1961), *Descending* (1965) and *Cataract 3* (1967) made Riley famous. At a time when most artists were deliberately eschewing the idea of preparatory work, Riley became notable for the exhaustive amount of preparation she undertook. As she explained, painting directly onto the canvas would have been impossible: 'The structure of my paintings has to be precisely balanced. They need

immaculate execution. I have to build up a bank of visual information first'.

Riley's earliest works were almost exclusively monochrome — from 1960 until 1967 she used no colour in her paintings at all. By the 1970s, however, she had begun experimenting with colours, fascinated by the way a certain hue could seem to change one's visual perceptions of lines and shapes. Riley uses colour not simply as colour but as a way of conveying light: 'I don't paint light. I present a colour situation which releases light as you look at it'. As she began moving away from monochrome, initially Riley allowed herself to use only three colours per painting; by the late 1970s, she had expanded to five colours per painting, first seen in *The Song of Orpheus* (1978).

Riley's work received constant acclaim, but throughout the 1980s her name was renowned mostly amongst people of her own generation. In the 1990s she suddenly burst back into the limelight, attracting a new generation of followers. In one decade, Riley retrospectives were held at London's Hayward Gallery (1992), the Tate Britain (1994) and the Serpentine Gallery (1999). In 2010–2011 the National Portrait Gallery in London showed a new side to Riley's art, with *From Life*, an exhibition of Riley's early portraits.

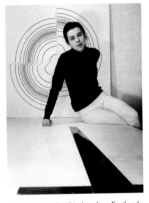

1931 Born 24 April in London, England
1949–52 Studies at Goldsmiths College
1952–55 Studies at the Royal College of Art with Peter Blake and Frank Auerbach
1957–58 Teaches art at the Convent of the Sacred Heart in Harrow
1959 Teaches art at Loughborough School of Art and Hornsey School of Art
1960s Develops signature Op Art style
1962 First solo show at Gallery One in London
1962–64 Teaches art at Croydon School of Art
1965 Exhibits in *The Responsive Eye* at the Museum of Modern Art in New York
1967 Begins experimenting with colour
1968 Represents Britain at the Venice Biennale; awarded International Prize for Painting
LATE 1960s Creates the SPACE arts organisation with Peter Sedgley
1981–88 Serves as a trustee of the National Gallery in London
1994 Retrospective at the Tate Gallery in London
2002 Co-curates *Paul Klee: the Nature of Creation* with Robert Kudielka at the Serpentine Gallery in London

FURTHER READING
Paul Moorhouse (ed.), *Bridget Riley*, London, 2003
Robert Kudielka (ed.), *The Eye's Mind: Bridget Riley: Collected Writings 1965–2009*, London, 2009

Bridget Riley, photograph by Jorge Lewinski, 1964

1888 Vincent van Gogh paints
Cafe Terrace at Night

1915 Franz Kafka publishes
The Metamorphosis

1931 *The Star-Spangled Banner* is adopted
as the US National anthem

1948 Andrew Wyeth paints *Christina's Wor*

1958–59 Salvador [
paints *The Dis*
of America by
Christopher Co

1880 1885 1890 1895 1900 1905 1910 1915 1920 1925 1930 1935 1940 1945 1950 1955 1960 1965

Frank Auerbach, *E.O.W. Sleeping*,
1966, oil on board, 38 x 60 cm,
Private Collection

1977 Woody Allen's *Annie Hall* is released **1997** *Sensation* opens at the Royal Academy of Art in London

967 Gabriel García Márquez **2000** Wolfgang Tillmans wins Turner Prize
One Hundred Years of Solitude
 1986 Kazuo Ishiguro publishes
 An Artist of the Floating World

| 1970 | 1975 | 1980 | 1985 | 1990 | 1995 | 2000 | 2005 | 2010 | 2015 | 2020 | 2025 | 2030 | 2035 | 2040 | 2045 | 2050 | 2055 |

FRANK AUERBACH

Frank Auerbach's figurative work echoes the vigour and handling of paint of the German Expressionists, but his themes are rooted in London, his adopted city.

Eight years before the start of World War II, Max and Charlotte Auerbach, a Jewish couple, were living in Berlin with their new baby, Frank Helmut. Max was a chemist and a patents lawyer with what seemed to be a successful career ahead; Charlotte was an art student. In 1939, the couple made the decision to send their son to England, hoping he would be safe. Just before his eighth birthday, Frank Auerbach sailed on the SS *George Washington*. Like many refugee children, he was sent to Bunce Court boarding school in Kent (although the school was evacuated to Shropshire during the worst of the bombing). He never saw his parents again — they were murdered in Nazi concentration camps.

By the late-1940s, Auerbach was living in London, having decided to become an artist. He took evening classes at Borough Polytechnic, where he was fortunate to be taught by David Bomberg. Soon, he had been accepted into St Martin's School of Art and, in 1952, he began three years at the Royal College of Art. Many of his earliest paintings are of bombed London streets, destroyed buildings and gaping holes where communities had once lived. He would later recall travelling around the city on buses through whose windows he would see 'sites of bombed buildings with the pictures still on the walls, the fireplaces and so on'; he compared it to a 'marvellous mountain landscape'. London became his muse, the place in which he felt safe and at home. He immortalised his muse constantly on canvas: 'I feel London is this raw thing. A higgledy piggledy mess of a city'.

In 1954, he began renting a studio in the Mornington Crescent area of North London, a studio that had previously been rented by his friend Leon Kossoff. Auerbach has remained there ever since, painting numerous pictures of the Mornington Crescent area, just as Walter Sickert, Spencer Gore and other members of the Camden Town Group had done at the start of the 20th century. His first solo show was at the Beaux Arts Gallery in London,

owned by Helen Lessore. Critics were not altogether complimentary, with many bemused by his application of extremely thick paint onto canvases, a technique that has now become one of his most respected trademarks.

Auerbach paints obsessively, often beginning a new painting day by obliterating much of what he had produced the day before and starting again. As a result, many of his works have taken years to complete. On occasion, he has bought his own works at auction because, on seeing them again, he decided they were not good enough and needed to be improved upon. He does not just paint vivid landscapes, he is also a portrait painter. He has three favourite models whom he has painted repeatedly: professional model Juliet Yardley Mills, known as 'J.Y.M.'; actress and Auerbach's longterm lover Stella West, known as 'E.O.W'; and his wife Julia. Auerbach does paint other models, including men, but his three favourite models dominate his portraiture. Stella, who had been widowed shortly before she met Auerbach, has three daughters, who have also modelled for the artist.

The affair with Stella was disrupted when Auerbach married Julia in 1958. Shortly afterwards Julia gave birth to a son, Jake, but the marriage was scuppered by Auerbach's relationship with Stella, which lasted for over two decades. In 1976, his relationship with Stella finally over, the artist fell back in love with Julia; the couple have remained together ever since. His art goes through regular stages of being fashionable followed by being unfashionable. Every decade a new generation of artists rediscovers Auerbach and another gallery decides to host a retrospective.

1931 Born 29 April in Berlin, Germany
1939 Sent to England as part of the Kindertransport programme
1947 Becomes a British citizen
1948–52 Studies at St Martin's School of Art, London
1952–55 Studies at Royal College of Art, London; attends classes given by David Bomberg at the Borough Polytechnic, together with Leon Kossoff; acquires Gustav Metzger's former studio in Camden
1958 Marries Julia Wolstenholme
EARLY 1960S Begins producing studies of Old Master paintings
1966 Begins series of paintings on the Camden Palace Theatre
1978 First major retrospective presented by the Arts Council of Great Britain at the Hayward Gallery in London
1981 *New Spirit in Painting* exhibition at Royal Academy of Arts in London
1986 Selected for the British Pavilion at the Venice Biennale
1995 National Gallery exhibition, *Working After the Masters*
2000 Tate Modern devotes a room to his works
2001 Retrospective at the Royal Academy

FURTHER READING
Robert Hughes, *Frank Auerbach*, London, 1990
William Feaver, *Frank Auerbach*, New York, 2009

Frank Auerbach, photograph by Kjeld Heltoft

PATRICK CAULFIELD ▬▬▬▬▬▬▬▬
ED RUSCHA ▬▬▬▬▬▬▬▬
GEORG BASELITZ ▬▬▬▬▬▬▬▬

1897 The Electron is discovered
by J. J. Thomson

1918–19 Max Beckmann paints *The Night*

1942 Edward Hopper paints *Nighthawks*

1957 Death of David Bomberg

1962 New York's Mus
of Modern Art h
Symposium on P

| 1885 | 1890 | 1895 | 1900 | 1905 | 1910 | 1915 | 1920 | 1925 | 1930 | 1935 | 1940 | 1945 | 1950 | 1955 | 1960 | 1965 | 1970 |

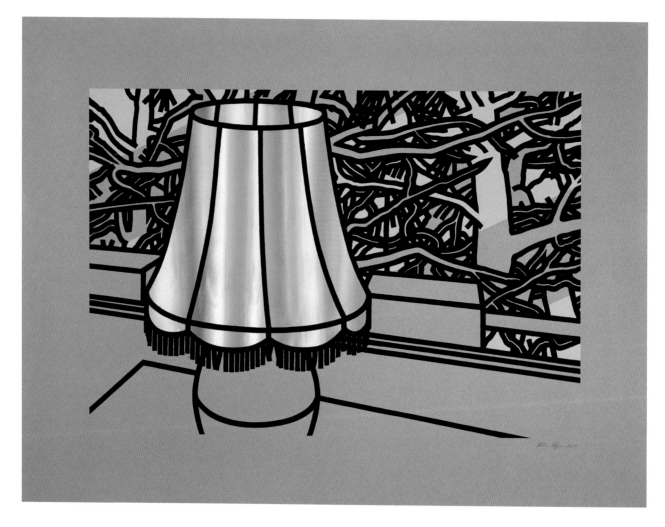

Patrick Caulfield, *Lamp and Pines*,
1975, screenprint, 77.3 x 102.6 cm,
Private Collection

1996 Death of Félix González-Torres

1983 Nintendo Entertainment System goes on sale in Japan

2005 Christo and Jeanne-Claude produce *The Gates*

1987 Death of William Coldstream

1991 Cornelia Parker makes *Cold, Dark Matter: An Exploded View*

1975 1980 1985 1990 1995 2000 2005 2010 2015 2020 2025 2030 2035 2040 2045 2050 2055 2060

PATRICK CAULFIELD

Although associated with the British Pop art movement, Patrick Caulfield always felt that the label was not quite right for his work. His calm, sometimes mysterious scenes are far removed from Pop's often glitzy surfaces, and lend a philosophical profundity to his art.

Patrick Caulfield was born in London just before the outbreak of World War II. He finished his studies at the Royal College of Art in 1963, whereupon Chelsea School of Art immediately offered him a teaching post. He taught there for eight years, a major influence on a new generation of artists.

Caulfield is a painter and printmaker. He had been just a university year below the first wave of Pop artists, but was rapidly assimilated into the movement. In 1965 he held his first solo exhibition, in London, and the international art world began to take serious notice of his name. Many of his works suggest a more introverted stance than his fellow Pop artists, showing images of solitude, sometimes bleakness, such as *Still Life with Dagger* (1963), *View Inside a Cave* (1965) and *The Hermit* (1967). While Pop art became renowned for its irreverent, cheeky attitude, Caulfield's work, although similar in technique, is often epitomised by an air of melancholy, such as his series of *Interiors*, screenprints of a window and lampshade at different times of the day (morning, noon, evening and night), which suggest an air of loneliness, of an unseen presence in the room staring at the same window for hours at a time. The series pays an obvious homage to both William Hogarth and Claude Monet. Caulfield's work shows a debt to a number of earlier artists, including Eugène Delacroix, Pablo Picasso and Juan Gris. Several of his paintings are bold homages to the artists who inspired him, and these paeans to the work of earlier artists spanned his career, such as the painting *Greece Expiring on the Ruins of Missolonghi (after Delacroix)* (1965), which was part of his final-year project for the Royal College of Art, and the bold screenprint *Les Demoiselles d'Avignon vues de derrière* (1999), in which a mature Caulfield imagined he was viewing the models of Picasso's famous painting from behind — while Picasso was painting them from the front. He also took inspiration from writers, including the poet Jules Laforgue and Hergé, the author of the Tintin comics.

Instead of using the immediately obvious Pop references that were all around him, Caulfield chose traditional subjects and then reinvented them. By the use of thick black lines, bold blocks of colours or monochrome, works such as *Black and White Flower Piece* (1963) and *Earthenware* (1967) become the artist's 20th-century versions of the traditional still life. His subjects vary from the everyday, items that people could find easily in their homes: a simple vase, jug or plate; to the abstract, such as *Freud's Smoke* (1997): the man is absent, all we see is his smoking cigar, but the title immediately makes the viewer imagine that Sigmund Freud is waiting just outside the frame.

In addition to his paintings and prints, Caulfield designed theatrical sets and costumes, most notably for the Royal Ballet in London's Covent Garden and the Paris Opera House. In the 1990s he was commissioned to create a giant mosaic for the National Museum of Wales in Cardiff; the resulting *Flowers, Lily Pad, Pictures and Labels* (2004) was inspired by the museum's collection of Monet's paintings.

In 1995, Caulfield was awarded the Jerwood Painting Prize; the following year he was awarded an Honorary Fellowship from the London Institute and he received a CBE. In 2005, Caulfield died of cancer; he was 69 years old. His art had never ceased to be in demand and he had hosted regular one-man exhibitions right up to his final illness. The year after his death, Tate Liverpool held a retrospective of Caulfield's works; the following year, the Waddington Galleries in London mounted a memorial exhibition.

1936 Born 29 January in London, England
1956–60 Studies at Chelsea School of Art
1960–63 Studies at the Royal College of Art with Hockney and Kitaj
1961 Selected for the Young Contemporaries Exhibition
1964 Included in the *New Generation* exhibition at the Whitechapel Gallery in London
1965 First solo exhibition at the Robert Fraser Gallery in London
LATE 1960S Begins painting with acrylic on canvas
1973 First print retrospective held at the Waddington Galleries in London
1981 Retrospective exhibitions held at the Tate Gallery in London and the Walker Art Gallery in Liverpool
1984 Designs sets and costumes for Michael Corder's ballet *Party Game* for the Royal Ballet in London
1987 Nominated for the Turner Prize
1994 Commissioned to design a mosaic for the National Museum of Wales in Cardiff
1995 Awarded Jerwood Drawing Prize jointly with Maggi Hambling
2005 Dies on 29 September in London

FURTHER READING
Mel Gooding, *Patrick Caulfield: The Complete Prints 1964–1999*, London, 1999
Marco Livingstone, *Patrick Caulfield: Paintings*, London, 2007

Patrick Caulfield, photograph by Jorge Lewinski, 1965

DAVID HOCKNEY

ANDY WARHOL

ALEX KATZ

1902 Carnegie Institution is founded in Washington, DC

1931 Salvador Dalí paints *The Persistence of Memory*

1944 Francis Bacon paints *Three Studies for Figures at the Base of a Crucifixion*

1956 *This Is Tomorrow* exhibition at Whitechapel Gallery, London

1966 Harold Wilson wins British General Ele

| 1890 | 1895 | 1900 | 1905 | 1910 | 1915 | 1920 | 1925 | 1930 | 1935 | 1940 | 1945 | 1950 | 1955 | 1960 | 1965 | 1970 | 1975 |

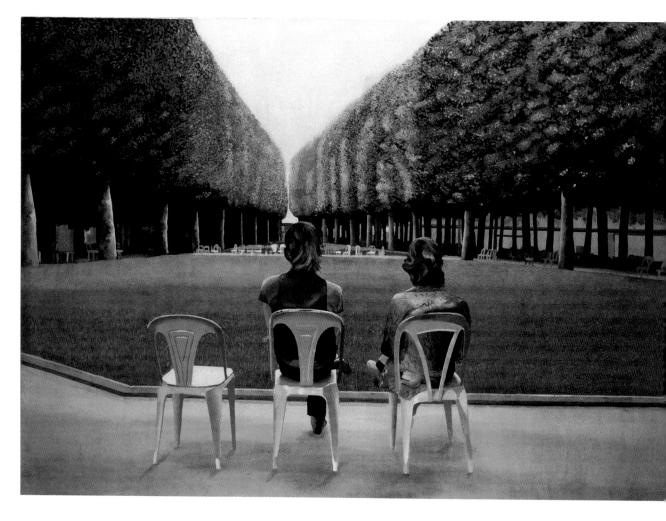

David Hockney, *Le Parc des Sources, Vichy*, 1970, acrylic on canvas, 213.4 x 304.8 cm, Marquis of Hartington, London

1982 Spain host FIFA World Cup

2001 George W. Bush elected US President

Seoul Tower in Seoul,
South Korea is completed

1993 Bill Clinton elected US President

1987 Mathias Rust lands plane on
Moscow's Red Square

| 1980 | 1985 | 1990 | 1995 | 2000 | 2005 | 2010 | 2015 | 2020 | 2025 | 2030 | 2035 | 2040 | 2045 | 2050 | 2055 | 2060 | 2065 |

DAVID HOCKNEY

Now working at the cutting edge of digital art on the iPhone and iPad, David Hockney has always loved experimentation. Whether oils or watercolours, cameras or faxes, his mastery of many media makes Hockney the Renaissance man of British art.

As a child David Hockney knew that he wanted to become an artist and, at the age of 16, he enrolled at the Bradford School of Art. Four years later, he moved to the Royal College of Art in London. When he completed his diploma, the Royal College awarded him a gold medal.

Hockney is a superbly talented draughtsman and a master of different artistic styles and media, including portraiture, landscapes, painting, collage, printmaking, graphic art, stage design and photography. Although he studied alongside several prominent Pop artists, including Patrick Caulfield, Hockney always shied away from the 'Pop art' label.

Throughout the 1960s, the name David Hockney grew in importance, from the opening of his first solo show in 1963 — at which every painting was sold — to being awarded first prize in Liverpool's John Moores Exhibition of 1967. By the 1970s, he had become internationally famous. In 1961 he travelled to New York; two years later he arrived in California. It was a trip that would change not just his life, but also his artistic style. Hockney was inspired instantly by California's colours, landscapes and lifestyle, encapsulated in one of his most iconic paintings, *A Bigger Splash* (1967). As a gay man, life in Britain during the 1960s was stifling. He had hidden his sexuality in Bradford, and. although he had felt freer during his years in London, it was in California that he could finally embrace his sexuality. Hockney made California his home, eventually moving to Los Angeles, although he made regular trips back to Yorkshire and his family. In his paintings, he created a smooth, brilliantly coloured world of beautiful young men, lithe tanned bodies, swimming pools, exotic foliage and consistently bright sunshine. Throughout the 1970s and 1980s, Hockney, a life-long fan of opera, was in great demand as a set designer and worked with some of the world's best opera companies.

Portraiture has been one of the mainstays of Hockney's career and includes some of his most famous works. *Beverley Hills Housewife* (1966), of the art collector Betty Freeman, and *Mr and Mrs Clark and Percy* (1970–71), of the designers Celia Birtwell and Ossie Clark with their cat are classic Hockney during his heyday. In later years his portraits have become softer and more realistic, exemplified in the beautifully intimate *Mum* (1988–89). By the end of the 1980s he had a yearning to begin a new series of portraits, of his friends and family. He described his inspiration very simply: 'I wanted to look at my friends' faces again'.

In recent years, Hockney has been drawn back to the UK, and Yorkshire has regained a central importance in his life and work. In the mid 2000s, he was inspired to begin a series of monumental landscapes, of a majestic wood at the village of Warter, not far from his Yorkshire home. The epic painting *Bigger Trees Near Warter* (2007), composed of 50 canvases, is 12 metres long. It was painted outside during six weeks of solid work. It was supposed to be just the beginning, as the artist had an even greater project planned, for a nearby wood. In 2009 Hockney was horrified to discover the trees he was in the middle of painting had all been felled. In a newspaper interview he commented, 'To me even the approach to that little wood had a kind of grandeur, like the approach to some marvellous great temple…. It was like coming into some little village or town and finding that overnight the people had obliterated a great church that had stood there for 900 years…. If they had pulled down a great church people would have seen and asked questions, but nobody asked about these trees, Nobody asks enough questions any more'.

1937 Born 9 July in Bradford, Yorkshire, England
1953–57 Studies at Bradford School of Art
1957–59 A conscientious objector, he works as a medical orderly in hospitals as National Service
1959–62 Studies at the Royal College of Art in London
1960 Exhibits two paintings at the *London Group 1960* exhibition
1963 First solo exhibition, *Pictures with People In*, in London; *A Rake's Progress* published; visits New York and meets Andy Warhol
1964 Solo exhibition in New York
1970 Retrospective at Whitechapel Gallery in London, which travels to Hanover, Rotterdam and Belgrade
1978 Settles in Los Angeles
1982 Begins producing photo-collages
1990 Designs sets and costumes for Puccini's *Turandot*
1995 Drawing Retrospective at the Royal Academy
2003 Receives Lorenzo de' Medici Lifetime Career Award
2009 Nottingham Contemporary Art Gallery in England opens with the exhibition *David Hockney 1960–1968: A Marriage of Styles*

FURTHER READING
David Hockney, *Secret Knowledge: Rediscovering the Lost Techniques of the Old Masters*, London, 2001
Gregory Evans, *Hockney's Pictures: The Definitive Retrospective*, New York, 2004

David Hockney, Bridlington Studio, February 2009

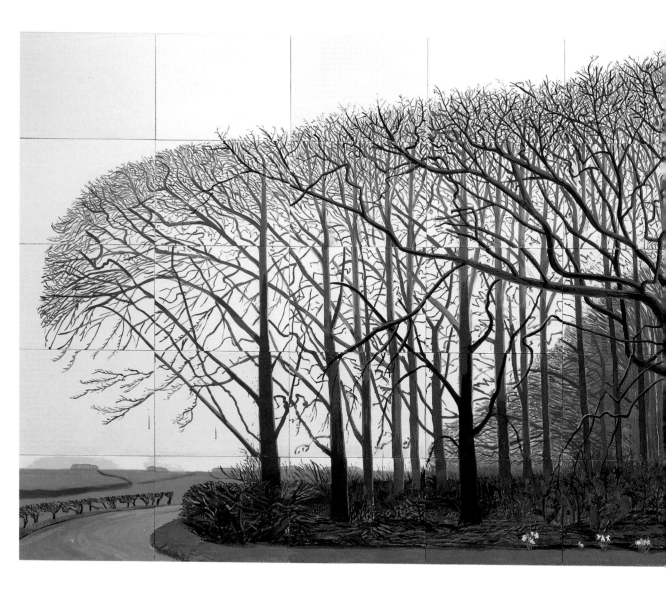

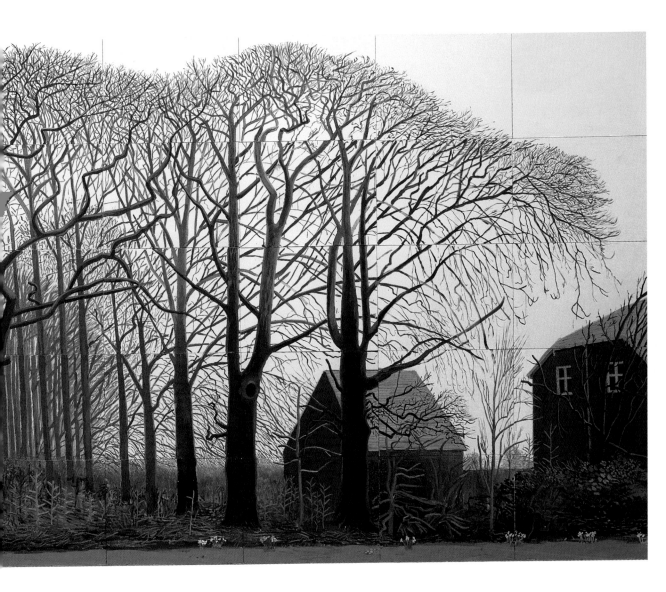

David Hockney, *Bigger Trees Near
Warter or/ou Peinture sur le Motif pour
le Nouvel Age Post-Photographique*,
2007, oil on 50 canvases, 91.4 x 121.9 cm
(each canvas), Tate, London

GILBERT & GEORGE

VITO ACCONCI

ALLAN KAPROW

1904 Great Baltimore Fire

1931 Empire State Biulding in New York
is completed

1964 President Lyndon Johnso
announces a 'War on Po

1956 Alexander Calder produces **1973** Sydney
Red Mobile House
opened

1890 1895 1900 1905 1910 1915 1920 1925 1930 1935 1940 1945 1950 1955 1960 1965 1970 1975

THE
EDGE
1988
Gilbert + George

1980 Umberto Eco publishes *The Name of the Rose*
1982 First commercial CD player is produced
1996 Chuck Palahniuk publishes *Fight Club*
1988 Young British Artists hold *Freeze* exhibition in London
2003 US invasion of Iraq

THE HENLEY COLLEGE LIBRARY

1980 1985 1990 1995 2000 2005 2010 2015 2020 2025 2030 2035 2040 2045 2050 2055 2060 2065

GILBERT & GEORGE

Dubbed the 'Queen Mothers of British Art' Gilbert & George purvey images of Englishness in their personal lives as well as their art. Elitist while proclaiming theirs is 'art for all', they have had more exhibitions across the world than any other contemporary artist.

Italian-born Gilbert and English-born George met at St Martin's School of Art, in London, in 1967 and have worked together ever since. Both initially trained as sculptors, but — aside from their 'living sculptures' — the majority of their works have involved drawing, painting, collage, photography, video and design. Their first success was *The Singing Sculpture* (1969). The act involved singing and dancing for hours at a time and they perfected the art of mirroring one another's actions. It would go on to characterise their work and their life — two elements that have become inter-changeable.

From the beginning, Gilbert & George have placed themselves at the centre of their work and laid themselves bare — figuratively and actually. In 1968, the couple began renting a flat in a run-down East London house, on Fournier Street, Spitalfields. Several years later they bought the whole house, which they renovated as their home and studio. The house is remarkable not only for the role it plays in their art (it appears regularly in their works), but also for the artists' choice not to have a kitchen. In the film *With Gilbert and George* which was filmed over 18 years by Julian Cole (one of their former models), Gilbert and George explain that they do not like, or need, to cook: they eat every meal out, usually at local cafés. Even walking along the street is an artistic act for Gilbert & George, created by the clothes they wear, the expressions on their faces and their careful, slow, measured pace of walking exactly in step together.

Their earliest works contain very few colours, most are monochrome, but by the 1980s their confidence and interest in colour had grown, resulting in pictures that seem garish in contrast. Initially, they used only images of themselves, but by the 1980s they had begun focusing on other models, almost exclusively young, good-looking men — with the artists playing less prominent roles, often appearing on the sidelines.

At the start of their career, the duo wanted to remove the idea of elitism and snobbery from art, creating the kind of works that their East End community would relate to. Ironically, their controversial subject matter — including gay sex, human excrement, semen, blood, pornography, religious blasphemy (such as *Shit Faith* [1982]) — led to their works gaining a cult following, in itself an artistic elite.

Their earliest pictures were charcoal drawings on paper, but the artists became frustrated by viewers ignoring the subject matter and simply trying to work out which bits had been drawn by Gilbert and which by George. Many of their earliest works hark back to an image of 'old England' or 'traditional England', glorifying the Victorian music hall, the hard-drinking culture of the English, the East End of London and the squalor of everyday life.

Gilbert & George's *oeuvre* is largely in series, and they work exhaustively on a subject until a new obsession takes hold. Their series include *Human Bondage* (1974), *Cherry Blossom* (1975), *Bloody Life* (1975), and *Youth Attack* (1982). *The Naked Shit* (1990s) pictures celebrated Gilbert & George's latest obsession: bodily excretions. They examined excrement, blood, sweat, tears, urine and semen under microscopes and produced paintings based on what they found: 'To see daggers and medieval swords in sweat, that's our aim.... Spunk ... really does look like a crown of thorns'.

In 2005, Gilbert & George represented Britain at the Venice Biennale with the *Ginkgo* series, made with leaves collected in New York's Gramercy Park, In 2007 London's Tate Modern held a Gilbert & George retrospective, the largest the gallery had yet mounted.

left
Gilbert & George, *The Edge*, c. 1988, mixed media, 241 x 201 cm, Private Collection

right
Gilbert & George, photograph by Herbie Knott, 1986

1943 Gilbert born 17 September in San Martin de Tour, Italy
1942 George born 8 January in Plymouth, England
1967 Gilbert & George meet while studying sculpture at St Martin's School of Art, London
1970 First presentation of *The Singing Sculpture* at Nigel Greenwood Gallery in London
1971 Begin producing large-scale pictures
EARLY 1980S Begin adding bright colours to their pictures
1987 Awarded the Turner Prize; major exhibition at the Hayward Gallery, London
1991–93 *The Cosmological Pictures* tour ten different European museums
2005 Represent Britain at Venice Biennale
2007 The artists serve as the subject of the BBC Documentary, *Imagine*; *The Complete Pictures, 1971–2005* is published; awarded South Bank Award and Lorenzo il Magnifico Award; retrospective at Tate Modern, which travels to Europe and America
2010 Awarded Magister Artium Gandensis by University College Gent, Belgium

FURTHER READING
Robin Dutt, *Gilbert & George*, London, 2004
Jan Debbaut, Michael Bracewell and Marco Livingstone, *Gilbert & George*, London, 2007

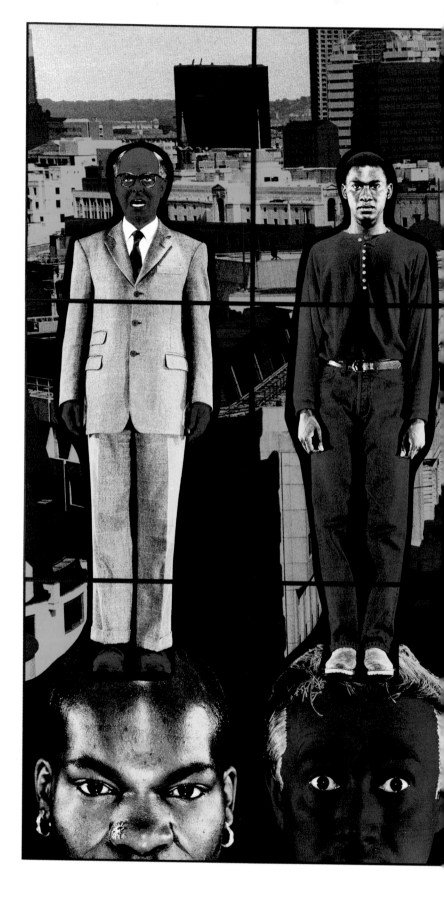

Gilbert & George, *Fair Play*, 1991, mixed
media, 253 x 355 cm, Private Collection

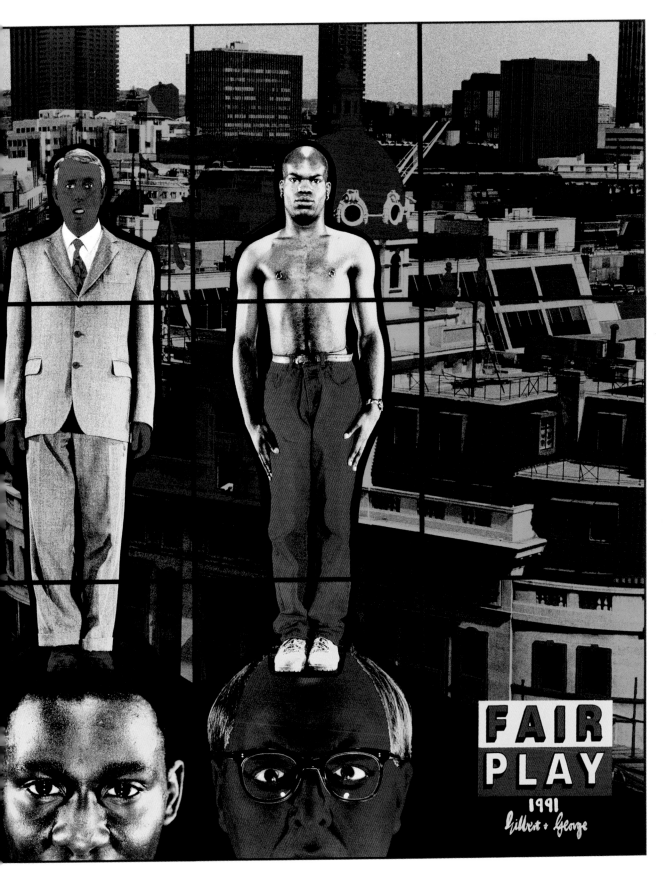

1930 Construction of the Chrysler
Building in New York is completed

1957 Allan Kaprow coins the
term *Happening*

1907 Romanian Peasants' Revolt

1943 The Pentagon building in
Washington DC is completed

1962 Anthony Burgess publishes
A Clockwork Orange

| 1890 | 1895 | 1900 | 1905 | 1910 | 1915 | 1920 | 1925 | 1930 | 1935 | 1940 | 1945 | 1950 | 1955 | 1960 | 1965 | 1970 | 1975 |

Maggi Hambling, *Scallop*, 2003, stainless
steel, h. 4 m, Aldeburgh Beach, Suffolk

following double page left
Maggi Hambling, *Wilde Talking*, 1996, oil on canvas,
76 x 61 cm, Private Collection

following double page right
Maggi Hambling, *Max Reading*, 1980, oil on canvas,
129.5 x 96.5 cm, Private Collection

Royal National Theatre building **1994** Channel Tunnel is opened
in London is completed
2000 Tate Modern opens in London
1989 Death of Robert Mapplethorpe
1997 Tony Blair elected British Prime Minister

| 1980 | 1985 | 1990 | 1995 | 2000 | 2005 | 2010 | 2015 | 2020 | 2025 | 2030 | 2035 | 2040 | 2045 | 2050 | 2055 | 2060 | 2065 |

MAGGI HAMBLING

With an unflinching yet compassionate gaze Maggi Hambling produces portraits that reveal the very essence of her subject. Both her painting and sculpture display a fearlessness in both her technique and the themes she tackles.

Maggi Hambling was born in Suffolk, a county that still draws her back and inspires her. A sculptor and painter, Hambling was a notably artistic child from her primary school days. As a teenager she studied at the Ipswich School of Art, before moving to London and attending the Camberwell School of Art and the Slade School. She remained in London. She became the first Artist in Residence at the National Gallery (1989–81), she won the Jerwood Prize for Painting in 1995 and received the Marsh Award for Excellence in Public Sculpture (2005). Works such as *A Conversation with Oscar Wilde* (1998), which serves as a seat on which sitters can 'chat' with Oscar Wilde as he smokes in a decadent fashion, and *Scallop* (2003), dedicated to Benjamin Britten, have changed the way British people interact with their landscape.

Much of Hambling's work is about the theme of freedom — physical, sexual, emotional and social freedom — and her public persona is as carefully crafted as her art. Her paintings and sculptures range from the monumental to the irreverent, epitomised in her two major achievements from 2003: one a series of spectacularly dramatic paintings of the North Sea, the other a series of paintings celebrating her favourite lager, Special Brew. Her portraits encompass a wide range of sitters, including celebrities, scientists, friends and lovers. She paints famous people — Max Wall, Oscar Wilde, George Melly, Derek Jarman, Dorothy Hodgkin and Stephen Fry — as well as deeply personal portraits: her father on his deathbed, her lover Henrietta Moraes shortly before she died. Hambling's portraits are painted exuberantly, in bold, sweeping strokes often employing a hectic, chaotic range of colours. Their execution veers from the intimate and sympathetic to the bawdy and flippant.

Often unimpressed by modern art, Hambling is inspired by the works of long-dead artists, including Rembrandt, Titian, Rubens and Van Gogh: 'I have stood and cried in front of a Van Gogh painting'. Her love of Oscar Wilde dates back to her childhood and her superb — albeit controversial — sculpture that resides opposite London's Charing Cross station was the culmination of years of hero worship. The emotion the artist felt when creating the work is evident to the Oscar Wilde fan who sits and has 'a conversation with Oscar'. As Hambling explained, 'I like art that hits you in the heart'.

Memories of her Suffolk childhood and the beach at Aldeburgh evoke in her the remembrance of sitting on the beach watching fireworks to celebrate Queen Elizabeth II's coronation in 1952. She was just seven years old in 1952, but the desire to recreate those mixed childhood feelings of excitement and awe were what led her to create *Scallop*. The 3-metre-high sculpture is a monument to the composer Benjamin Britten, who was also the founder of the annual Aldeburgh Festival. The sculptor intended the huge stainless steel shell to be sited a place at which people could celebrate, commemorate and commiserate, a place to come when happy or when sad. 'That explosion of those fireworks was something like the explosion of Britten's music. The *Scallop* explodes out of the shingle.' Opinion about the sculpture was divided with many locals and walkers furious about such a large and obvious addition to the 'heritage coastline', while others considered it an artistic jewel to be treasured.

In one of many interviews about *Scallop* and the controversy it had provoked, Hambling commented: 'The older I get I identify with the land which is being eroded. The sea is like time — you can do nothing about it. Death will come, the sea will come.... There's nothing any of us can do about the fact we're going to die'.

1945 Born 23 October in Sudbury, Suffolk, England
1960–62 Studies at East Anglian School of Painting and Drawing
1962–64 Studies at Ipswich School of Art
1964–67 Studies at Camberwell School of Art
1967–69 Studies at the Slade School of Art, University College London
1969 Receives Boise Travel Award; travels to New York
1977 Receives Arts Council Award
1980–81 First Artist in Residence at the National Gallery in London; produces series of portraits of the comedian Max Wall
1995 Awarded Jerwood Painting Prize jointly with Patrick Caulfield; awarded OBE
1998 *A Conversation with Oscar Wilde*, commissioned by the National Gallery, is installed in Adelaide Street, London
2003 *Scallop*, in commemoration of the composer Benjamin Britten, is installed on Aldeburgh Beach, Suffolk
2005 Receives Public Monuments and Sculpture Association Marsh Award for Excellence in Public Sculpture
2010 Awarded CBE

FURTHER READING
Maggi Hambling and John Berger, *Maggi and Henrietta: Drawings of Henrietta Moraes*, London, 2001
Maggi Hambling, *The Works*, London, 2006

Maggi Hambling, photograph by Simon Turtle

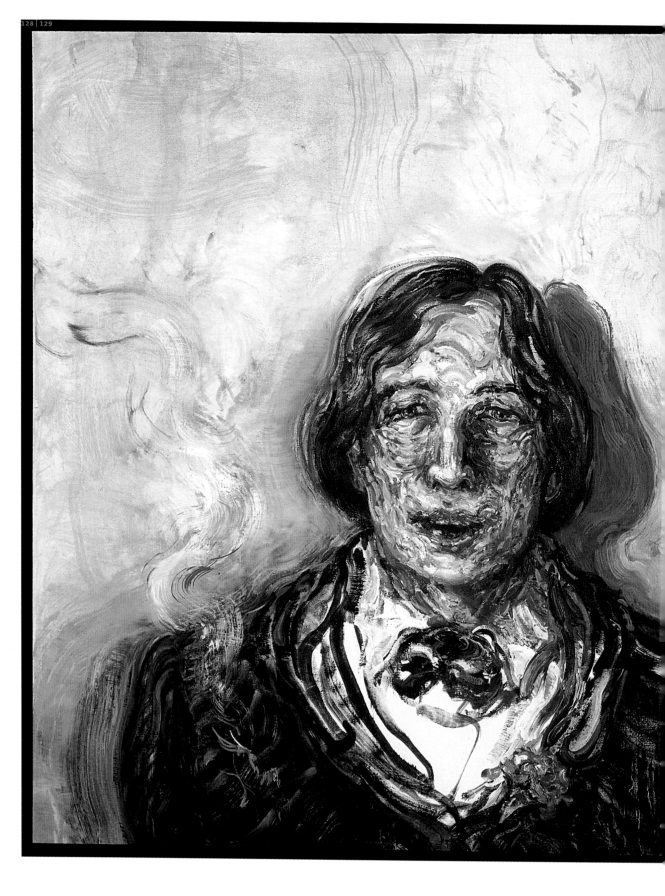

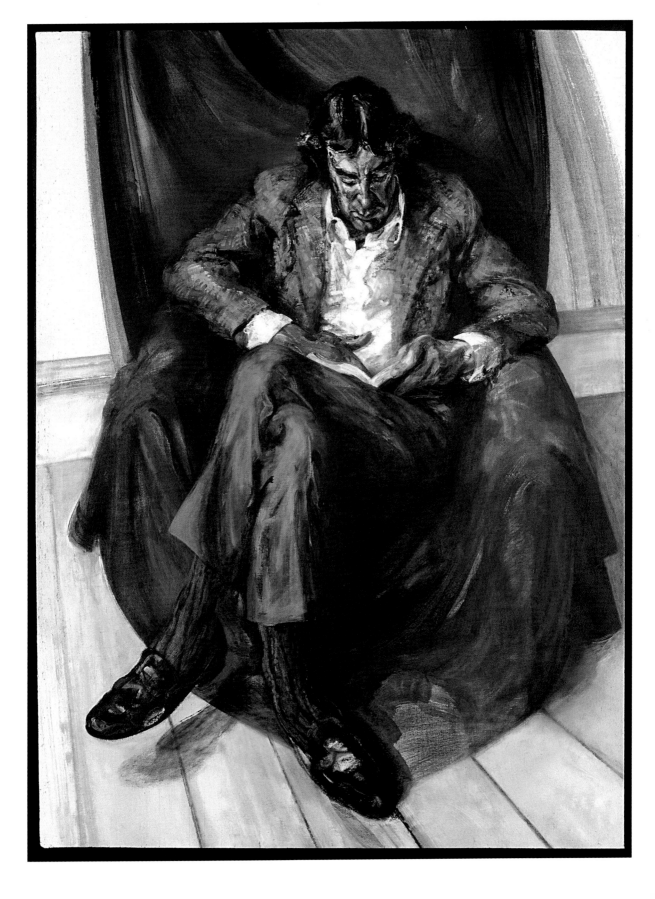

1910 Accession of George V

1923 Yankee Stadium opens in
the Bronx, New York

1950 Comic Strip *Peanuts* is
first published

1961 Piero Manzoni creates 90 sma
cans labelled *Merda d'Artista*

1976 Richard Da
publishes
Selfish Gene

| 1890 | 1895 | 1900 | 1905 | 1910 | 1915 | 1920 | 1925 | 1930 | 1935 | 1940 | 1945 | 1950 | 1955 | 1960 | 1965 | 1970 | 1975 |

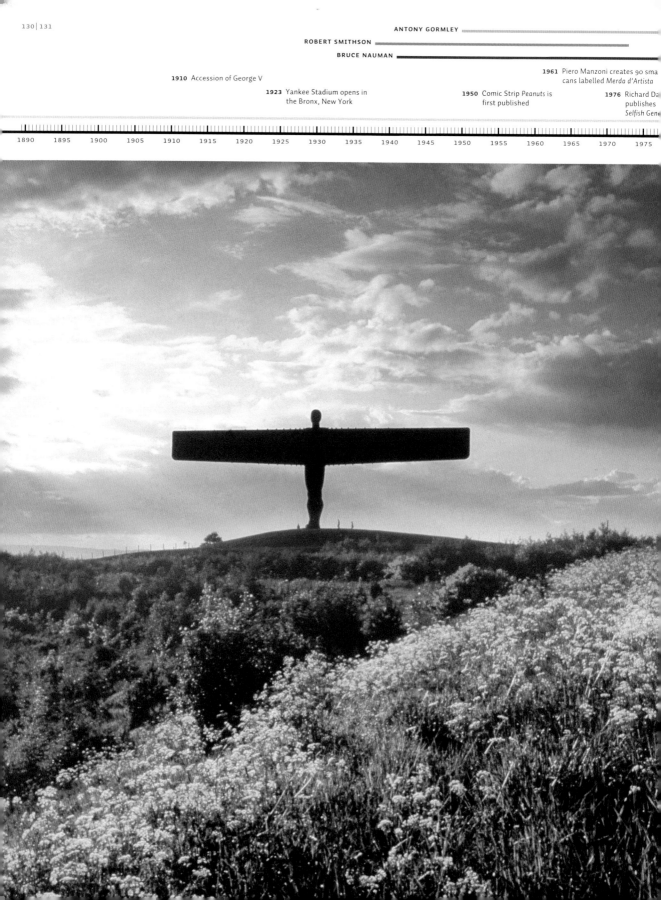

1980 Independent trade union Solidarity
is established in Poland
1983 Red Hot Chili Peppers release first,
self-titled album
1991 Collapse of USSR

1998 Tom Clancy publishes
Rainbow Six
2005 Cormac McCarthy publishes
No Country for Old Men

| 1980 | 1985 | 1990 | 1995 | 2000 | 2005 | 2010 | 2015 | 2020 | 2025 | 2030 | 2035 | 2040 | 2045 | 2050 | 2055 | 2060 | 2065 |

ANTONY GORMLEY

For Antony Gormley the space around his sculptures is as important as the sculptures themselves. Whether as single figures or groups his works reflect back at the viewer and question our place in the world.

Antony Gormley's sculptures stem from a fascination with ancient history and spirituality, as well as with the art of sculpture itself. Gormley was born in London in 1950, but he was not always destined to become an artist. He went to Cambridge University where he took a degree in archaeology, anthropology and art history. After graduating, he travelled to India, where he spent three years studying the art of meditation. The experience would shape his future art — many of his sculptures are often made from casts of his own body, which he believes allows him to 'return to a primal condition of life' and connect with the inner world. In the late 1970s, living in London once again, he enrolled at the Slade School of Fine Art, where he experimented with a variety of sculptural media, including lead, clay, concrete, iron and steel.

In 1998 the name Antony Gormley suddenly became the one on everyone's lips, thanks to the unveiling of *The Angel of the North* – a 20-metre-high sculpture with a wingspan of 54 metres. The rusty red statue stands beside the A1, just outside the town of Gateshead. It is on the site of a former colliery, once the area's major employer. The figure's construction required more than 200 tonnes of steel, a tribute to Britain's formerly thriving steel industry, as well as to the generations of miners who once worked beneath the angel's feet. It is estimated that more than 90,000 people drive past the angel every day; added to which are thousands of train passengers and all those who make a specific pilgrimage to see Gormley's statue up close. Gormley commented, 'People are always asking, why an angel? The only response I can give is that no one has ever seen one and we need to keep imagining them. The angel has three functions — firstly a historic one to remind us that below this site coal miners worked in the dark for two hundred years, secondly to grasp hold of the future, expressing our transition from the industrial to the information age, and lastly to be a focus for

our hopes and fears — a sculpture is an evolving thing'.

In 2009, Gormley masterminded *One & Other*, taking the idea of figurative sculpture into the world of exhibitionism. He recruited 2,400 volunteers from all over the UK, each of whom was allotted a one-hour opportunity to occupy the vacant Fourth Plinth in London's Trafalgar Square and create their own living work of art. The project, which was dubbed 'a portrait of Britain', lasted for a hundred days.

Ever since achieving fame with *The Angel of the North*, Gormley's career has been littered with awards and accolades. In 1994, he won the Turner Prize, in 1997 he was honoured with a OBE for 'services to sculpture', in 1999 he won the South Bank prize for Visual Arts and in 2007 he was named the winner of the Bernhard Heiliger Award for Sculpture. Gormley has also been awarded honorary fellowships from the Royal Institute of British Architects and from two Cambridge colleges: Trinity and Jesus. Somehow, he has avoided much of the backlash that so often dogs modern sculptors. His works are never mundane and are always talked about; the hard-to-please British media appears to love and celebrate his work and the public interacts with it. Gormley describes his work as being 'to make bodies into vessels that both contain and occupy space'.

1950 Born in London, England
1968–71 Studies Archaeology,
Anthropology and Art History
at Trinity College, Cambridge
1974–77 Studies at the Central
School of Art and Design and
Goldsmiths' College, London
1977–79 Postgraduate course in
sculpture at the Slade School
of Art, University College
1981 First solo exhibition at the
Whitechapel Gallery, London
1994 Awarded the Turner Prize for
Field for the British Isles; receives
commission to design a sculpture
for a hill on the southern edge of
Low Fell, Gateshead
1997 Awarded OBE for his services to
sculpture
1998 *Angel of the North* installed in
Gateshead
1999 Awarded the South Bank Prize
for visual art
2003 Elected Royal Academician
2007 Awarded the Bernhard Heiliger
prize for sculpture; *Event Horizon*
installed along London's South
Bank
2009 *One & Other* takes place on
Trafalgar Square's Fourth Plinth
2010 *Event Horizon* installed in
locations around New York
City's Madison Square

FURTHER READING
Richard Noble, *Antony Gormley*,
Göttingen, 1999
Martin Caiger-Smith, *Antony Gormley*,
London, 2009

left
Antony Gormley, *Angel of the North*, 1995/1998, steel,
22 x 54 x 2.2 m, Gateshead

right
Antony Gormley at the Hayward Gallery in London,
photograph by Bruno Vincent

Antony Gormley, *Exposure*, 2010,
galvanised steel, 25.64 x 13.25 x 18.47 m,
The 6th Flevoland Landscape Artwork,
Permanent installation, Lelystad,
The Netherlands

1895 Death of Berthe Morisot

1923 Constantin Brancusi produces
Bird in Space series

1945 US President Harry Truman
announces Fair Deal programme

1968 Prague Spring

1971 Foundin
Greenpe

| 1890 | 1895 | 1900 | 1905 | 1910 | 1915 | 1920 | 1925 | 1930 | 1935 | 1940 | 1945 | 1950 | 1955 | 1960 | 1965 | 1970 | 1975 |

Anish Kapoor, *Cloud Gate*, 2004,
stainless steel, 100.6 × 201.2 × 128 m,
Chicago

1994 North American Free Trade Agreement is established

1983 Björn Borg retires from tennis

2000 Louise Bourgeois is first artist commissioned to produce work for Tate Modern's Turbine Hall

1979 Death of Peggy Guggenheim

1998 Construction begins on International Space Station

1980　1985　1990　1995　2000　2005　2010　2015　2020　2025　2030　2035　2040　2045　2050　2055　2060　2065

ANISH KAPOOR

Anish Kapoor's sculptures, in their monumental scale and poetic titles, evoke an experience of the sublime in the viewer. But even his public works relate to private journeys of self-discovery and mystical revelation.

Anish Kapoor was born in India, to an Indian father and Jewish–Iraqi mother. He grew up in Bombay before deciding to travel to England to study art. He arrived in London in 1973 where he studied for three years at the Hornsey College of Art before being accepted to the Chelsea School of Art. He had soon made London his home and, at the age of 26, was signed to the prestigious Lisson Gallery, which has represented him ever since. Kapoor's sculptures are seen to their best advantage in the open air and his public-space exhibitions, such as *Cloud Gate* (2004–06) in Chicago's Millennium Park (known affectionately to the locals as 'The Bean'), have helped make his name globally famous.

In 1978, Kapoor had his first major artistic breakthrough when his work was included in the *Young Contemporaries* exhibition at the Royal Academy. In the following year, he accepted a teaching position at Wolverhampton Polytechnic, while working towards his first solo exhibition — which was held in Paris in 1980. A year later he held his first solo exhibition in London; in the same year he was one of the featured British sculptors whose work was showcased at the Whitechapel Art Gallery.

Kapoor's sculptures have gone through a fascinating evolution since his earliest days of wood sculpting. Unsurprisingly his earliest works were created from much cheaper materials than his monumental polished steel or glistening ruby-red fibreglass sculptures of the 21st century. Kapoor works in a variety of media, creating charismatic, often undeniably erotic sculptures that make the viewer long to reach out and touch them. The sculptor understands this need and many of his works require interaction, whether it be trying to discover one's reflection in his highly polished mirror pieces, such as *Sky Mirror* (2006), or the feeling of being cocooned when standing underneath the enveloping curves of *Hive* (2009).

In 1990, Kapoor was chosen to represent Britain at the Venice Biennale. The following year, he won the Turner Prize and in 1999 he was elected a Royal Academician. His importance to British art has been recognised with an Honorary Doctorate from the London Institute and Leeds University (1997); an Honorary Fellowship from RIBA (2001) and a CBE (2003).

In 2002, *Marsyas*, a '10-storey-high' sculpture, was exhibited at Tate Modern in London. It attracted an estimated 1.8 million visitors, an indication of how strongly the public is attracted to Kapoor's work. He has exhibited all over Europe, in North America, Scandinavia, Australia and Asia. The news that Kapoor was planning a major exhibition in India was welcomed with great excitement by the country's media. It took Kapoor and the British Council some time to discover a venue large enough to exhibit his sculptures in the way he wanted the Indian public to see them; unable to find a museum space, they eventually decided to stage the exhibition inside a Bollywood studio. In 2009 the Royal Academy in London held a major retrospective of Kapoor's work, tickets for the exhibition sold out. In 2010, the same year in which his major exhibition opened in India, Kapoor was chosen to create a monumental sculpture for the 2012 Olympic Games in London: a 115-metre-high spiralling sculpture entitled *Arcelor Mittal Orbit*, incorporating the five Olympic rings. In 2010–11 London's Kensington Gardens hosted an exhibition of Kapoor's social space sculptures known as *Turning the World Upside Down*. It was an aptly named exhibition for a man whose *oeuvre* has changed the face of monumental sculpture throughout the world.

1954 Born in Bombay (Mumbai), India
EARLY 1970S Moves to London; studies at Hornsey College of Art
1977–78 Studies at Chelsea School of Art, London
1978 Exhibits as part of the New Sculpture exhibition at the Hayward Gallery in London
1990 Represents Britain at the Venice Biennale, where he is awarded the Premio Duemila
1991 Awarded Turner Prize
2001 Commissioned to produce *Sky Mirror* for a site outside the Nottingham Playhouse
2002 Produces *Marsyas* for the Tate Modern Turbine Hall
2003 Awarded CBE
2006 A second *Sky Mirror* is installed at the Rockefeller Centre in New York; *Cloud Gate* is permanently installed in Chicago's Millennium Park
2010 Commissioned to produce *Turning the World Upside Down, Jerusalem*, for the Israel Museum in Jerusalem; designs *ArcelorMittal Orbit* with Cecil Balmond for the 2012 London Olympics; exhibition in Kensington Gardens, London

FURTHER READING
Rainer Crone and Alexandra Von Stosch, *Anish Kapoor To Darkness: Svayambh*, Munich, 2008
Peter Noever, *Anish Kapoor: Shooting into the Corner*, Ostfildern, 2009

Anish Kapoor, photograph

Anish Kapoor, *Marsyas*, 2002, PVC and
Steel, dimensions variable, Tate Gallery,
London

Anish Kapoor, *Svayambh*, 2006,
wax, dimensions variable, Musée des
Beaux-Arts, Nantes

1969 Mario Puzo pub[...]
The Godfather

1894–95 Edvard Munch paints *Madonna* **1926** Death of Mary Cassatt **1954** J. R. R. Tolkien publishes **1971** Robert Moth[...]
first volume of *The Lord* paints *Elegy*
of the Rings *the Spanish [...]*
No. 110

1890	1895	1900	1905	1910	1915	1920	1925	1930	1935	1940	1945	1950	1955	1960	1965	1970	1975

Grayson Perry, *Jane Austen in E17*, 2009, glazed ceramic,
100 x 51.5 cm, Victoria Miro Gallery, London

Harold Wilson resigns as **1992** English FA Premier League is officially formed
British Prime Minister
 2001 9/11 terrorist attacks in US
 1985 Live Aid pop concerts in London and Philadelphia
 1999 The Euro is established

1980 1985 1990 1995 2000 2005 2010 2015 2020 2025 2030 2035 2040 2045 2050 2055 2060 2065

GRAYSON PERRY

A self-confessed practitioner of 'guerrilla tactics' Grayson Perry uses the traditional crafts of ceramics and needlework to comment on the contemporary world. In his work satire, beauty and autobiography form an artistic whole.

Grayson Perry is a ceramicist whose work is often overshadowed by the media's obsession with his transvestite alter-ego, Claire. The artist studied at his local college, Braintree College of Further Education, and Portsmouth Polytechnic. In the early 1980s he was part of the performance art group, the Neo Naturists, but it took a long time for his work to be recognised by the art establishment. He struggled to be taken seriously as an artist well into his thirties, making financial ends meet by doing jobs such as 'working as a sandwich-maker in a hairdresser's'. Now the most famous ceramicist in Britain, Perry also works as a journalist and presenter on TV and radio.

In 2009 Perry moved into the world of textiles with *The Walthamstow Tapestry*. Fifteen metres long and three metres wide, the tapestry is decorated with poignant images and hundreds of brand names. When read from left to right, the scenes begin with a graphic image of childbirth, painful and bloody, and continue through the 'seven ages of man' ending with death — yet this is not the crux of the tapestry. It looks at how consumerism, and those hundreds of famous corporate names, swamp our lives, from brand-name disposable nappies to brand-name funeral parlours. Alongside are depicted stories of human misery, doomed drug addicts, starving refugees, car crash victims — and Claire, who is depicted clutching a Jesus doll. Perry has his studio in Walthamstow, but *The Walthamstow Tapestry* can also be seen as an ironic homage to William Morris. The 19th-century artist and designer was born in Walthamstow (his childhood home is now a museum) and founded the Arts and Crafts group, one of whose principles was to bring medieval crafts, including tapestry, back to the forefront of art.

Despite this foray into the world of textiles, Perry describes himself first and foremost as a ceramicist. He produces between 12 and 25 pots a year, which he creates by coiling clay, not by using a potter's wheel. His work is richly textured, delicately glazed and exquisitely painted — usually with provocative titles guaranteed to make the right-wing press explode with fury, such as *We've Found the Body of your Child* (2000) and *Saint Claire 37 Wanks across Northern Spain* (2003). Perry's work, however, is not gimmicky: it is painstaking and stylistically diverse, incorporating a collage-style variety of media, including photo-transfers, painting and lettering. The artist may use titles to shock, but the content is usually politically poignant, or employs what Perry calls a 'guerrilla tactic': *We've Found the Body of your Child* looks at the issue of domestic child abuse. *Jane Austen in E17* is a comment on the changing British class system: its scenes of genteel 18th-century ladies transported into an ugly tableau of modern urban living demonstrate that 'taste is what defines the classes now, not economics'.

In 2003, Perry was the first ceramicist to be awarded the Turner Prize; he made the occasion even more historic by accepting the award wearing an elaborate dress. Although the newspapers have had a field day with Grayson's choice to wear girlish, frilly dresses and make-up and carry a teddy bear, his wife, Philippa, is far more pragmatic. She describes her husband's choice of women's clothing as 'glamorous. He's found his own style', but adds 'He doesn't do [the washing up] if he has a dress on, though. That's the only annoying thing about living with a transvestite — he thinks it's feminine to just hang around in a chair'.

1960 Born 24 March in Chelmsford, England
1978–79 Art Foundation at Braintree College of Further Education
1982 Graduates with BA in Fine Art from Portsmouth Polytechnic
1980 Exhibits first pottery piece at *New Contemporaries* exhibition at the Institute of Contemporary Arts in London
1983 Takes pottery lessons at the Central Institute
1984 First exhibition of ceramic works at James Birch Gallery in London
2002 Large solo exhibition at the Stedelijk Museum in Amsterdam
2003 Awarded Turner Prize
2005 Featured in Channel 4 documentary *Why Men Wear Frocks*
2006 Publishes *Portrait of the Artist as a Young Girl*
2009 Exhibits *The Walthamstow Tapestry* at Victoria Miro Gallery in London

FURTHER READING
Grayson Perry and Wendy Jones, *Portrait of the Artist as a Young Girl*, London, 2006
Jacky Klein, *Grayson Perry*, London, 2009

Grayson Perry, photograph

Grayson Perry, *The Walthamstow
Tapestry*, 2009, tapestry, 300 x 1500 cm,
Victoria Miro Gallery, London

1912 Thomas Mann publishes
Death in Venice

1933 Adolf Hitler is appointed
Chancellor of Germany

1942 Albert Camus publishes
L'Étranger

1961 Founding of Amnesty
International

1974

1890 1895 1900 1905 1910 1915 1920 1925 1930 1935 1940 1945 1950 1955 1960 1965 1970 1975

Yinka Shonibare, *The Swing (after
Fragonard)*, 2001, mixed media,
330 x 350 x 220 cm, Tate Gallery, London

1994 Kurt Cobain, lead singer of
Nirvana, commits suicide 2005 7/7 London bombings
2002 London City Hall, designed by Norman Foster,
opens on the South Bank of the Thames
1998 Japan hosts 1998 Winter Olympics
1989 Nintendo Game Boy is released in North America

1980 1985 1990 1995 2000 2005 2010 2015 2020 2025 2030 2035 2040 2045 2050 2055 2060 2065

YINKA SHONIBARE MBE

In his re-creation of well-known images in the fabrics of former colonies, Yinka Shonibare MBE plays with ideas of authenticity and stereotyping. The resulting artworks are a vibrant reflection of London and multicultural Britain.

Yinka Shonibare was born in London but raised in Lagos, Nigeria. His African childhood inspired the artist with a love of brilliant colours and richly patterned textiles. Shonibare returned to England as a young man, where he studied at the Byam Shaw College of Art and then Goldsmiths College in London. He made London his home, setting up a studio in the artistic enclave of the East End from where he produces sculpture, paintings, photography and performance art.

The themes of colonialism and post-colonialism, race and class are vitally important to Shonibare's work. He uses his art to look at the multi-layered relationships and tensions between European countries and their former colonies, especially Africa. He maintains, however, his work is not intended to be moralistic or political: 'If I did, I think I would have become a politician'. He believes artists are often unaware of why they choose to produce certain works or of what message they trying to get across; Shonibare wants his art to make people think and, perhaps, to identify with his work. His main inspiration comes from the fashion world, and the versatility of textiles, not only as clothing but as a multi-faceted sculptural material.

Although often identified with the tail end of the YBA movement, Shonibare did not share the dubious fame of his more outgoing YBA predecessors. His first solo show was held at the Byam Shaw Gallery in London in 1989, but, despite holding regular solo shows, his name remained little known and the major galleries expected Shonibare to exhibit only as part of a larger group. In 1998, his exhibition *Diary of a Victorian Dandy* was commissioned by London Underground, bringing him to a truly modern, diverse audience. The following year his exhibition *Dressing Down* travelled around the UK and to Norway. By the 2000s, Yinka Shonibare had become an artist of note.

In 2004 he was nominated for the Turner Prize for *The Swing (after Fragonard)* (2001) an exuberant

multi-media sculpture that pays decadent homage to Fragonard's controversial rococo painting. In the same year, he was awarded an MBE. Shonibare, who describes himself as a 'post-colonial hybrid', is extremely proud of this honour and of its full title 'Member of the Most Excellent Order of the British Empire'; he uses 'MBE' as part of his professional name.

In 2008, the MCA in Sydney held a mid-career retrospective of Shonibare's work, an exhibition that took his works not only to Australia but on to the Brooklyn Museum in New York and the Museum of African Art in Washington, DC. A year later, Shonibare achieved much wider recognition in his home country after his giant ship in a bottle — a recreation of Admiral Lord Nelson's *HMS Victory* — was chosen to occupy the much-discussed Fourth Plinth in London's Trafalgar Square. Working closely with the Keeper of the ancient ship (which is open to visitors as a museum), Shonibare produced as close a replica as possible, with one important difference: the sails. Shonibare's sails are of gloriously coloured fabric. As the artist explained: 'We think of these fabrics as African textiles; in fact these are Indonesian textiles produced by the Dutch for the African market. I'm interested therefore in their global nature, in the Indonesian, Dutch and indeed British connections, since they were also manufactured in Manchester'. He sees *Nelson's Ship in a Bottle* as a celebration of global diversity: 'This piece celebrates the legacy of Nelson — and the legacy that victory at the Battle of Trafalgar left us is Britain's contact with the rest of the world, which has in turn created the dynamic, cool, funky city that London is'.

1962 Born in London, England
1984–89 Studies at Byam Shaw College of Art
1989–91 Studies at Goldsmiths College
1989 First solo exhibition at the Byam Shaw Gallery in London
1997 Exhibits in Charles Saatchi's *Sensation* exhibition
1999 Nominated for the Citibank Photography Award for *Diary of a Victorian Dandy*
2002 Commissioned by Okwui Enwezor at Documenta 10 to produce *Gallantry and Criminal Conversation*
2004 Nominated for the Turner Prize
2005 Awarded MBE
2008–09 Mid-career retrospectives at the Museum of Contemporary Art, Sydney, Australia and the Brooklyn Museum, New York
2010 Produces *Nelson's Ship in a Bottle* for the Fourth Plinth in London's Trafalgar Square

FURTHER READING
Jaap Guldemond (ed.), *Yinka Shonibare*, Rotterdam, 2004
Rachel Kent, Robert Hobbs and Anthony Downey, *Yinka Shonibare MBE*, Munich, 2008

Yinka Shonibare, photograph by Charlotte Player, 2009

1903 Death of Paul Gauguin

1925 Edward Hopper paints
House by the Railroad

1941 Death of Virginia Woolf

1964 Post Office Tower (now
BT Tower) in London is
completed

1890 1895 1900 1905 1910 1915 1920 1925 1930 1935 1940 1945 1950 1955 1960 1965 1970 1975

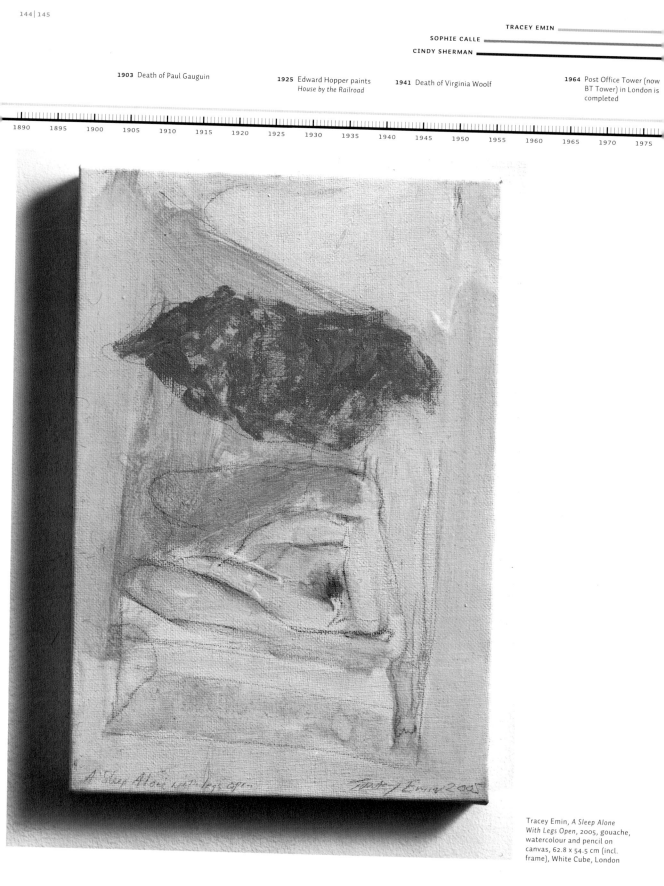

Tracey Emin, *A Sleep Alone
With Legs Open*, 2005, gouache,
watercolour and pencil on
canvas, 62.8 x 54.5 cm (incl.
frame), White Cube, London

1989 Burmese opposition leader Aung San 2001 Jeremy Deller produces *The Battle of Orgreave*
Suu Kyi is placed under house arrest
1992 The Church of England allows women priests 2003 Olafur Eliasson installs *The Weather Project*
in the Tate Modern Turbine Hall
Viking 1 successfully
lands on Mars 1996 International Monetary Fund approves a $10.2
billion loan to Russia for economic reform

1980 1985 1990 1995 2000 2005 2010 2015 2020 2025 2030 2035 2040 2045 2050 2055 2060 2065

TRACEY EMIN

Tracey Emin's life and art are inextricably linked, presenting an ongoing narrative of self-criticism and self-analysis. Sometimes crude, sometimes heartbreakingly delicate, her paintings, drawings and installations chart the artist's progress.

Tracey Emin was born in London, but grew up in Margate, Kent. In 1986 she graduated from Maidstone College of Art before enrolling as a post-graduate at the Royal College of Art in London; by the time she left the Royal College she had become known as one of the YBAs or 'Young British Artists', inextricably linked with her YBA contemporaries, including Damien Hirst, Sarah Lucas and Angus Fairhurst.

Emin has become famous — and notorious — for using her own life as inspiration. She works with varied media producing installations, videos and performance art, as well as drawings and prints. Works such as *Everyone I Have Ever Slept With 1963–1995* (1995), *My Bed* (1998) and *A Sleep Alone With Legs Open* (2005) guaranteed Emin a place in the gossip columns as well as in furious 'letters to the editor', helped by Emin's penchant for giving interviews when drunk and being immortalised by such quotations as 'I got a reputation not just of being a slag but of being a devious slag'. *Everyone I Have Ever Slept With*, nicknamed, 'The Tent', contained over 100 names of people Emin had shared a bed with — not only her sexual partners but those she had slept alongside, including her grandmother and her teddy bear. It was destroyed, along with many other examples of 'Britart', in the 2004 fire at the Momart warehouse.

The video installation *How it Feels* (1996) laid Emin's soul bare to her viewers as she wanders through London and answers questions posed by an invisible interviewer; the journey takes her back to the hospital where, in 1990, she had an abortion, prompting her to call herself 'a failure in life, a failure as an artist and a failure as a human being'.

Emin has received a quite extraordinary amount of misogynous criticism, by those who are content to laud the work of her male contemporaries but disapprove of Emin's very female and personal journey through art. Despite what has amounted at times to a concerted anti-Emin campaign, the artist has con-

tinued to develop her style and, in 2007 reached much-craved serious recognition: in that year she was asked to represent Britain at the Venice Biennale and was made a Royal Academician.

In 2008 Emin was invited to curate a room at the Royal Academy's Summer Exhibition. In the same year, the Scottish National Gallery of Modern Art held the first full retrospective of Emin's works; it was a touring exhibition which then travelled to Spain and Switzerland.

Emin often appears to have a childlike vision of art — a world in which the magic of creation is what moves her to produce her works and a world in which she, although an adult, is often reduced by society and her own paranoia to the role of re-calcitrant teenager. In 2010 the Royal Academy held an exhibition of Emin's prints, entitled *Walking with Tears*: for many, it was a chance to see the less controversial, softer side to Emin's talents. As the artist commented: 'I've always had a love of print-making because of the magic and alchemy of it all. You never really know how it's going to be until you turn the paper over … printmaking is a very intimate practice'.

One of Emin's favourite artists is the ill-fated Austrian painter Egon Schiele, who died of Spanish influenza at the age of 28. Many of Schiele's paintings were as scorned in his lifetime as Emin's have been in hers, and a number of her works, such as *The Last Thing I Said to You was Don't Leave Me Here II* (2000) attempt to capture the essence and especially the melancholic squalor of Schiele's style.

1963 Born 3 July in London, England
1980–82 Studies fashion at Medway College of Design; meets Billy Childish and become associated with the Medway Poets
1984–86 Studies printmaking at Maidstone Art College
1987–89 Studies at the Royal College of Art in London
1993 First solo exhibition, *My Major Retrospective*, at the White Cube in London; opens *The Shop* with Sarah Lucas in Bethnal Green
1995–98 Runs gallery in Waterloo Road, The Tracey Emin Museum
1995 Exhibits *Everyone I Have Ever Slept With 1963–1995* at the South London Gallery
1997 Exhibits in Charles Saatchi's *Sensation* exhibition
1999 Nominated for the Turner Prize; exhibits *My Bed* at the Turner Prize exhibition
2007 Chosen to represent Britain at the Venice Biennale; elected Royal Academician
2008 First major retrospective held at the Scottish National Gallery of Modern Art in Edinburgh
2010 Joint exhibition with Paula Rego and Matt Collishaw at the Foundling Museum in London

FURTHER READING
Neal Brown, *Tracey Emin*, London, 2006
Tracey Emin, *Strangeland*, London, 2006

Tracey Emin, photograph

1907 Pablo Picasso paints
Les Demoiselles d'Avignon

1925 Birth of Robert Rauschenberg

1953 Arthur Miller's
The Crucible opens
on Broadway

1967 Jacques Derrida
publishes *De la
grammatologie*

| 1890 | 1895 | 1900 | 1905 | 1910 | 1915 | 1920 | 1925 | 1930 | 1935 | 1940 | 1945 | 1950 | 1955 | 1960 | 1965 | 1970 | 1975 |

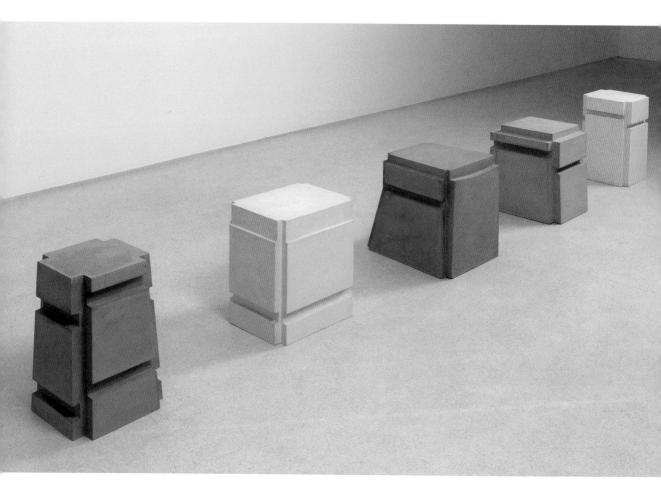

Rachel Whiteread, *Untitled*, 2010,
mixed media, dimensions variable,
Gagosian Gallery, London

1982 The Barbican Centre opens in London

1987 Docklands Light Railway opens in London

1999 Jackson Pollock retrospective at the Tate, London

5 Charlie Chaplin awarded KBE **1994** Rwandan Genocide **2008** Olafur Eliasson creates
The New York City Waterfalls

1980 1985 1990 1995 2000 2005 2010 2015 2020 2025 2030 2035 2040 2045 2050 2055 2060 2065

RACHEL WHITEREAD

Andrew Graham-Dixon called Rachel Whiteread's House *'One of the most extraordinary and imaginative public sculptures created by an English artist this century'. Her work today is often on a more intimate scale, exploring notions of still life, the multiple and colour.*

In 1993 Rachel Whiteread shot to fame with *House*, a monumental sculpture of a condemned terraced house in the East End of London for which she made a cast of the home's interior by spraying liquid concrete onto the walls. When the house's exterior walls were removed, her sculpture remained. It led Whiteread to win the coveted Turner Prize. Her sculpture was demolished the following year, amid widespread protests.

Whiteread was born in London in 1963. She studied painting at Brighton Polytechnic before studying sculpture at the Slade School of Fine Art in London. As one of the YBAs, Whiteread's work was bound to be controversial. In the same year in which she won the Turner Prize, for which the winner receives £20,000, Whiteread also won the 'anti-Turner Prize', a satiric comment on the state of British art set up by the K Foundation. Its founders named Whiteread the winner in their hunt for 'the worst artist in Britain' and awarded her £40,000 in prize money. Initially, Whiteread rejected the money, but on learning the K Foundation intended to burn the money if she didn't accept it, Whiteread donated it all to charity.

Two of Whiteread's sculptural themes are the recognition of spaces, as well as objects that create them, and the use of everyday items. In a move evocative of Marcel Duchamp's readymades, Whiteread tries to turn the everyday, domestic and mundane into works of art. *House* was a continuation of her early experiments with creating sculptures from the 'negative spaces' of domestic items including a bathtub, a chair, a hand basin and an airbed; she continued the theme with sculptures such as *Untitled (Stairs)* (2001). In her earliest works, Whiteread concentrated largely on autobiographical themes — evoking her own life and places in which she had lived — her later work is less egocentric, focusing on the outside world and, often, on injustice.

Three years after being awarded the Turner and anti-Turner prizes, Whiteread won the commission to design a Holocaust memorial for Vienna. The commission reinforced her status as an internationally recognised artist. In 1997, she represented Britain at the Venice Biennale and in 1998 she received her first commission from the US. The Public Art fund paid for her to create *Water Tower*, composed of steel and translucent resin. It was displayed on the rooftop of a building in New York's SoHo, its translucence reflecting perfectly the changes in the sky and weather. The sculpture, which was moulded from the empty space inside a utilitarian water tower, was later reinstalled on the roof of New York's MoMA. In 2001, Whiteread's *Monument* was erected on the empty Fourth Plinth in London's Trafalgar Square: it was a cast of the inside space of the Fourth Plinth itself, and when in place it transformed the plinth into a mirror image.

Although she won the Viennese commission in 1996, it took four years of political squabbling for her design to come to fruition. In 2000 Whiteread's *Nameless Library* was finally unveiled: it is a library turned inside out, the cast of an interior of a library, with the spines of multiple books jutting out of the walls. These empty spines acknowledge the loss of so many people whose names might never be recovered; they also emphasize how much learning and wisdom was destroyed in the concentration camps and the many thousands of skills that disappeared with all those who perished under the Nazi regime. Whiteread's intention with the sculpture was to 'invert people's perception of the world and to reveal the unexpected'.

1963 Born 20 April in London
1982–85 Studies painting at Brighton Polytechnic
1985–87 Studies sculpture at the Slade School of Art, University College London
1988 First solo exhibition at the Carlyle Gallery in London
1990 Produces *Ghost*
1992–93 Works in Berlin on the DAAD Artist's Programme
1993 Awarded the Turner Prize
1993 Produces *House*
1997 Exhibits *Untitled (One Hundred Spaces)* at the Royal Academy of Art's *Sensation* exhibition
1998 Produces *Water Tower* as part of a grant for the New York City's Public Art Fund
2000 Commissioned by Austrian authorities to produce *Holocaust Memorial* for the Judenplatz in Vienna
2001 Commissioned to produces *Untitled Monument* for the Fourth Plinth in Trafalgar Square
2005–06 Commissioned to produce *Embankment* for the Tate Modern Turbine Hall
2008 Short-listed for the *Angel of the South* project

FURTHER READING
Chris Townsend and Jennifer R. Cross, *The Art of Rachel Whiteread*, London, 2004
Allegra Pesenti, Ann Gallagher and Rachel Whiteread, *Rachel Whiteread: Drawings*, Munich, 2010

Rachel Whiteread, photograph

DAMIEN HIRST

MATTHEW BARNEY

JULIAN SCHNABEL

1924 Surrealist Manifesto is issued

1933 Paul Nash forms the Unit One group

1968 Assasination of Martin Luther King, Jr.

1962 Alberto Giacometti is awarded grand prize for sculpture at Venice Biennale

| 1890 | 1895 | 1900 | 1905 | 1910 | 1915 | 1920 | 1925 | 1930 | 1935 | 1940 | 1945 | 1950 | 1955 | 1960 | 1965 | 1970 | 1975 |

below
Damien Hirst, *Heaven Above, Hell Below*, 2003, pills and flies on canvas, 38.2 x 51 cm, White Cube, London

right
Damien Hirst, photograph by Luke Stephenson, 2007

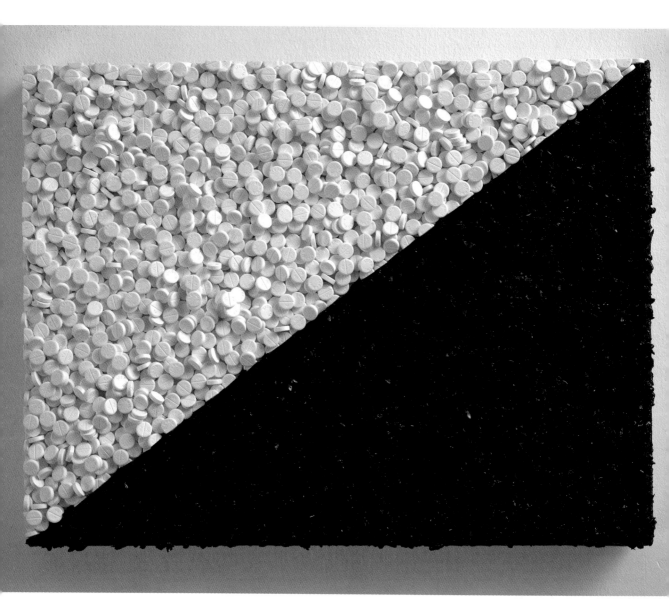

1991 Irish Museum of Modern Art opens in Dublin

1992 Paul Simon tours South Africa **2009** Barack Obama elected US President

1982 Falklands War **1994** Matthew Barney begins working on the *Cremaster Cycle*

1996 Douglas Gordon wins Turner Prize

1980 · 1985 · 1990 · 1995 · 2000 · 2005 · 2010 · 2015 · 2020 · 2025 · 2030 · 2035 · 2040 · 2045 · 2050 · 2055 · 2060 · 2065

DAMIEN HIRST

Damien Hirst is a prodigious self-promoter whose public relations and marketing savvy cannot be questioned. His art may often be the object of criticism, yet he retains the title of highest-selling living artist of all time.

Hirst burst onto the British art scene in the 1980s, as the most vocal of the YBAs (Young British Artists). From 1986 to 1989, Hirst studied at Goldsmiths College in London, and in his second year he curated the show that would put the YBAs on the map: Freeze, which was held in an abandoned warehouse in London's Docklands (then a little-known area, ripe for development). The exhibition included works by 16 unknown artists, including Hirst, Sarah Lucas and Angus Fairhurst.

Two years later, Charles Saatchi — the multi-millionaire advertising mogul turned art-collector — bought Hirst's *A Thousand Years*, a controversial installation of the type that would make Hirst's name. As soon as Saatchi became involved, Hirst was firmly established as one of the most famous artists in Britain. *A Thousand Years* was composed of a large glass case, inside which was a rotting cow's carcase being devoured by flies and maggots. Other controversial works followed, including several animals preserved in formaldehyde. A four-metre installation of a dead tiger shark in formaldehyde was given the title *The Physical Impossibility of Death in the Mind of Someone Living*; it ensured Hirst received notoriety, hate-mail and a constant stream of publicity. His 2003 work *Heaven Above, Hell Below*, which is composed of pills and flies attached to a canvas, melds the theme of death and decay with his other prominent theme of drugs and the idea of altered states of mind.

Throughout the 1990s, Hirst remained at the forefront of the BritArt movement, which was helped along by the late 1990s' concept of 'Cool Britannia'. The YBAs, along with the Indie music scene, changed Britain's overseas reputation in much the same way that The Beatles and Rolling Stones had done in the 1960s.

In 2010 *The Economist* magazine reported that in 2009 Hirst's sales had plummeted by 93% in twelve months. The year 2008 had been an impossible one to follow. At 'Beautiful Inside My Head Forever', a two-day sale at Sotheby's in September 2008, Hirst had made history by accrueing more money than any other living artist. The day after the sale finished, the world awoke to the news of the fall of Lehmann Brothers. The artist who had made £175 million in 48 hours was unable to realise such heights in the climate that followed.

In an unusual move, Hirst approached London's Wallace Collection — a gallery housing a collection of old masters, brimming with works by Boucher, Greuze, Reynolds, Rembrandts, and other 17th- and 18th-century masters — in the hopes of arranging an exhibition. The exhibition, which opened in late 2009, was billed as Damien Hirst showing the public that he was able to draw. The majority of the critics were underwhelmed by the exhibition of his paintings and many commented wryly that the exhibition had achieved precisely the opposite of its intention.

Hirst's career has been dogged by criticism and accusations of plagiarism. By 2010, 15 instances of alleged plagiarism were claimed to have been investigated. These included some of the works that made Hirst famous: his diamond-encrusted skull (2007), his series of medicine cabinets (from 1989) and the ensuing room-sized installation *Pharmacy* (1992); the latter two were compared by some critics to Marcel Duchamp's readymades. The skull, entitled *For the Love of God*, was created from a 19th-century human skull Hirst bought in a London junk shop, 8,601 'ethically sourced' diamonds and a set of pristine new teeth. It is estimated to have cost the artist around £14 million to make; when it sold for £50 million it became the world's most expensive piece of contemporary art.

1965 Born in Bristol, England
EARLY 1980S Studies at Leeds College of Art
1986–89 Studies at Goldsmiths College
1988 Organises the independent student exhibition, *Freeze*, in London's docklands
1991 First solo exhibition, *In and Out of Love*, in a disused shop in London
1992 Exhibits *The Physical Impossibility of Death in the Mind of Someone Living* and *A Thousand Years* at Saatchi Gallery's first Young British Artists exhibition; nominated for Turner Prize
1993 Exhibits *Mother and Child Divided* at Venice Biennale
1994 Curates *Some Went Mad, Some Ran Away* at Serpentine Gallery, London
1995 Wins Turner Prize; directs video for Blur's *Country House*
1997 Exhibits in Charles Saatchi's *Sensation* exhibition
2008 Holds two-day auction of new work, *Beautiful Inside My Head Forever*, at Sotheby's, London
2009 Exhibits *No Love Lost*, at Wallace Collection, London

FURTHER READING
Gordon Burn and Damien Hirst, *On the Way to Work*, London, 2001
Damien Hirst, *I Want To Spend the Rest of My Life Everywhere, with Everyone, One to One, Always, Forever, Now*, London, 2006

1928–29 René Magritte paints *The Treachery of Images*

1951 Jack Kerouac publishes *On the Road*

1967 Richard Diebenkorn his *Ocean Park* series

1969 Michel Fouca publishes *L'A logie du Savoi*

1890	1895	1900	1905	1910	1915	1920	1925	1930	1935	1940	1945	1950	1955	1960	1965	1970	1975	

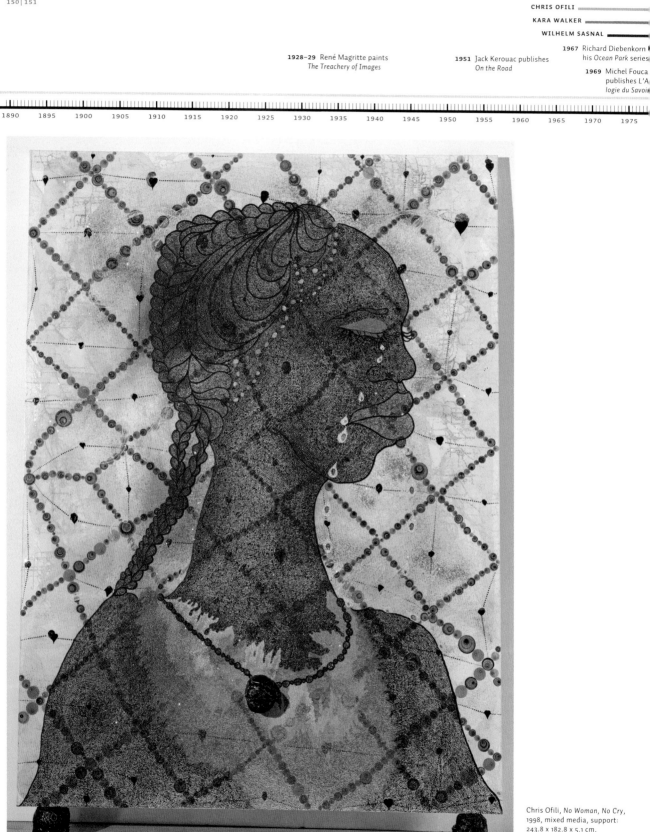

Chris Ofili, *No Woman, No Cry*, 1998, mixed media, support: 243.8 x 182.8 x 5.1 cm, Tate Gallery, London

1988 Death of Jean-Michel Basquiat
1994 Edvard Munch's *The Scream* is stolen in Oslo
1998 Google search engine launched
1984–85 Miners' strike in Britain **2004** Fire in Momart storage warehouse
2009 Barack Obama awarded Nobel Peace Prize

1980 1985 1990 1995 2000 2005 2010 2015 2020 2025 2030 2035 2040 2045 2050 2055 2060 2065

CHRIS OFILI

Chris Ofili's multilayered images break down the hierarchies between black and white culture. Using collage, found objects and, infamously, elephant dung, he brings hip-hop sampling into the art gallery.

Chris Ofili was born in Manchester in 1968. He spent three years at London's Chelsea School of Art, followed by two years completing his Masters degree at the Royal College of Art — but he was making a name for himself long before he finished his education. In 1989, during his second year at Chelsea, his work was included in the Whitworth Young Contemporaries exhibition for the first time. A year later, he was chosen to exhibit in the BP Portrait Award at the National Portrait Gallery.

Ofili's parents emigrated to Britain from Nigeria and the artist has always been inspired by African art. In 1991, he was awarded a British Council Travel Scholarship which gave him the opportunity to travel to Zimbabwe. It was his first trip to Africa. Ofili's work encompasses painting and collage and in Zimbabwe he became inspired by a new medium, elephant dung. It was a quirk that made his name famous. He 'smuggled' his first batch of dung back home in his suitcase; when that ran out, he began buying elephant dung from London Zoo and drying it out in his airing cupboard. He used it to add texture to his paintings and to create sculptures. Even before he discovered elephant dung, Ofili used a variety of different media to add layers to his paintings. In addition to traditional African art, Ofili's major influences include ancient cave paintings, comic books, illustrated magazines including pornography, 1970s Blaxploitation films and hip-hop culture.

By 1997, Ofili had been noticed by the art collector Charles Saatchi and his work formed part of the *Sensation* exhibition at the Royal Academy. In 1998, following a highly successful year in which his work was exhibited in Southampton, London and Manchester, he won the Turner Prize — he was the first black artist ever to win the prize, and the first painter to do so since 1985. One of Ofili's paintings in the 1998 Turner Prize was *No Woman, No Cry* (1998), the artist's response to the racist murder of British teenager Stephen Lawrence and the highly criticised police investigation into the crime — for which no one was found guilty. The emotive painting, of a woman weeping copious tears, was a tribute to the murdered boy's mother, Doreen Lawrence.

The euphoria of 1998 was countered the following year when the mayor of New York, Rudolph Giuliani, blocked the proposed exhibition of Ofili's *The Holy Virgin Mary* (1996), which shows a pregnant African Mary with a background of images cut from pornographic magazines and balls of elephant dung. The mayor threatened the Brooklyn Art Museum with legal action if it displayed Ofili's painting.

Ofili's formative years were influenced by his parents' African heritage, the ubiquitous American pop culture and his own British upbringing. In 2005, Ofili moved to Trinidad where his work was instantly transformed by the landscapes and lighting all around his Port of Spain studio. His Trinidadian works burst with colour, exemplifying how strongly Ofili's works absorb the influences of the artist's surroundings.

Despite the hype around his use of elephant dung, which some critics claimed was simply a publicity stunt, Ofili is a traditionally trained and skilled fine artist. As he himself commented during the Turner Prize ceremony, it is more important for people to decide whether a work is 'good art or bad art', rather than focus on whether the media includes elephant faeces. At the basis of his works is a deep understanding of colour, composition and draughtsmanship. In 2010, when Ofili was 42 years old, the Tate held a major 'mid-career' retrospective of his work — including *The Holy Virgin Mary*.

1968 Born 10 October in Manchester, England
1987–88 Studies at Tameside College of Technology
1988–91 Studies at Chelsea School of Art in London
1991–93 Studies at the Royal College of Art
1991 First solo exhibition at the Kepler Gallery in London
1992 Awarded British Council Travel Scholarship; travels to Zimbabwe; begins incorporating elephant dung into his paintings
1997 Exhibits in Charles Saatchi's *Sensation* exhibition
1998 Awarded the Turner Prize
1999 Causes controversy after exhibiting *The Holy Virgin Mary* at the Brooklyn Museum of Art for the *Sensation* exhibition
2003 Represents Britain at the Venice Biennale
2005 *The Upper Room* is purchased by the Tate Gallery

FURTHER READING
David Adjaye and Thelma Golden, *Chris Ofili*, New York, 2009
Judith Nesbitt, *Chris Ofili*, London, 2010

1929 Geneva Convention is signed

1948 Formation of British
Transport Police

1964 René Magritte paints
The Son of Man

1961–62 Construction of Seattle
Space needle

1890　1895　1900　1905　1910　1915　1920　1925　1930　1935　1940　1945　1950　1955　1960　1965　1970　1975

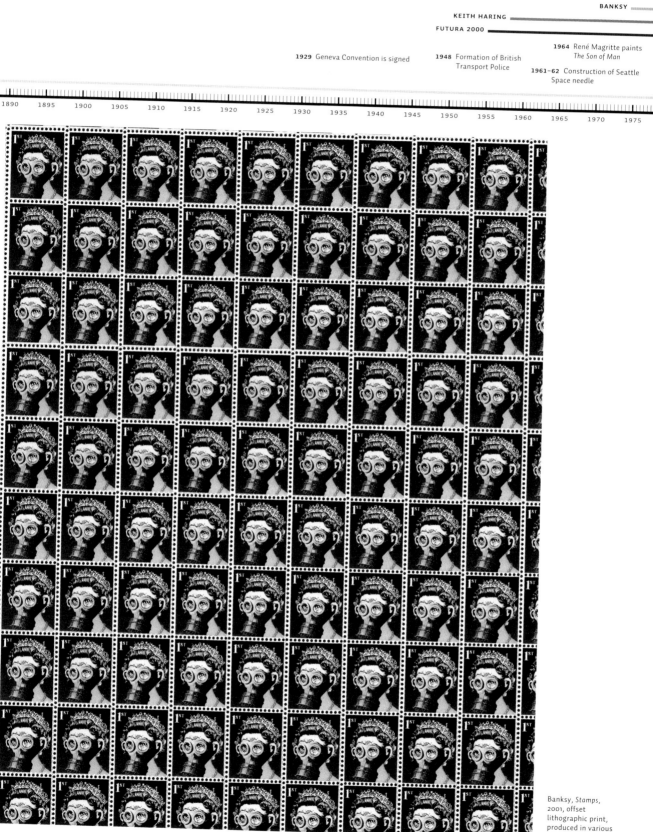

Banksy, *Stamps*,
2001, offset
lithographic print,
produced in various
sizes

1980 1985 1990 1995 2000 2005 2010 2015 2020 2025 2030 2035 2040 2045 2050 2055 2060 2065

BANKSY

Guerrilla artist, graffiti master, social commentator, anonymous. Banksy spray-painted his way into the British art scene in the 1980s and has successfully kept his real identity out of the media.

Banksy was born in Bristol in the 1970s, which is as much information as his manager is willing to give (other sources pin the year down to 1974). After years of making his social statements on the walls, tunnels and streets of Britain, Banksy began to gain cult international status, exemplified by the 2002 show *Existencilism* in Los Angeles. By 2006, Banksy's US reputation had grown emphatically: *Barely Legal*, also in L.A., attracted over 70,000 visitors. In 2008, more than 120,000 New Yorkers queued to see Banksy's exhibit of animatronic pets at the Village Pet Store and Charcoal Grill.

In 2004, *Turf War* opened in a warehouse in über-trendy East London. The exhibition featured painted live animals, including a bull covered in black arrows to emulate an old-fashioned convict's suit. The show began on the Friday and was closed down on the Sunday; Banksy's website explained the closure was 'for legal reasons'. As with so many of Banksy's actions, the furore only served to make the artist even more talked about. In the same year he created the 'Banksy of England', printing £1 million worth of fake £10 notes, on which the portrait of Queen Elizabeth II had been replaced by Princess Diana.

Banksy's images are intended to be thought-provoking, often shocking and always ready to be talked about. His images have included prisoners from a concentration camp alongside a sheep wearing identical stripes, people in gas marks, gay policeman kissing on the street and a small girl frisking a uniformed soldier as he stands, hands up, against a wall, his gun abandoned by his side.

When his native Bristol held a Banksy exhibition in 2009, it attracted over 100,000 visitors per month. He has been claimed as a hero of the forgotten, a left-wing political activist and a voice of the urban people; others call him a vandal and many fellow graffiti artists deride him for 'selling out'.

By the end of the noughties, Banksy was globally famous. In 2005, his actions attained worldwide coverage when he successfully graffitied the controversial wall dividing Israeli and Palestinian territories. In a statement the artist said '[the wall] essentially turns Palestine into the world's largest open prison'. Through his press spokeswoman Banksy told the media he had been threatened by gun-toting soldiers and been told by a Palestinian that he had made the wall look too beautiful: 'We don't want it to be beautiful, we hate this wall'. In the same year Banksy inserted spoof works of art onto the walls of galleries and museums including the British Museum, the Metropolitan Museum of Art and the Louvre; in some cases it took the curators weeks to notice them.

In 2007, *Space Girl & Bird* made a record sale at Bonham's auction house, £288,000 — yet in the same year London Transport painted over his iconic *Pulp Fiction* mural near Old Street station, saying it was encouraging anti-social graffiti. The mural depicted Samuel L. Jackson and John Travolta holding bananas instead of guns.

In 2010, Banksy was commissioned to design a special opening sequence for US cult TV show *The Simpsons*. In the same year he won a Grierson Award and an Oscar nomination for his documentary *Exit Through the Gift Shop*, which was lauded as 'original and insightful'; he dedicated his award to fellow graffiti artists because they '[risk] life and limb every night'. He commented: 'I do like to think that in this world of graffiti art — which is essentially mindless, messy and stupid — we finally gave it the kind of documentary it deserves'.

1970s Born Bristol, England

FROM LATE 1980S Develops trademark style of stencil street art; paints tens of thousands of different images on public walls all over the world

2002 'Existencilism' show in Los Angeles

2004 'Turf War' show in old East London warehouse includes painted live animals

2004 'Banksy of England' prints £1 million of British £10 notes, with Princess Diana's head replacing the Queen. Hastily withdrawn after people start successfully spending them

2005 Large images painted on Israel's dividing wall in Palestine attract global press attention; hangs 'interfered with' oil paintings and pseudo-exhibits in major public galleries including the British Museum in London, Metropolitan Museum of Art in New York and the Louvre in Paris

2006 Three-day 'Barely Legal' exhibition in Los Angeles attracts 70,000 people including Hollywood celebs

2007 The sixth of Banksy's annual Santa's Ghetto Xmas shows takes place in Bethlehem; *Space Girl and Bird* original painting sells for £288,000 at Bonhams

2008 'Village Pet Store and Charcoal Grill' in New York is stuffed with animatronic pets doing unexpected things. Over 120,000 people queue up to view exhibits

2009 'Banksy vs the Bristol Museum' exhibition at Bristol City Museum presents paintings, sculpture, installations and animatronics. Over 300,000 people visit the exhibition in three months

2010 Commissioned to design one-off opening sequence for *The Simpsons*; cinema release of Banksy's film *Exit Through the Gift Shop*

FURTHER READING
Banksy, *Wall and Piece*, London, 2005
Steve Wright, *Banksy's Bristol: Home Sweet Home*, Bristol, 2007

Banksy, *I Hate Mondays*, 2009,
spray paint and emulsion on canvas,
203 x 198 cm

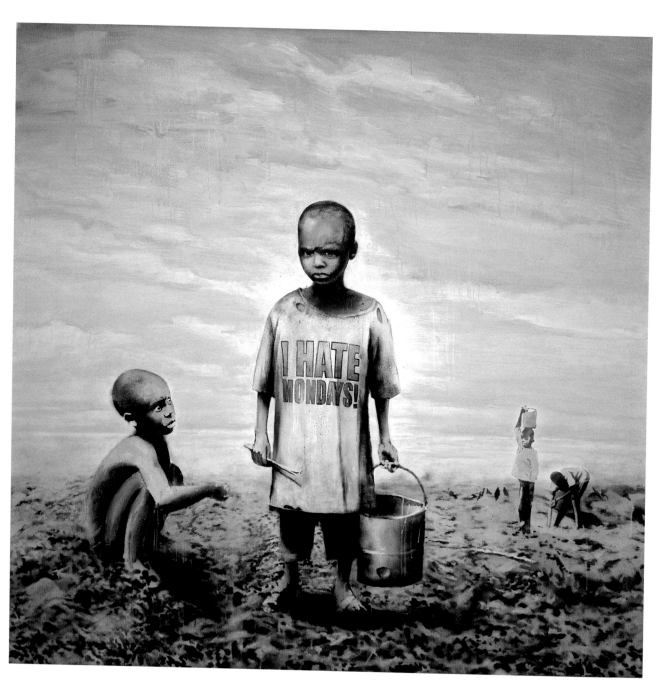

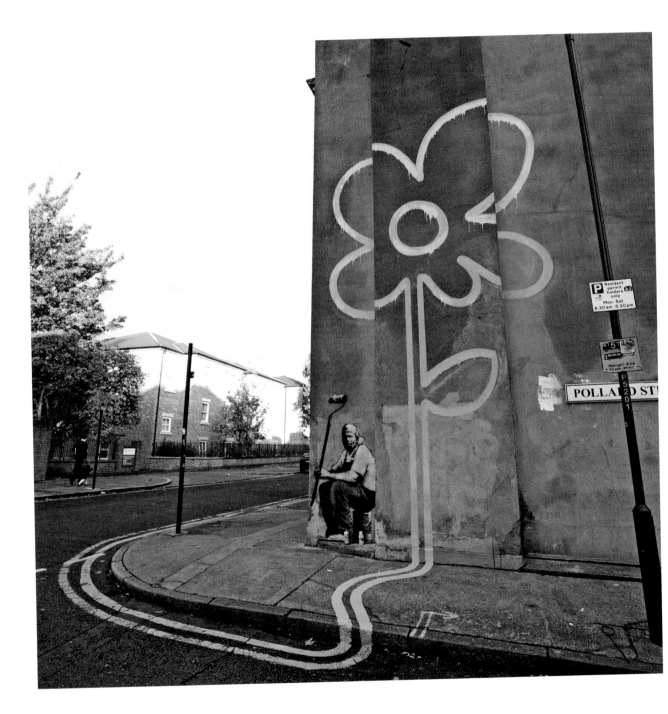

INDEX OF NAMES

PHOTO CREDITS